JAPANESE GRAPHICS NOW!

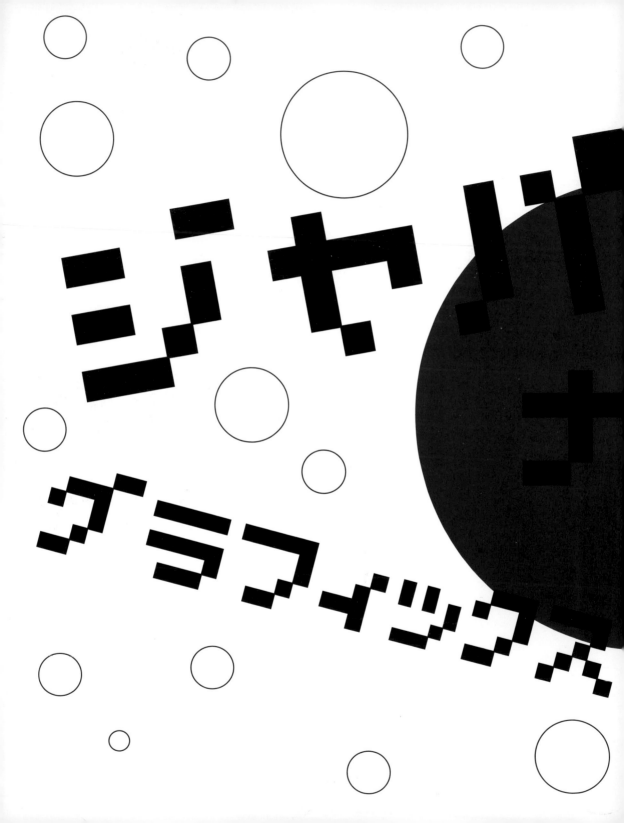

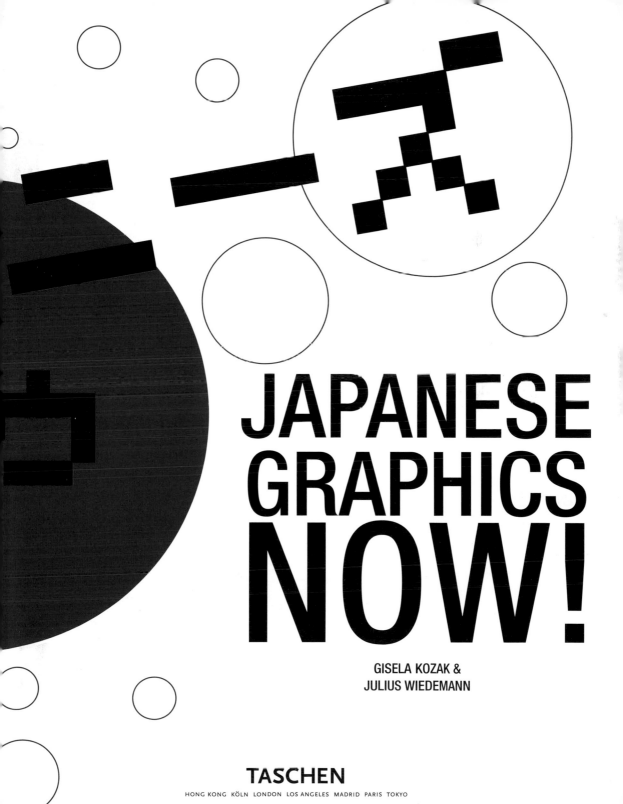

JAPANESE GRAPHICS NOW!

**GISELA KOZAK &
JULIUS WIEDEMANN**

TASCHEN

HONG KONG KÖLN LONDON LOS ANGELES MADRID PARIS TOKYO

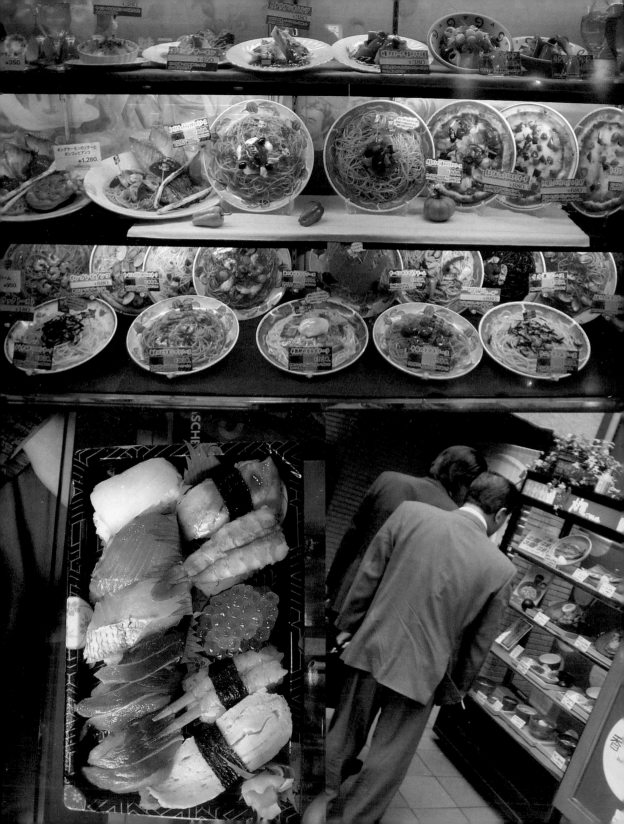

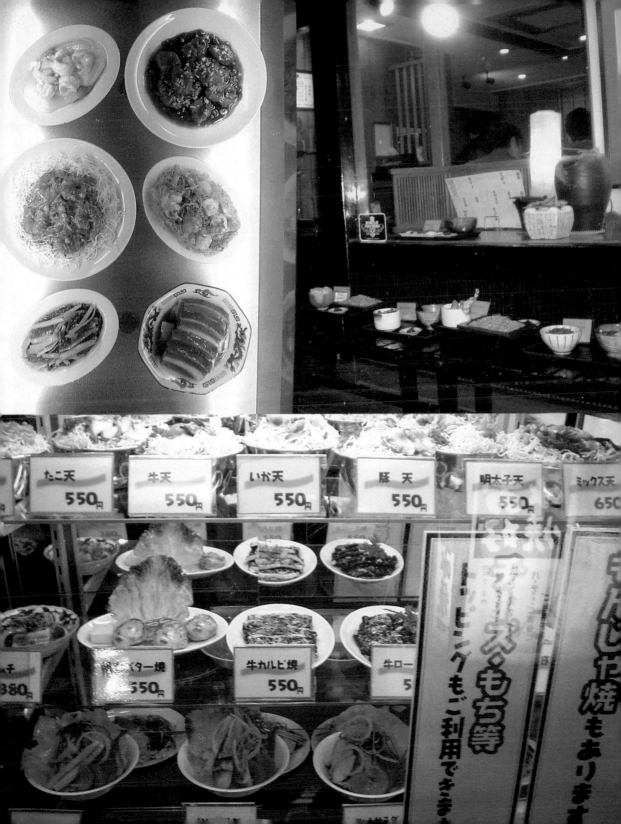

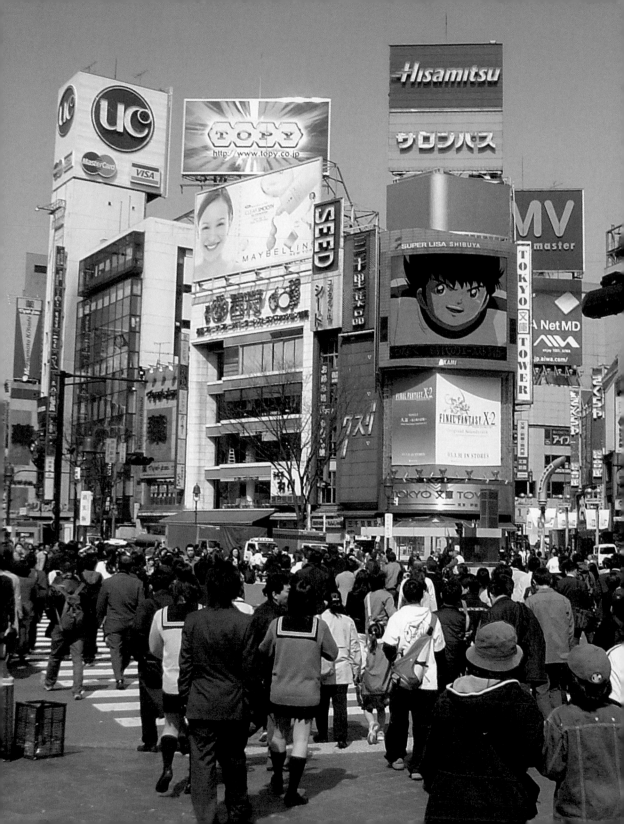

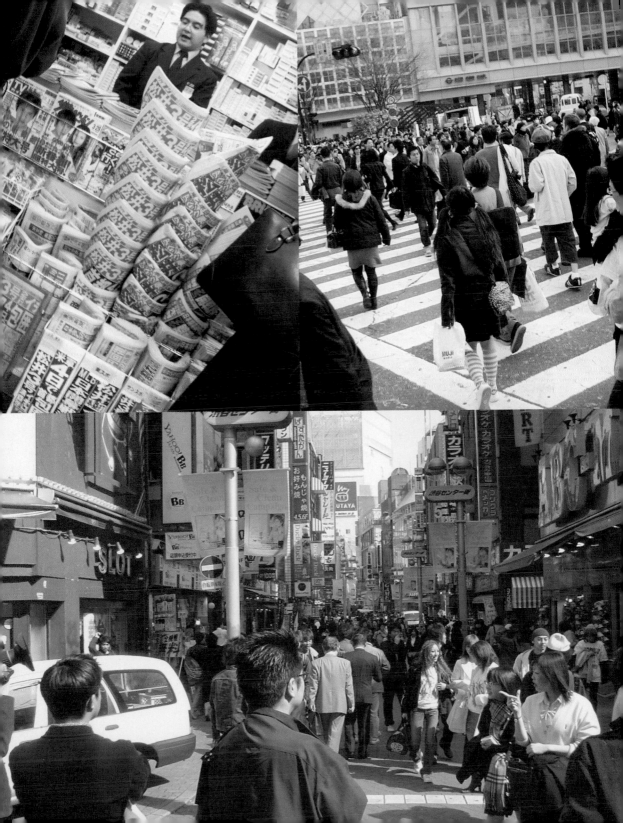

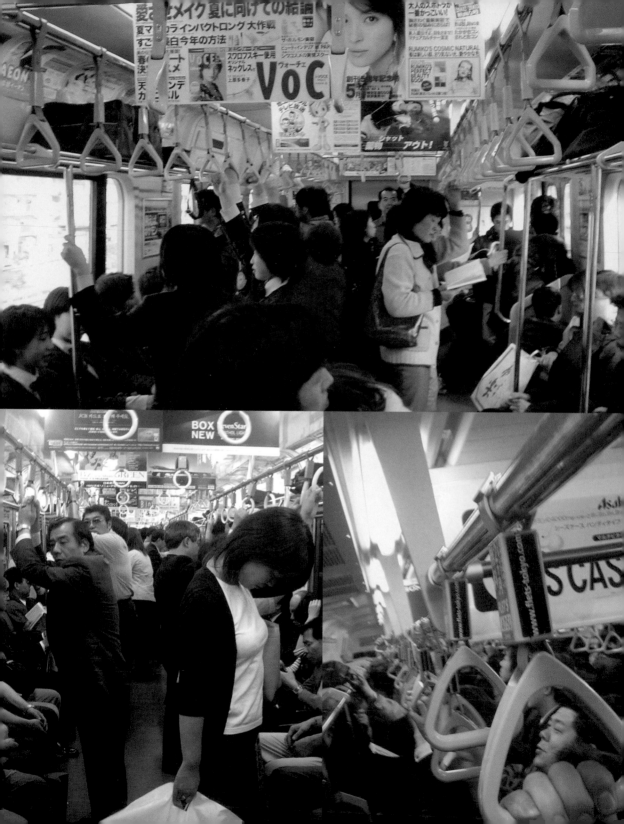

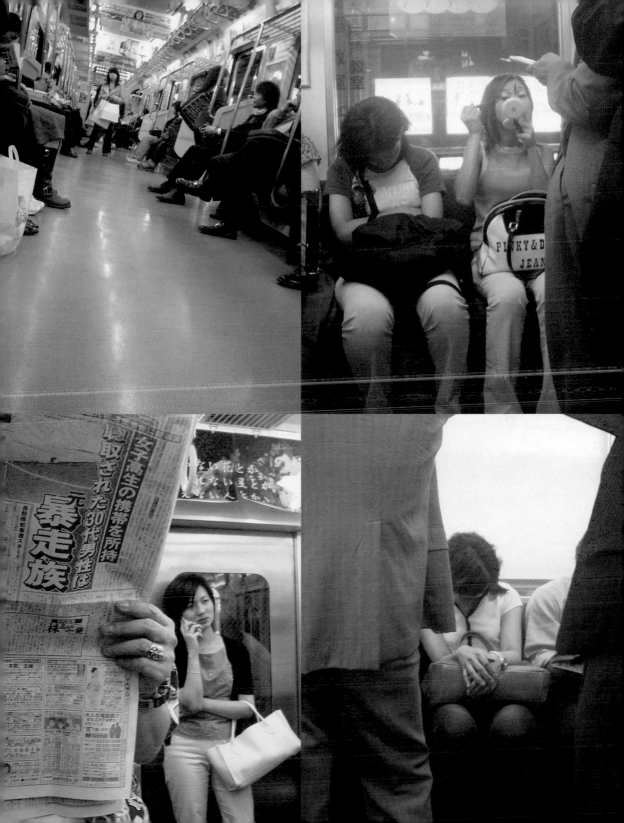

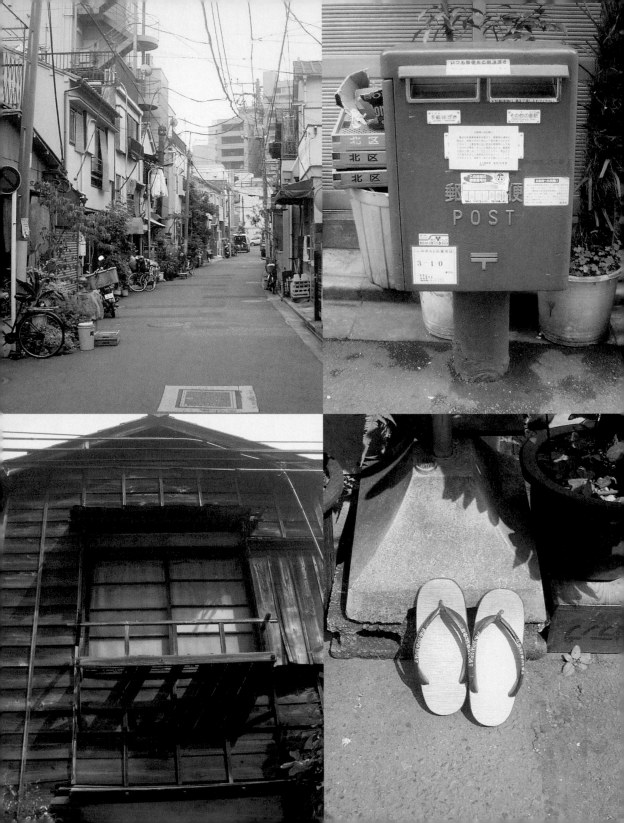

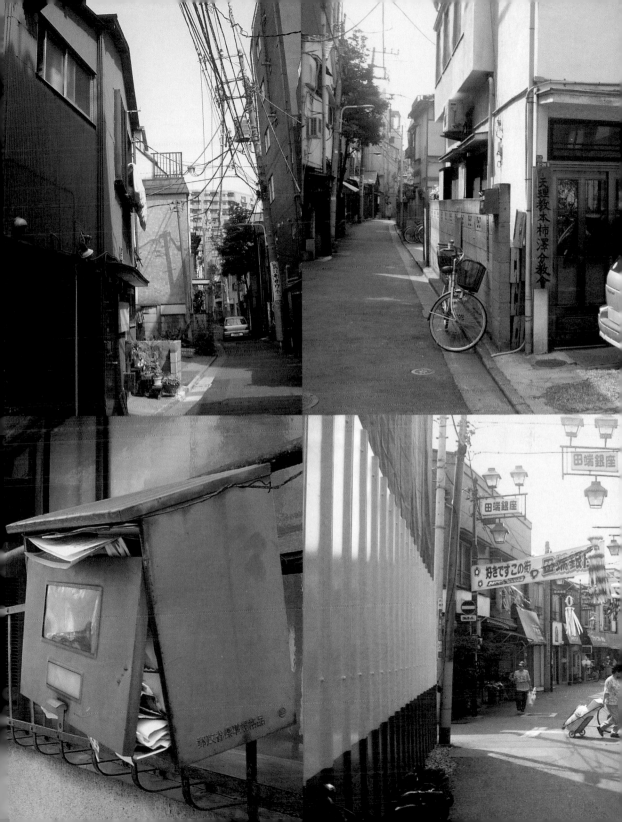

CONTENTS

Packaging パッケージ 024

Posters & Ads ポスターと広告 126

Print プリント 286

INTRODUCTION

彼女は20歳になったが、今日が誕生日というわけではない。今日は彼女の「成人の日」である。それで、今年20歳を迎えた他の女の子たちと同じように着物を着ている。彼女は個人的に誕生パーティーを開きたくないわけではないのだが、実を言えば、ここでは個人的な事柄を祝うことがあまりない。一方、他の人たちがしないのなら、自分たちも個別にパーティーを開こうとはしないらしい人々にとって、伝統的な祭りは祝いごとを合同で済ませるのに適しているようである。

というわけで、彼女は最新のデジカメ付き携帯電話を使って友人たちの写真や動画を撮りながら、人混みのなかを歩いていく。式典が終わりに近づくと、出席者たちは2次会に向けてどこかへ出かけていく。茶会（茶道の）などまったく計画になく、おそらくどこかのファーストフード・レストランに腰を据えるのだろう。あるいはカラオケ・パーティーかも知れない。互いに写真を撮り合う撮影会はまだ終わらないが、彼女たちは移動し始める。お茶しに（ソフトドリンクを飲みに）行く前にちょっとしたショッピングに出かける。ショッピング・リストの上位を占めるのはヨーロッパの高級ブランド品である。そこには東京のワンルーム・マンションの家賃3ヶ月分に相当する値段のハンドバッグも含まれている。彼女たちは結局のところ、まったく同じタイプのバッグを買うことになる。似たような趣味を共有することが、安心感になるらしい。個別のパーティーを開くよりも、混雑した祭りを共有するのと大して変わらない。パターンは同じである。ショッピング・タイムが終わる－少なくとも今日のところは－ソフトドリンクを飲み終えると、彼女たちは全員家へ帰りはじめる。最終電車に間に合うように帰らなければならないからである。これは、いわば鉄道会社に「後援」された日本の戒厳令である。

日本では、これが当たり前の風景として日常的に見られるのである。着物に携帯電話、伝統的な儀式の仕上げがファーストフード・レストラン、高価なブランド・バッグ、身動きも取れないほど混雑した電車－これらすべてが特に違和感もなく肩を並べている。日本の社会では、実に驚嘆すべきことに、新旧の伝統へのリスペクトが特徴の1つとなっているのである。

日本のデザインにも、まさにこれと同じ現象が見られる。伝統と新しいものの両者が最も良いところを引き出され、共存するのである。そうした印象的な例の数々をこの『ジャパニーズ・グラフィックス・ナウ！』全編を通じて読者はご覧になれるはずである。

日本のグラフィックスは見るものが気づかないうちに過去と現在を往来させてくれる能力を持っている。うっかりすれば、どれが過去でどれが現在かに気づくことさえ難しいかも知れない。それこそが日本様式または「和風」なのである。

何よりも、日本的な感性ではバランスが重視される。この感性が最も端的に見られるのが日本語そのものだろう。日本語には異なる3つの文字種があるが、それが同じ比率で使用されるのである。文章を書くときは、漢字と2種類の音節文字である「ひらがな」と「カタカナ」との組み合わせが使用される。実際には「カタカナ」は基本的に外来語や日本生まれでないものを表すのに使われる。

そして文化を維持しようとするためか、その特殊な習慣がデザインの起源を区別するときにも同じように存在する。日本人が自分たちの作り出したデザインの起源をはっきりさせる必要性を強調するのは、おそらく彼らが「アジア人」と呼ばれるのを嫌うせいかも知れない。グラフィック・デザインが国産風であろうと外国風であろうと、風合いが商品に与える重要な役割を果たしている。例えば、コーヒーやチョコレートのグラフィックスなら、ロゴやパッケージ、広告までヨーロッパ・スタイルでデザインした方がより理に叶っている。ちょうど「カタカナ」の原則が日本のものと外国産のものとを分ける一線を維持して

いるかのようだ。それがおそらく製品の起源に敬意を表しつつ、日本のアイデンティティーを維持する方法なのだろう。同じ理由から、昔ながらの和風デザインのパッケージに入っていない「水ようかん」などの和菓子や日本酒にお目にかかることはめったにない。竹や和紙のような昔ながらの素材が現代的なプラスチック素材に取って代わられるようになった今でも、古いデザインのエッセンスはそのまま残っている。日本のアイデンティティーは国レベルで残されているばかりか、それぞれの地域レベルでも残されている。これは、日本が島国で、独自の文化を維持しやすいことに原因があるのかも知れない。しかし、バランスと釣り合い、あるいはミニマリズム（外国人が日本のデザインについておそらく最も強く抱くイメージだろう）だけが日本のデザインではない。ときにはグラフィック・デザインはたぶん人口の過密な状態に起因するのだろうが、悪い意味ではなく、いささかごちゃごちゃしたものになる。こうしたデザインの好例は電車の車内広告に見られる。デザイナーたちは忙しく走る電車と「騒々しい」広告で競うつもりはないらしい。むしろ彼らはぎゅうぎゅう詰めの通勤電車で毎日かなりの長時間を過ごさなければならない不幸な乗客を楽しませようとしている可能性がとても高い。乗客は疲弊する通勤中に何か読むものを与えられて感謝さえしているかも知れない。車内広告は、見る人の視力に挑戦しているかのような、たいてい非常に小さなサイズの文字で書かれた情報で埋め尽くされている。信じようと信じまいと、平日午前7時30分の満員電車に乗り合わせたら、これを全部読めるチャンスに遭遇できるにちがいない。

もう1つ見逃せない特徴は、マンガに極めて近く、ときには子供っぽくさえあるユーモアのセンスだ。キュート、または「かわいい」ものが何よりも求められる。望ましい「キュート」なイメージを得ようと、たいてい小さなペットのようなキャラクターやフィギュアがあらゆる商品の販売促進に使われている。仮に商品が大人向けのものであっても、こうした、より「心に触れる」効果を得る方法を使うのがトレンドになっている。

『ジャパニーズ・グラフィックス・ナウ！』は日本の最高のデザイナーたちの作品を巡る旅に読者を誘う。伝統と新しさ、ミニマリストと煩雑さ、バランスの良さとかわいらしさへの感性をどうか楽しんで欲しい。そして何よりも、現代日本文化をより身近に見るという、このユニークなチャンスを満喫していただきたい。

She has turned 20, but today is not her birthday. It is her "coming-of-age ceremony day" (seijin-shiki) and she, like all the other girls who turned 20 this year, is wearing a kimono. It is not that she would not like to have a private birthday party. The truth is you don't really get to celebrate your personal affairs that often here. On the other hand, traditional celebrations (matsuri) seem an ideal way to share the festivities, while assuring people that they will not stand out as much as at a party of their own.

So there she goes, walking among the crowd using the latest mobile phone to take pictures and movies of her friends. The ceremony is almost over and the group is heading somewhere for the second stage of the party. No tea ceremony in their plans… probably some fast-food restaurant will do the trick. Or perhaps a karaoke party? The picture session is not over yet, but they start moving. A little shopping before going for a soft drink. Up-market European brands top the list - including handbags that may cost as much as three months rent for a one-room-flat in Tokyo. They almost end up with the same type of handbag. Sharing a similar taste seems to give them a sense of relief. Not much different from sharing a crowded festival instead of a private party… the pattern is the same. Shopping time is now over - at least for today. After finishing their soft drinks, they all start to head off home. They need to catch the last train, a kind of curfew in Japan "sponsored" by the railway companies.

This could be just a regular day in Japan: kimonos and mobile phones; traditional ceremonies ending at fast food restaurants; expensive branded handbags; and totally packed trains. All of these things occur side by side, without any apparent contradiction. The respect for old and modern traditions marks one of the most astonishing characteristics of Japanese society.

This is exactly the same as you will find in Japanese design. The traditional and the modern coexist, bringing out the best in both. You will get a chance to see impressive examples of this - all the way through Japanese Graphics Now!

Japanese graphics have the ability to let you move between the past and the present without even noticing it. It may even be hard to see the difference between the two. Let's say, rather, Japanese style or "wafu".

The Japanese style sensitivity is based, among other things, on a respect for balance. This sensibility is probably best seen in the Japanese language, in which every character preserves the same proportion throughout the three different Japanesewriting systems. A combination of Chinese characters and two syllabic systems called "hiragana" and "katakana" is used in actual writing. In reality, "katakana" is basically used for foreign words or for things that do not have their origin in Japan. And probably, in an effort to preserve the culture, that peculiarity is also present in order to distinguish the origins of the designs. Perhaps it's because Japanese people dislike being called "Asians" that they emphasize the need to recognize the origin of the design in their products. Graphic design plays an important part in giving their products either a local or foreign flavour. For example, it makes more sense that the graphics for coffee or chocolate – including logo, packaging and advertisement - are designed in a European style. It is as if the "katakana" principle persisted to define the lines between what is Japanese and what is foreign. It is probably a way of keeping the Japanese identity while showing respect for the origin of the products. For the same reason, you will rarely see a Japanese sweet, such as "mizu youkan" (a sort of jelly made from beans) or sake packaged in a way that does not contain a traditionally Japanese design. Even though nowadays the traditional materials such as bamboo or washi paper are sometimes replaced by modern plastic variations, the essence of the old design still remains. Identity is not only being preserved with regard to countries, but also with regard to different areas of the Japanese territory. It is probably because Japan is an island that it has been easier to preserve its own culture. But

Japanese design is not only about balance and proportion, or even minimalism, which is probably the strongest image that people abroad have about Japanese design. Sometimes graphic design gets a little more chaotic – and not in a negative sense - probably due to the overcrowded atmosphere. A good chance to see this kind of design is through the adverts on trains. It is not that the designers are trying to compete with the busy trains by "noisy" advertising. It is quite possible that they are trying to entertain the unfortunate passengers, who have to spend quite a long time everyday commuting to their jobs in packed trains. The passengers might even be grateful to have something to read during such a tiring trip. Train adverts are usually saturated with information written in very small font sizes, sometimes even challenging your eyesight. Believe it or not, you may even get the chance to read it all if you happen to get a crowded 7.30 AM train on a weekday. Another characteristic that will not pass unnoticed is the sense of humor: pretty close to the comic (manga) subculture, and sometimes even close to being childish, with no other claim than to being cute or "kawai". Characters, figures, usually like little pets, are used for promoting all manner of products in an attempt to get that desired "cute" image. Even when the products are supposed to be aimed at adults, the trend is to use this method to achieve a more "touching" effect.

Japanese Graphics Now! will take you on a tour of the works of some of the best Japanese designers. Enjoy the traditional and the modern, the minimalist and the chaotic, the sensitivity to proportion and the cuteness. And, above all, enjoy this unique chance of getting a closer look at today's Japanese culture.

Elle vient d'avoir 20 ans mais ce n'est pas son anniversaire aujourd'hui. C'est le jour de sa cérémonie « de passage à l'âge adulte » (seijin shiki). Elle porte un kimono, comme toutes les autres filles qui ont atteint l'âge de 20 ans cette année. Ce n'est pas qu'elle ne souhaite pas fêter son anniversaire en privé. En vérité, on ne fait pas très souvent de fêtes privées ici. D'un autre côté, les cérémonies traditionnelles (matsuri) semblent être la manière idéale de partager les festivités, tant qu'elles ne donnent pas l'impression de ressembler à des fêtes privées !

Ainsi donc elle se promène à travers la foule, utilisant un portable dernier cri pour prendre des photos et des vidéos de ses amies. La cérémonie est presque terminée. Le groupe se dirige vers l'endroit où se déroulera la seconde partie de la fête. La cérémonie du thé ne fait pas partie de leurs projets… Un fast-food fera l'affaire. Pourquoi pas un karaoké ? La séance photo n'est pas encore terminée mais elles continuent leur chemin. Elles feront les magasins avant d'aller prendre une boisson sans alcool. Les marques européennes de luxe sont tout en haut de leur liste, et notamment les sacs à main qui peuvent coûter jusqu'à trois mois de loyer d'un appartement d'une pièce à Tokyo. Elles finissent presque par acheter les mêmes modèles. Partager les mêmes goûts les soulage presque autant que d'aller toutes à un concert plein de monde plutôt qu'à une fête privée… la tendance est toujours la même. Les courses sont terminées, au moins pour aujourd'hui. Après avoir terminé leur verre, elles retournent chez elles. Elles doivent prendre le dernier train, une sorte de couvre-feu japonais « sponsorisé » par la compagnie ferroviaire.

Ce pourrait être un jour comme les autres au Japon : kimonos et portables, cérémonies traditionnelles se terminant au fast-food, sacs à main de luxe et trains bondés. Tout cela côte à côte, sans contradiction apparente. Le respect des traditions anciennes et modernes est l'un des aspects les plus étonnants de la société japonaise.

C'est exactement ce que reflète le design japonais. Le traditionnel et le moderne coexistent, faisant ressortir ce que les deux ont de meilleur. Vous pourrez en voir des exemples incroyables tout au long de Japanese Graphics Now!

Les représentations graphiques japonaises peuvent vous faire naviguer entre le passé et le présent sans que vous vous en rendiez compte. Vous ne verrez peut-être même pas la différence entre les deux. Disons plutôt qu'il s'agit du style japonais, ou « wafu ».

La sensibilité du style japonais repose, entre autres, sur l'équilibre. Elle est probablement le plus visible dans la langue japonaise, dans laquelle chaque caractère conserve les mêmes proportions au travers des trois systèmes d'écriture japonais. Une combinaison de caractères chinois et de deux systèmes syllabiques appelés « hiragana » et « katakana, » est utilisée pour les mots étrangers ou pour tout ce qui n'a pas ses origines au Japon. Dans un effort pour préserver la culture, cette particularité sert également à distinguer les origines des créations. C'est peut-être parce que les Japonais détestent être appelés « asiatiques » qu'ils mettent l'accent sur la reconnaissance des origines des créations dans leurs produits. La conception graphique est capitale pour donner un aspect local ou étranger aux produits. Par exemple, il est tout à fait logique que le graphisme du café ou du chocolat, dont le logo, l'emballage et la publicité, soit réalisé dans un style européen. C'est comme si le principe du « katakana » persistait pour définir la frontière entre ce qui est japonais et ce qui ne l'est pas. C'est probablement une manière de préserver l'identité nippone tout en respectant l'origine des produits. Pour les mêmes raisons, vous verrez rarement des sucreries japonaises, telles que les « mizu youkan » (une sorte de gelée de haricots) ou du saké, présentés sans graphisme japonais traditionnel. Bien que les matériaux traditionnels tels que le bambou et le papier washi soient aujourd'hui quelquefois remplacés par leurs équivalents en plastique, l'essence du design traditionnel reste présente. L'identité n'est pas seulement préservée par égard pour

les pays, mais également par égard pour les différentes régions du territoire japonais. C'est probablement parce que le Japon a un caractère insulaire qu'il a pu préserver sa propre culture. Les créations japonaises ne sont pas seulement une question d'équilibre et de proportion, ou encore de minimalisme, ce qui est probablement l'image la plus forte que les étrangers aient des créations japonaises. Quelquefois, la conception graphique devient un peu plus chaotique, mais pas dans un sens négatif, probablement à cause de l'atmosphère surpeuplée. Ce type de création est très visible si l'on observe des publicités dans les trains. Ce n'est pas que les publicitaires essaient de concurrencer les trains bondés par des publicités « bruyantes ». Il est très possible qu'ils essaient de divertir les malheureux passagers qui doivent effectuer un long trajet jusqu'à leur lieu de travail dans des trains surchargés. Les passagers peuvent même être reconnaissants d'avoir quelque chose à lire durant ces trajets pénibles. Les publicités dans les trains sont habituellement saturées d'informations rédigées en très petit corps, et sont parfois même quasiment impossible à déchiffrer. Croyez-le ou non, vous aurez peut-être la chance de les lire en intégralité si vous prenez un train en pleine heure de pointe pendant la semaine. Une autre caractéristique qui ne passe pas inaperçue est le sens de l'humour très proche de la culture manga, presque enfantin, et qui n'a pas d'autre but que d'être mignon, ou « kawai ». Des personnages et des silhouettes, habituellement de petits animaux, sont utilisés pour promouvoir toutes sortes de produits en les dotant d'une image « mignonne. » Même lorsque les produits sont destinés aux adultes, cette tendance vise à émouvoir.

Japanese Graphics Now! vous fait découvrir les travaux des meilleurs designers japonais. Nous espérons que vous apprécierez le traditionnel et le moderne, le minimaliste et le chaotique, la sensibilité aux proportions et l'aspect attendrissant. Cet ouvrage vous rapprochera indéniablement de la culture japonaise d'aujourd'hui.

Sie ist zwanzig geworden, doch heute ist nicht ihr Geburtstag. Es ist ihr „Tag der Volljährigkeit" (seijin-shiki) und sie trägt einen Kimono, genau wie all die anderen Mädchen, die in diesem Jahr zwanzig geworden sind. Es ist nicht so, dass sie sich nicht auch eine private Geburtstagsfeier wünschen würde. Die Realität sieht jedoch so aus, dass man hier nicht sehr oft Gelegenheit findet, etwas privat zu feiern. Andererseits sind traditionelle Feiertage (matsuri) ein idealer Anlass, Feste gemeinsam zu feiern und dabei nicht so sehr im Mittelpunkt zu stehen wie bei einer eigenen Party. Da läuft sie, bewegt sich inmitten der vielen Menschen, die mit ihren brandneuen Handys Fotos und Videoaufnahmen von ihren Freunden machen. Die Zeremonie ist fast vorbei und die Gruppe wird gleich gehen, um irgendwo anders weiterzufeiern. Eine Teezeremonie ist nicht eingeplant ... wahrscheinlich werden sie sich für ein Fast-Food-Restaurant entscheiden. Oder vielleicht für eine Karaoke-Party? Noch sind nicht alle Fotos geschossen, aber sie setzen sich in Bewegung. Ein bisschen Shopping, bevor sie etwas Alkoholfreies trinken gehen. Teure europäische Marken werden am liebsten gekauft – unter anderem Handtaschen, die bis zu drei Monatsmieten für eine Einzimmerwohnung in Tokio kosten können. Am Ende haben die jungen Frauen praktisch alle die gleichen Handtaschen gekauft. Denselben Geschmack zu haben, scheint ihnen eine Erleichterung zu sein. Wie schon beim gemeinsamen Feiern eines Festes mit vielen Leuten anstelle einer privaten Party ... das Muster ähnelt sich. Jetzt ist man fertig mit dem Shoppen – zumindest für heute. Als alle ihre Softdrinks ausgetrunken haben, machen sie sich auf den Nachhauseweg. Sie müssen den letzten Zug erreichen – die Art Ausgangssperre, die den Eisenbahngesellschaften zu „verdanken" ist.

So könnte ein ganz normaler Tag in Japan aussehen: Kimonos und Handys, traditionelle Zeremonien, die in Fast-Food-Restaurants beschlossen werden, teure Markenhandtaschen und hoffnungslos überfüllte Züge. All das existiert nebeneinander, ohne einen offensichtlichen Widerspruch darzustellen. Der Respekt, der sowohl alten wie auch neuen Traditionen entgegengebracht wird, ist eines der erstaunlichsten Merkmale der japanischen Gesellschaft.

Dies gilt auch für das japanische Design. Das Traditionelle und das Moderne existieren nebeneinander, wodurch von beidem das Beste zum Ausdruck kommt. Eindrucksvolle Beispiele für diese Verbindung sind überall in Japanese Graphics Now! zu finden.

In japanischen Grafiken sind Vergangenheit und Gegenwart gleichzeitig präsent, ohne dass sich der Betrachter dessen unbedingt bewusst wird. Es kann sogar schwierig sein zu erkennen, was alt und was neu ist. Vielleicht sollten wir einfach vom japanischen Stil sprechen: wafu!

Das japanische Stilgefühl beruht ganz besonders auf der Wertschätzung von Ausgewogenheit. Dies lässt sich vermutlich am besten an der japanischen Sprache ablesen, da jedes Schriftzeichen in allen drei japanischen Schriftsystemen dieselben Proportionen bewahrt. Zum Schreiben selbst wird eine Kombination aus chinesischen Wortzeichen und den zwei Silbenschriften Hiragana und Katakana benutzt. Faktisch wird Katakana zumeist für ausländische Wörter oder für Dinge gewählt, deren Herkunft nicht in Japan liegt. Diese Unterscheidung lässt sich auch im Bereich des Designs ausmachen: Im Bemühen um die Bewahrung der eigenen Kultur, so ist zu vermuten, sind „einheimische" und „ausländische" Designansätze jeweils klar zu erkennen. Japaner mögen es nicht, wenn man sie als „Asiaten" bezeichnet – vielleicht erklärt dies das Bedürfnis, die Herkunft eines Designs in ihren Produkten zu verdeutlichen. Grafikdesign spielt eine entscheidende Rolle dabei, ob ein Produkt einen lokalen oder einen globalen Beigeschmack hat. So ist es beispielsweise sinnvoll, dass das grafische Erscheinungsbild für Kaffee oder Schokolade – einschließlich Logo, Verpackung und Werbung – in einem europäischen Stil entworfen wird. Es ist, als ob das Katakana-Prinzip existierte, um die Grenzlinie zwischen dem Japanischen und dem Ausländischen zu definieren. Es ist vermutlich eine Methode zur Wahrung der japanischen Identität, die zugleich der Herkunft der Produkte Respekt entgegenbringt. Aus dem gleichen Grund wird man kaum eine japanische Süßigkeit wie mizu-youkan (ein aus Bohnen hergestelltes Gelee) oder Sake finden, deren Verpackung nicht mit traditionell japanischen Designelementen gestaltet ist. Auch wenn heutzutage herkömmliche Materialien wie Bambus oder Washi-Papier durch moderne Plastikvariationen ersetzt werden, bleibt die Essenz des alten Designs doch erhalten. Identität spielt nicht nur im Hinblick auf Länder, sondern auch im Hinblick auf verschiedene Regionen Japans eine Rolle. Die Tatsache, dass Japan eine Insel ist, hat es vermutlich einfacher gemacht, die eigene Kultur zu bewahren. Doch im japanischen Design geht es nicht nur um Ausgewogenheit und Proportion oder Minimalismus, was wohl das vorherrschende Bild ist, das Ausländer vom japanischen Design haben. Das Grafikdesign kann durchaus auch chaotisch werden – und das ist ganz und gar nicht negativ gemeint –, was vermutlich auf das Leben in so großer Enge zurückzuführen ist. Diese Art des Designs lässt sich sehr gut auf den Werbetafeln in den Zügen beobachten. Es ist nicht so, als versuchten die Designer, durch „laute" Werbung mit den überfüllten Zügen zu wetteifern. Es ist sehr gut möglich, dass sie die bedauernswerten Fahrgäste unterhalten wollen, die auf dem Weg zur Arbeit jeden Tag sehr viel Zeit in vollgestopften Zügen verbringen müssen. Vielleicht sind die Passagiere sogar dankbar, dass sie während der ermüdenden Fahrten etwas zu lesen haben. Zugwerbungen sind für gewöhnlich mit Informationen in derart kleiner Schrift vollgepackt, dass sie das Sehvermögen bis zum Äußersten herausfordern. Unglaublich, aber wahr: Wenn man an einem Wochentag um 7 Uhr 30 einen vollen Zug betritt, in dem man die ganze Zeit über stehen muss, hat man womöglich die Gelegenheit, so viel Text auch tatsächlich durchzulesen. Eine andere, auffällige Eigenschaft ist der Humor: Er ist vermutlich der Comic-Subkultur (Manga) recht nahe, oft an der Grenze zum Kindischen, mit dem einzigen Anspruch, süß oder „kawai" zu sein. Figuren, für gewöhnlich kleine Tierchen, werden eingesetzt, um alle möglichen Produkte zu bewerben und ihnen das begehrte „süße" Image zu verleihen. Selbst bei Produkten, die auf Erwachsene abzielen, gibt es diesen Trend, der einen „gefühlvolleren" Effekt erzielen soll.

Japanese Graphics Now! nimmt Sie mit auf einen Rundgang zu den Arbeiten von einigen der besten japanischen Designer. Erfreuen Sie sich am Traditionellen und am Modernen, am Minimalistischen und am Chaotischen, am Gefühl für Proportionen und am Süßen. Erfreuen Sie sich vor allem an der einmaligen Gelegenheit, einen näheren Einblick in die japanische Kultur von heute zu gewinnen.

外国から日本を見ると、けん騒に満ちた、あわただしくにぎやかな東京の風景に驚きとショックを感じずにはいられない。単に2000万人以上の人々が往来する大都会というだけではなく、外国人の目からは計り知れない、ほとんど何を意味しているのかわからない看板やポスター、ネオンサインで街中が溢れているからである。確かに西洋と日本との地理的な距離が、西洋人が自分の目で日本を実際に見ることを難しくしていることもある。しかし現実の東京や日本はそれだけに留まらない。東京の混雑した池袋からわずか20分ほど離れた駒込駅のそばには、鯉が池に泳ぐ日本庭園や老人たちが桜を愛でる、信じられないほど静かで穏やかな場所が存在する。それが同じ1つの都市に混在しているのである。

現在の日本は正反対のものが混在する国であり、何もかもが同時に発生する場所である。日本文化は元来、自分の気持ちを表すにも、食事を供するにも、簡潔さを旨としていた。人々がコミュニケートし合う方法も、しばしばこの簡潔さを強調したものだった。同じことが歌舞伎や浮世絵など、昔ながらの芸術様式にも見られる。ここで最も敬意を払われるのは調和である。同時に、日本にはまったく異なるコミュニケーションの方法が生まれている。昔ながらの簡潔さとは対照的に、このもう1つの方法はたいてい、マンガやアニメなど最新の流行に大きく影響され、大胆であわただしく、カラフルである。これらもう1つの文化は非常に強烈で、それぞれに独自のヒーローが存在する。

日本文化が持つ重要な要素であり、人が何かをしたりコミュニケーションをとったりするために大切なのは文字である。日本語の書き言葉では規則的に異なる4つの文字種を使う。まず、最も古いのが「漢字」だ。中国を起源とする漢字は日本に少なくとも6世紀頃に入ってきた。漢字は表意文字であり、それぞれ独自の意味を持つ、おびただしい数のシンボルから持つ、他の文字との組み合わせによってさまざまな読み方をされる。2つ目は48個の音節文字からなる「ひらがな」で、漢字を単純化し、漢字の音を再生する文字だ。ひらがなは奈良時代（710−794年）に吉備真備によって作られた。3つ目は奈良時代末期から次の平安時代（794−1185年）初期の空海という仏教僧が作った「カタカナ」で、ひらがなと類似のものだが、主に外来語を書き表すのに使われる。最後がアルファベットを使ったローマ字である。これはしばしば日本人にとって、西洋人が日本語の文字に対して抱くのと同じ視覚効果を持っている。グラフィック的に言って、日本の活版印刷が使用できる組み合わせは他の多くの文化よりもはるかに多い。

日本人の創作物はこの文字やその他の多様性を探り、どこから導入されたものであろうとメディアやサウンド、ツール、動きなどあらゆるリソースを余すことなく利用する。その一例として、ひらがなの発展なくしては困難だった形式の和歌が平安時代に生まれたことが挙げられる。この環境と日本人の精神性が組み合わさることで、コミュニケーションの方法は常に進化し、新たな対応構造を生み出しては、事実上領域を無限に広げてきたのである。

現代日本で必ず論じられるもう1つのポイントは、デジタル文化の大きな影響である。この技術は単に利用可能だという域を超えて、当然のように日常的に使われている。携帯電話から家庭用パソコンまで、このハイテク指向の社会は可能な限りのコミュニケーション・ツールすべてを利用する。天気予報を知りたい、本を買いたい、ピザを注文したい――どんなことでも電子的に処理できる。この結果、多くの創造物が業界の規模や影響に、またこうした思考方法の拡大に対応するようになってきたと思われる。それで、日本が生み出す作品スタイルは主に2つに分けられるようになった。1つは非常に煩雑で単語や色彩、イメージが豊かなもの、そして2つ目は大きな絵

にわずかなメッセージを持たせた、明瞭でシンプルなものである。しかも両者共にそれぞれユニークなオリジナル・スタイルを持っている。

生産面から言えば、日本市場は大きいので、大多数のクリエーターが海外へ進出する必要がない。それで、時間のほとんどを極めて日本的なアプローチに注ぎ込むことができる。これが日本のデザインのアイデンティティーをいっそう色濃くすることにつながるのである。本書はポスターや広告、ロゴ、デザイン印刷や印刷物の形態を見ることができる、大多数のものの見方やライフスタイルを表す断片として捉え、さらにこの活気に溢れた文化を商業的な対応物の一部として解釈した。

日本のデザイン・スタイルについては好き嫌いがあるだろうが、全体像として、このユニークなコミュニケーション方法の重要性に気づく必要性はあるはずである。何よりも、世界中のデザイナーやコミュニケーションの専門家にとって、日本のデザインはヴィジュアルの参考書としての役割をこれまで長らく演じてきている。『ジャパニーズ・グラフィックス・ナウ！』は日本のデザイン事務所およそ80社の最新作を収録し、コミュニケーションや広告、デザインに新たな方法を模索する人たちへのヴィジュアル・ガイドとして役立つようにした。どうか楽しんでいただきたい。

D:デザイナー／デザインオフィス
d:デザイン
ad:アートディレクター
adv:広告主
pr: P R
art w:作品
a:アート
cg:コンピュータグラフィック
p:写真
c:コピーライト
cc:クリエイティブディレクター
cl:クライアント
i:イラスト

When Japan is seen from abroad, inevitably people are both amazed and shocked by scenes dominated by the clamour of busy, bustling Tokyo. The capital is not only big, with its more than 20 million people coming and going, but also inscrutable in the eyes of the non-Japanese. The city is packed with signboards, posters, and light boxes that can be hardly understood. Moreover, the physical distance between western countries and the islands of Japan makes it hard for people to come and see what the country is about with their own eyes. But the city of Tokyo and Japan itself is not only that. Just 20 minutes away from Tokyo's crowded Ikebukuro Station, you will find the quietest and most peaceful place imaginable, with carp swimming in a lake, and elderly people contemplating cherry blossoms - a Japanese Zen garden in the very centre of the city.

Today Japan is a country of contrasts, a place where everything occurs simultaneously. Japanese culture is originally based on the simplicity of things, whether in the way you express your feelings or serve the food. The manner in which people communicate also often highlights this simplicity. The same can easily be seen in traditional art forms, such as Kabuki theatre and Ukiyo-e woodcuts. Harmony is the most respected value here. At the same time, another completely different approach to communication has emerged in Japan. In contrast to the traditional simplicity, this other approach is usually brash, busy, colourful, and mainly influenced by other, more recent popular currents in Japan, such as Manga, the comic magazine scene, and Anime, the animated movies. These other cultures are very strong and have their own national heroes. Among the many important aspects of Japanese culture, and the consequences it has for how one does things and communicates, is the written language. Japanese writing regularly uses four different alphabets. The first and oldest is Kanji, originating from China and introduced to the island around the 6th century, if not earlier. Kanji is an ideographic system consisting of thousands of symbols each with its own meaning, which can be read as representing a variety of sounds, depending on the combination in which they appear. Secondly, the Japanese also use Hiragana, a phonetic alphabet that consists of 48 symbols for writing Japanese words, as well as for simplifying and reproducing the sounds of Kanji. It was created by Kibi-no-Makibi during the Nara Period (710 to 794). Thirdly, they use Katakana, which is similar to Hiragana but mainly used to write foreign words. It was created by a Buddhist priest known as Kuukai, who lived at the end of the Nara Period and at the beginning of the subsequent period, named Heian (794 to 1185). Finally, they also use the Roman alphabet, which often has the same aesthetic appeal for them that the Japanese symbols have for Westerners. Graphically speaking, the possibilities for combination offered by Japanese typography are far greater than those available in most other cultures.

The Japanese creations explore this and other diversities, and make full use of all the resources in terms of media, sounds, tools, movements, etc, no matter where they are from. One example is the Heian Period, which saw the invention of Japanese poetry, a literary form that was difficult before the invention of Hiragana. This environment, combined with the Japanese mind set, has generated a virtually boundless territory for exploration, where the way of communicating is always in evolution and undergoing new adaptations.

Another point constantly discussed today is the strong presence of digital culture in Japan. Technology is not simply available but also used on a daily basis. From mobile phones to home computers, this high-tech-oriented society makes use of all the possible communication tools. No matter what you do, if you want to see a weather forecast, buy a book or order a pizza, it all can be done electronically. The result can also be seen in the way many creations have responded to the size and influence of the industry, and to the spread of this way of thinking. So the works from Japan can be mostly divided into two main styles. One that is very busy, full of words, colour, and images, and the second one that is clear and simple, having one big picture and few words. Yet both in their own ways are original and unique.

In terms of production, the market in Japan is big enough that most creators do not need to go outside for jobs, and can most of the time adopt a very local approach - which reinforces the identity of the design in the region. Almost every conceivable vision of Japan and every consequence of its lifestyle has been captured in this book in the form of posters, ads, logos, print designs and printed media. It is a showcase not only of works, but above all of the way this vibrant culture is translated into its commercial counterpart. One may or may not like the style of many of the Japanese designs, but it is crucial to realize the importance of this unique approach to communication as a whole. More than that, for a long time now it has served as a visual reference for designers and communication professionals worldwide. Japanese Graphics Now! showcases recent works from about 80 design offices in Japan, and intends to serve as a visual guide for those who seek new ways in communications, advertising and design. Have a nice trip.

Symbols for the captions:
D: Designer /Design Office
d: design
ad: art direction
adv: advertiser
pr: public relationship
art w: art work
a: art
cg: computer graphics
p: photography
c: copywrite
cd: creative direction
cl: client
i: illustration

Lorsqu'ils regardent le Japon de loin, les gens sont inévitablement impressionnés et choqués par la clameur d'un Tokyo très affairé. La capitale n'est pas seulement gigantesque, avec ses quelque 20 millions de gens qui vont et viennent, elle est également insondable aux yeux des non-Japonais. La ville est remplie de panneaux publicitaires, d'affiches et de néons difficiles à comprendre. De plus, la distance physique entre les pays occidentaux et les îles du Japon ne facilite pas la découverte du pays. Mais Tokyo et le Japon ne se limitent pas à cela. A 20 minutes à peine de la gare toujours pleine de monde d'Ikebukuro à Tokyo se trouve l'endroit le plus calme et le plus paisible qu'on puisse imaginer, avec des carpes nageant dans un lac, un jardin zen, et des personnes âgées contemplant des cerisiers en fleur, près de la gare de Komagome, dans la même ville.

Le Japon d'aujourd'hui est un pays de contrastes, un endroit où tout se déroule en même temps. La culture japonaise repose à l'origine sur la simplicité des choses, que ce soit dans la manière d'exprimer des sentiments ou dans la manière de servir la nourriture. La façon dont les gens communiquent met souvent l'accent sur cette simplicité. Il en va de même pour les formes artistiques traditionnelles, telles que le Kabuki et l'Ukiyo-e. L'harmonie est la valeur la plus respectée ici. Parallèlement, une autre manière de communiquer tout à fait différente émerge au Japon. Contraste avec la simplicité traditionnelle, cette autre approche est plutôt tape-à-l'œil, affairée, colorée et principalement influencée par d'autres courants populaires plus récents au Japon, tels que les Manga, les bandes dessinées, et l'Anime, les dessins animés. Ces autres cultures sont très présentes et ont leurs propres héros nationaux.

Le langage écrit est l'un des aspects les plus importants de la culture japonaise, avec ses conséquences sur la manière dont les gens communiquent et font les choses. L'écriture japonaise utilise régulièrement quatre jeux de caractères différents. Le premier et le plus ancien est le Kanji, originaire de Chine et introduit sur l'archipel aux environs du 6e siècle, ou plus tôt encore. Le Kanji est composé de milliers d'idéogrammes, chacun ayant un sens propre et pouvant être lu comme représentant une variété de sons, en fonction des combinaisons dans lesquelles ils sont ordonnés. Les Japonais utilisent ensuite les 48 caractères de l'Hiragana pour écrire les mots japonais, et pour simplifier et reproduire les sons du Kanji. Il a été créé par Kibi no Makibi pendant la période Nara (de 710 à 794). Ils utilisent également le Katakana, similaire à l'Hiragana, mais employé principalement pour écrire des mots étrangers. Il a été créé par un moine bouddhiste appelé Kuukai, qui a vécu à la fin de la période Nara et au début de la période suivante, appelée Heian (de 794 à 1185). Enfin, ils utilisent l'alphabet romain, pour lequel ils éprouvent le même attrait esthétique que les occidentaux pour les symboles japonais. Graphiquement parlant, les possibilités offertes par la typographie japonaise sont nettement plus importantes que celles qu'offrent la plupart des autres cultures.

Les créations japonaises explorent cette diversité ainsi que d'autres, et tirent pleinement parti de toutes les ressources en termes de supports, de sons, d'outils, de mouvements, etc. quelles que soient leurs provenances. La période Heian en est un bon exemple, qui a vu l'invention de la poésie japonaise, une forme littéraire difficile à exprimer avant l'arrivée de l'Hiragana. Cet environnement, combiné au mode de pensée japonais, a généré un territoire à explorer virtuellement sans limites, où les moyens de communiquer évoluent en permanence et s'adaptent aux nouvelles situations.

Un autre point que l'on ne cesse de discuter aujourd'hui est la forte présence de la culture numérique au Japon. La technologie n'est pas seulement disponible, elle est également utilisée quotidiennement. Des portables aux ordinateurs, cette société orientée sur les technologies de haut niveau utilise tous les outils de communication possibles. Quoi que vous fassiez, que ce soit consulter la météo, acheter un livre ou commander une pizza, tout peut être fait électroniquement. On peut également constater cela dans la manière dont les créations ont réagi à l'importance et l'influence de ce marché, et à cette nouvelle manière de penser. Ainsi, les travaux provenant du Japon peuvent être divisés en deux styles essentiels. Un style dynamique, plein de mots, de couleurs et d'images, et un style clair et simple avec une image principale et quelques mots. Tous deux, à leur manière, sont pourtant originaux et uniques. En termes de production, le marché japonais est suffisamment vaste pour que la plupart des créateurs n'aient pas besoin de rechercher un emploi à l'extérieur, mais puissent la plupart du temps adopter une approche très locale, qui renforce l'identité des créations de la région. Quasiment toutes les visions imaginables du Japon et les conséquences de son mode de vie ont été recueillies dans cet ouvrage, sous forme d'affiches, de publicités, de logos et d'imprimés. C'est une vitrine de créations, mais c'est avant tout la façon dont cette vibrante culture est traduite dans un but commercial.

Que l'on apprécie ou non le style de certaines créations japonaises, il est crucial de réaliser l'importance de cette approche unique de la communication en un tout. Plus important encore, ces créations ont depuis longtemps déjà servi de référence visuelle aux designers et aux professionnels de la communication du monde entier. Japanese Graphics Now! illustre les travaux récents de 80 agences de design japonaises et compte servir de guide à ceux qui recherchent de nouvelles manières de communiquer, de faire de la publicité ou de concevoir. Bon voyage !

D : Designer / Agence de design
d : design
ad : direction artistique
adv : publicitaire
pr : relations publiques
art w: graphique
a : art
cg : image
p : photographie
r : rédaction publicitaire
cd : direction de création
cl : client
i : illustration

Wer Japan von außen betrachtet, ist unweigerlich erstaunt und erschreckt zugleich vom Gewühl des betriebsamen, geschäftigen Tokio. Die Stadt mit ihren mehr als 20 Millionen Einwohnern und Pendlern ist nicht nur groß, sondern für den Nichtjapaner auch undurchschaubar. Überall hängen unverständliche Wegweiser, Plakate und Leuchtreklamen. Bedingt durch die enormen Entfernungen zwischen den japanischen Inseln und den westlichen Ländern ist es darüber hinaus schwer, selbst zu kommen und mit eigenen Augen zu sehen, wie das Land nun wirklich ist. Täte man dies, würde man merken, dass Tokio und Japan ganz anders sind, als es der erste Eindruck vermittelt. Nur zwanzig Minuten von der hektischen U-Bahn-Station Ikebukuro in Tokio entfernt, befindet sich der stillste, friedlichste Ort, den man sich nur vorstellen kann: Karpfen schwimmen im Teich, ältere Leute erfreuen sich an der Kirschblüte - ein japanischer Zen-Garten mitten in der Stadt.

Das heutige Japan ist ein Land der Kontraste, ein Ort, an dem verschiedenste Dinge zugleich geschehen. Die ursprüngliche Grundlage der japanischen Kultur ist die Einfachheit, sei es in der Art, wie man seinen Gefühlen Ausdruck verleiht oder wie man das Essen serviert. Einfachheit spielt auch in der Kommunikation eine große Rolle. Dieses Ideal lässt sich auch in traditionellen Kunstformen wie dem Kabuki-Theater und dem Ukiyo-e-Holzschnitt leicht erkennen. Harmonie ist der Wert, der am höchsten geschätzt wird. Gleichzeitig hat sich jedoch in Japan ein weiterer Ansatz in der Kommunikation herausgebildet. Im Gegensatz zum traditionellen Kult der Reduktion geht es hier laut, hektisch und bunt zu, gewinnen andere, jüngere Strömungen in der japanischen Populärkultur wie etwa die Manga, Comicbücher, oder die Anime, Zeichentrickfilme, großen Einfluss. Sie sind weit verbreitet und haben ihre eigenen, im ganzen Land bekannten Helden.

Zu den wichtigen Facetten japanischer Kultur zählt die geschriebene Sprache, die einen großen Einfluss darauf hat, wie Dinge gemacht und kommuniziert werden. In der japanischen Schriftsprache werden vier verschiedene Alphabete nebeneinander benutzt. Das älteste ist Kanji, das im 6. Jahrhundert, wenn nicht früher, aus China auf die Inseln kam. Kanji ist ein ideografisches System, das aus Tausenden von Symbolen mit jeweils verschiedener Bedeutung besteht, die auch als verschiedene Laute gelesen werden können, je nachdem, in welcher Reihenfolge sie auftreten. Als zweites verwenden die Japaner die Schrift Hiragana, ein phonetisches Alphabet, das aus 48 Silbenzeichen besteht, mit denen japanische Wörter geschrieben und die Lautwerte des Kanji vereinfacht nachgeahmt werden. Die Schrift wurde in der Nara-Zeit (710-794) von Kibi-no-Makibi geschaffen. Als drittes gibt es das Katakana, das dem Hiragana verwandt ist, jedoch hauptsächlich zum Schreiben ausländischer Wörter benutzt wird. Es wurde von einem buddhistischen Mönch namens Kukai erfunden, der am Ende der Nara-Zeit und am Anfang der darauf folgenden Heian-Zeit (794-1185) lebte. Schließlich wird auch das lateinische Alphabet benutzt, das für die Japaner einen ähnlichen ästhetischen Reiz besitzt wie japanische Schriftzeichen für Europäer und Amerikaner. Vom grafischen Gesichtspunkt aus betrachtet bietet die japanische Typografie weit mehr Kombinationsmöglichkeiten als fast alle anderen Kulturen der Welt.

Die kreativen Arbeiten Japans feiern diese Vielgestaltigkeit und machen sich sämtliche Ressourcen zunutze, die an Medien, Klängen, Hilfsmitteln, Bewegungen usw. zur Verfügung stehen, ungeachtet ihrer Herkunft. Ein Beispiel dafür ist die Heian-Zeit, in der die japanische Dichtung ihren Ursprung nahm, eine literarische Form, die vor der Entwicklung des Hiragana kaum denkbar gewesen wäre. Dieses Umfeld hat zusammen mit dem japanischen Geist ein praktisch grenzenloses Spielfeld für neue Ideen geschaffen, in dem sich die Kommunikation in ständiger Evolution befindet und immer wieder von neuem wandelt und anpasst.

Ein anderer Punkt, über den heute sehr viel gesprochen wird, ist die starke Präsenz digitaler Kultur in Japan. Hochtechnologie ist weit verbreitet und im täglichen Leben allgegenwärtig. Von Handys bis zu PCs nutzt diese stark hightech-orientierte Gesellschaft alle möglichen Hilfsmittel zur Kommunikation. Alles lässt sich elektronisch erledigen, ob man die Wettervorhersage sehen, ein Buch kaufen oder eine Pizza bestellen möchte. Das Resultat lässt sich auch an der Art ablesen, wie das Design auf die Größe und den Einfluss der Elektronikindustrie sowie auf die Verbreitung der mit ihr einhergehenden Denkweise reagiert. Kreative Arbeiten aus Japan können also zum Großteil in zwei Hauptstile unterteilt werden: einen sehr geschäftigen Stil, der in Wörtern, Farben und Bildern schwelgt, und einen zweiten, der klar und einfach ist und aus einem großen Bild mit wenigen Wörtern besteht. Beide sind auf ihre Weise originell und einzigartig.

Der japanische Markt ist so groß, dass die meisten Kreativen nicht im Ausland nach Arbeit zu suchen brauchen und zumeist eine stark lokal gefärbte Herangehensweise praktizieren können – was wiederum zur Verstärkung der Identität des japanischen Designs führt. In diesem Buch ist nahezu jede denkbare Vision von Japan und seinen Lebensstilen in der Form von Plakaten, Anzeigen, Logos, Druckgrafiken und Printmedien zu finden. Es ist ein Kompendium nicht nur der Arbeiten, sondern insbesondere der Art, wie diese höchst lebendige Kultur in kommerzielles Design übersetzt wird. Ob einem nun der Stil des japanischen Designs gefällt oder nicht: Es ist sehr wichtig, die enorme Bedeutung dieses einzigartigen Ansatzes für die Kommunikation insgesamt zu erkennen. Darüber hinaus dient die japanische Grafik seit langem als visueller Bezugspunkt für Designer und Kommunikationsexperten auf der ganzen Welt. Japanese Graphics Now! bietet einen Überblick über neue Arbeiten aus ca. 80 Designagenturen in Japan und soll denjenigen als visueller Reiseführer dienen, die nach neuen Wegen in Kommunikation, Werbung und Design suchen. Wir wünschen eine angenehme Reise.

Symbole für die Bildunterschriften:
D: Designer /Designagentur
d: Design
ad: Art Director
adv: Advertiser
pr: Public Relations
art w: Kunstwerk
a: Kunst
cg: Computergrafik
p: Fotografie
c: Texter
cd: Creative Director
cl: Kunde
i: Illustration

PACKAGING

AJINOMOTO Catering
要冷蔵

DELICATESSEN

ポテトフィリング
（調理パン・サンドイッチ用）

北海道士幌農協の責任指導により、
ていねいに栽培された良品種の馬鈴薯だけを使用しています。

http://www.ajinomoto-catering.com/

1kg

AJINOMOTO Catering
要冷蔵

DELICATESSEN

ゆで卵フィリング
（調理パン・サンドイッチ用）

指定農場から出荷された良質の卵だけを使用し、
ゆで卵本来の風味が特長の調理パン・サンドイッチ用のフィリングです。

http://www.ajinomoto-catering.com/

1kg

AJINOMOTO Catering
要冷蔵

DELICATESSEN

ふんわり
スクランブルエッグ
フィリング
（調理パン・サンドイッチ用）

ふんわりと柔らかいスクランブルエッグと、マヨネーズがほどよくなじんだ
調理パン・サンドイッチ用のフィリングです。

http://www.ajinomoto-catering.com/

1kg

AJINOMOTO Catering
要冷蔵

DELICATESSEN

しこしこ
スパゲティサラダ

当社の技術をいかし、パスタのコシに持続性があります。

当社の技術をいかし、しこしこと歯ごたえのあるスパゲティと、マイルドな味つけのマヨネーズ、
ほどよくなじんだサラダです。スパゲティは食べやすい長さにカットしました。

http://www.ajinomoto-catering.com/

1kg

AJINOMOTO Catering
要冷蔵

DELICATESSEN

しこしこ
たらこスパゲティ

当社の技術をいかし、パスタのコシに持続性があります。

当社の技術をいかし、しこしこと歯ごたえのあるスパゲティと、クリーミーなコクのあるたらこ風味の
ソースがよくなじんだサラダです。スパゲティは食べやすい長さにカットしました。

http://www.ajinomoto-catering.com/

1kg

AJINOMOTO Catering
要冷蔵

DELICATESSEN

士幌ポテト
大きなポテトの彩りサラダ

北海道士幌農協の責任指導により、ていねいに栽培された良品種の馬鈴薯だけを使用しています。

http://www.ajinomoto-catering.com/

1kg

AJINOMOTO Catering
要冷蔵

DELICATESSEN

士幌ポテト
うすあじサラダ

北海道士幌農協の責任指導により、ていねいに栽培された良品種の馬鈴薯だけを使用しています。

http://www.ajinomoto-catering.com/

1kg

AJINOMOTO Catering
要冷蔵

DELICATESSEN

士幌ポテト
男爵サラダ
（減農薬栽培 男爵いも、たまねぎ、にんじん使用）

北海道士幌農協の責任指導により、ていねいに栽培された良品種の馬鈴薯だけを使用しています。

http://www.ajinomoto-catering.com/

1kg

AJINOMOTO Catering
要冷蔵

DELICATESSEN

しこしこ
マカロニサラダ

当社の技術をいかし、パスタのコシに持続性があります。

当社の技術をいかし、しこしこと歯ごたえのあるエルボーマカロニと、
マイルドな味つけのマヨネーズがほどよくなじんだサラダです。

http://www.ajinomoto-catering.com/

1kg

↓ Mitsukan "Bistro vinegar":
 Seasoning vinegar
 D: Toru Ito
 cd: Kenji Urabe

Mitsukan "2033": vinegar
D: Toru Ito
cd: Kenji Urabe

→ Benibana Brand Grape Oil
 D: Minato Ishikawa

パッケージ 28

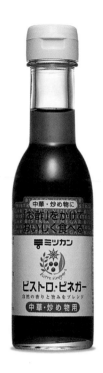
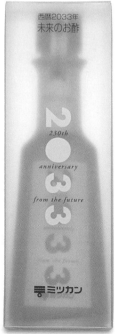
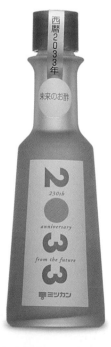
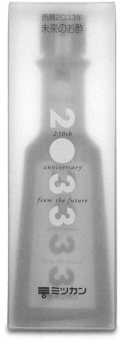

Dole

新鮮素材で、かんたん手作り。
Cookin'工房

アスパラガスとしめじの
炒め物用

野菜たっぷりヘルシー料理

■ アレンジ自在、素材のおいしさ生きています！

P－プラス

調理時間 約10分
1～2人前

要冷蔵

香りもおいしいコンビネーションです。
グリーンアスパラガス・しめじ

 Dole

イタリア風野菜煮込み
カポナータ用

野菜たっぷりヘルシー料理

新鮮素材で、かんたん手作り。
Cookin'工房

■ みずみずしいおいしさ！
■ 洗わずに安心してそのまま使えます！

調理時間 約35分
3～4人前

要冷蔵

トマトを加えて煮込むだけです。
なす・パプリカ・ズッキーニ・ベコロス・ローリエ

新鮮素材で、かんたん手作り。
Cookin'工房

れんこんスライス

ヘルシーおかずの定番素材

■ 素材のおいしさが生きています！
■ アク抜きがしてあり、下ごしらえいらず！

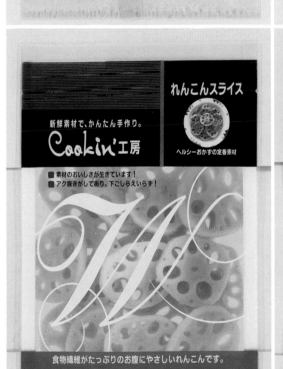

食物繊維がたっぷりのお腹にやさしいれんこんです。

新鮮素材で、かんたん手作り。
Cookin'工房

里芋

ヘルシーおかずの定番素材

■ 素材のおいしさが生きています！
■ アク抜きがしてあり、下ごしらえいらず！

要冷蔵

煮物、炒め物に、ほくほくのおいしさです。

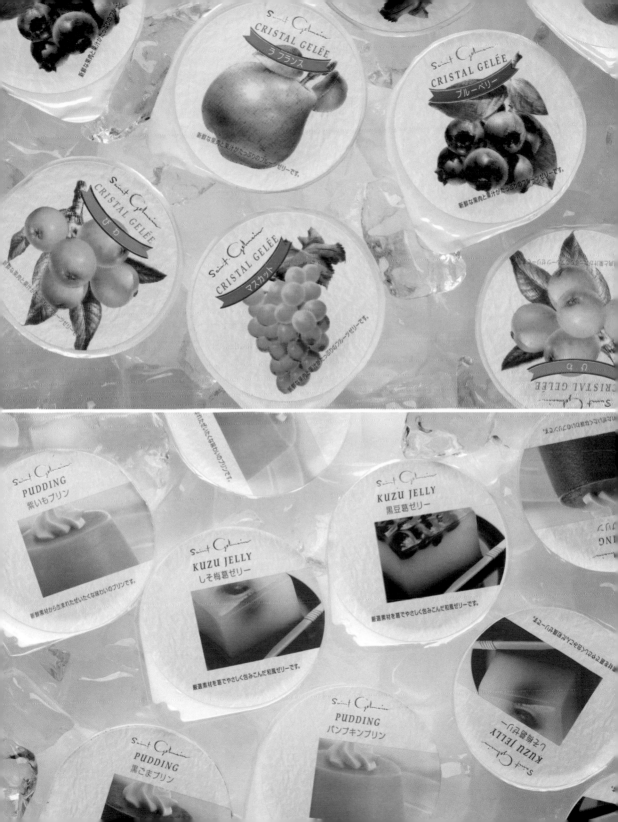

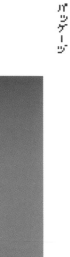

Apple pudding
D: Aquas

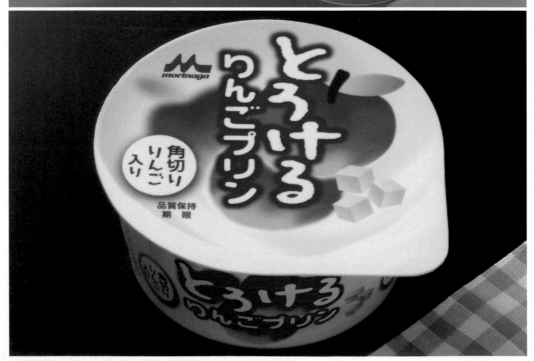

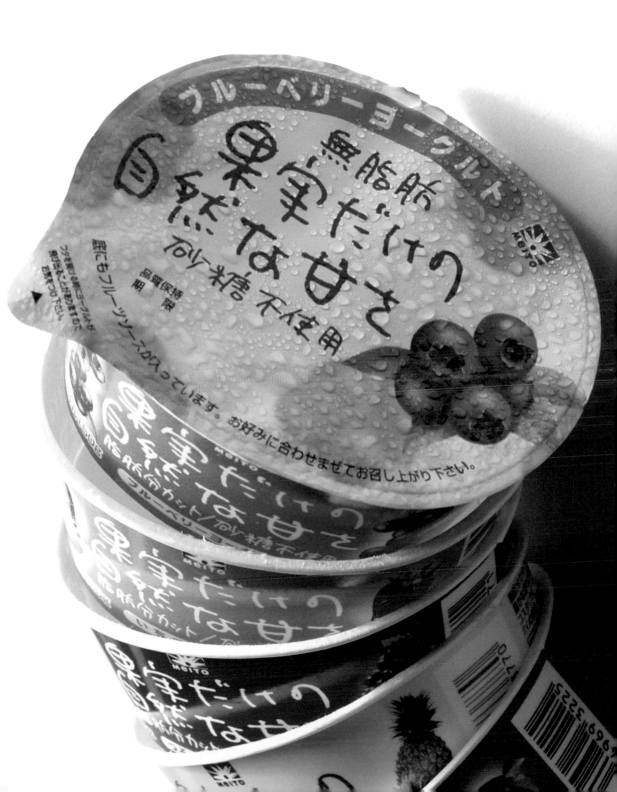

↓ Figure-Package
 To-fu oyako 400% kubrick pack
 D: Devilrobots Inc.

Figure-Package
To-fu oyako kubrick pack
D: Devilrobots Inc.

To-fu box
D: Devilrobots Inc.

→ Chinese Diet Tea for Gourmet house
 D: Minato Ishikawa

パッケージ

38

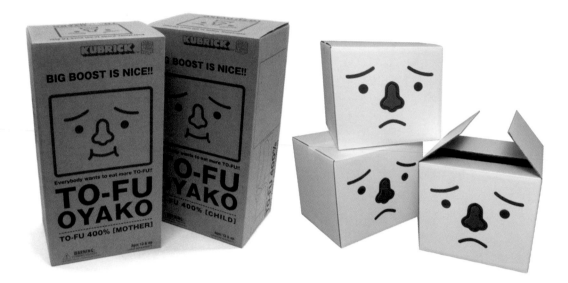

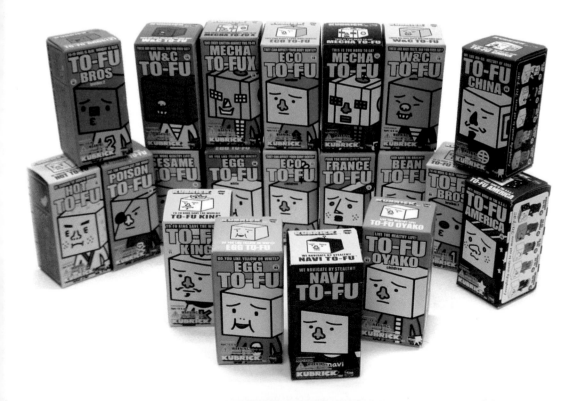

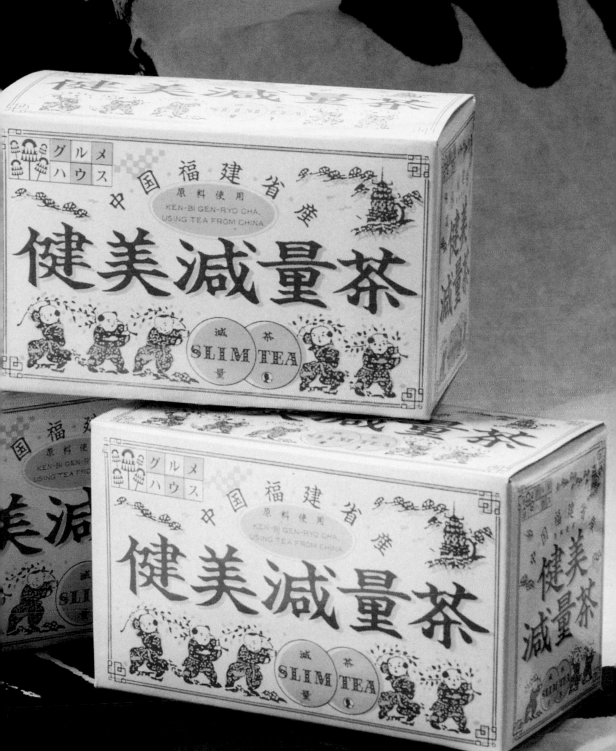

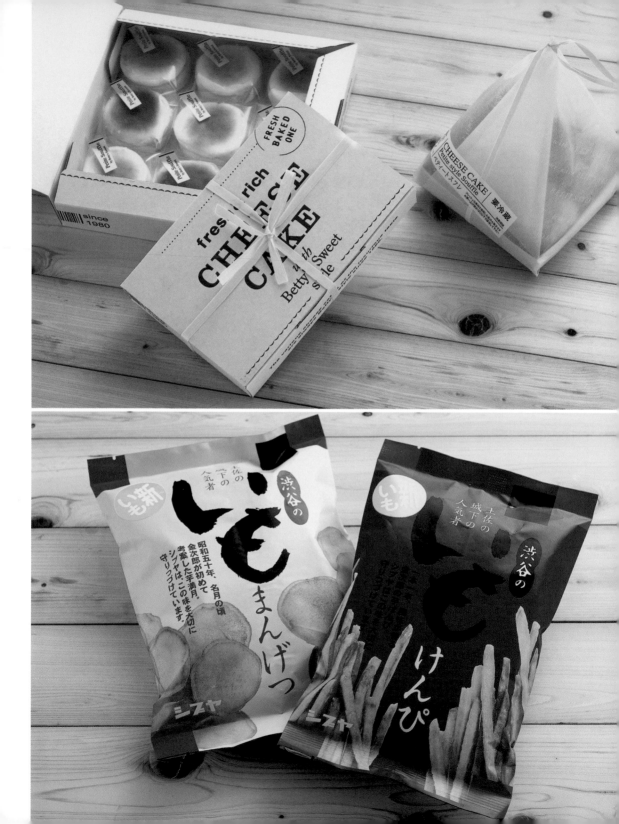

←Betty's Sweet Cheese cake
　D: Mihiko Hachiuma

Potato confectionery bag
D: Mihiko Hachiuma

↓ Ice dessert for families
　D: Mihiko Hachiuma

Betty's Sweet roll cake gift
D: Mihiko Hachiuma

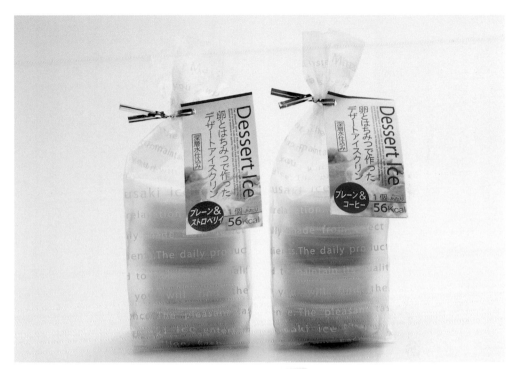

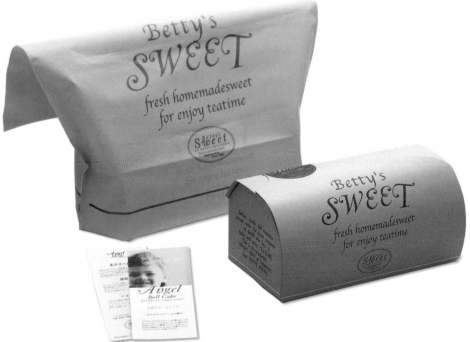

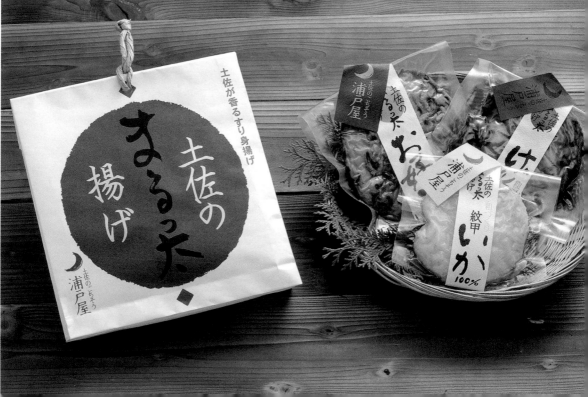

← Tempura gift
D: Mihiko Hachiuma

Assortment of tempura for souvenir
D: Mihiko Hachiuma

↓ Potato confectionery
D: Mihiko Hachiuma

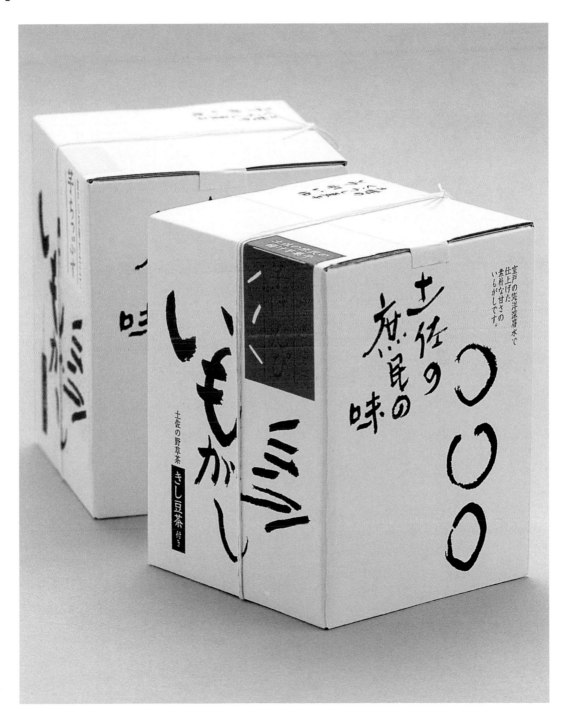

↓ Sweet bean paste and
natural Japanese tea gift
D: Mihiko Hachiuma

→ Rice cracker
D: Mihiko Hachiuma

Sweet bean paste for souvenir
D: Mihiko Hachiuma

パッケージ

44

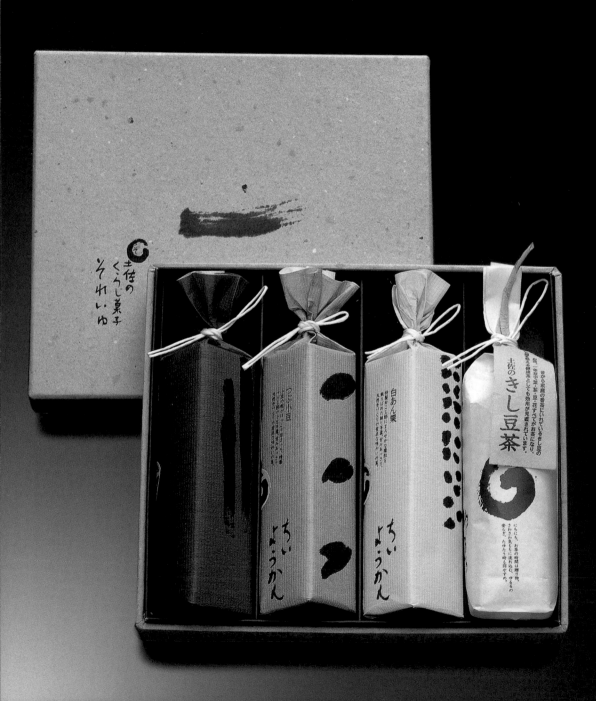

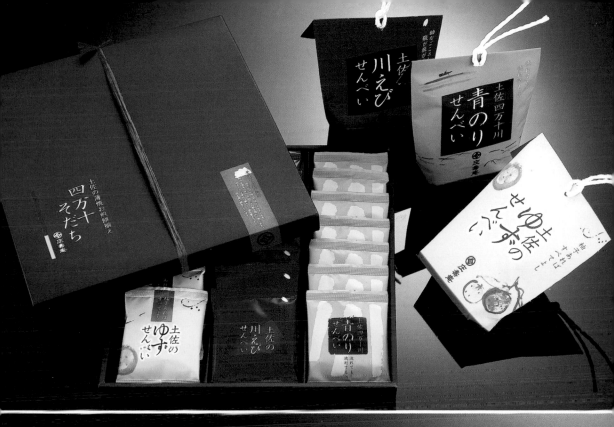

土佐の川えびせんべい

土佐四万十川
青のりせんべい

土佐のゆずかぶ

土佐の薄焼きお煎餅揃え
四万十そだち

土佐のゆずせんべい

土佐の川えびせんべい

青のりせんべい

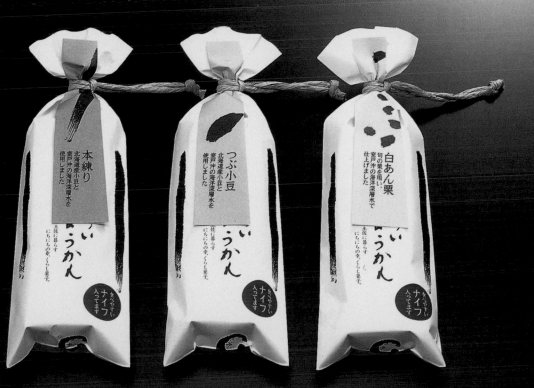

本練り
北海道産小豆と
室戸沖の海洋深層水を
使用しました

つぶ小豆
北海道産小豆と
室戸沖の海洋深層水を
使用しました

白あん栗
旬の栗を用い
室戸沖の海洋深層水で
仕上げました

食べやすいナイフ入ってます

食べやすいナイフ入ってます

食べやすいナイフ入ってます

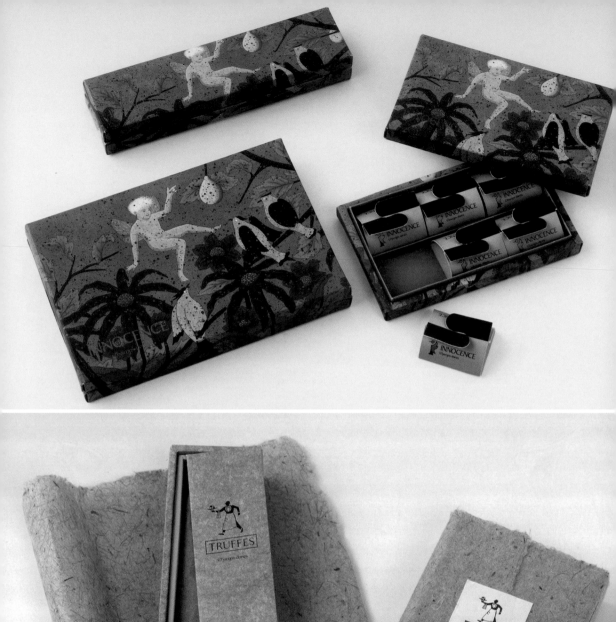
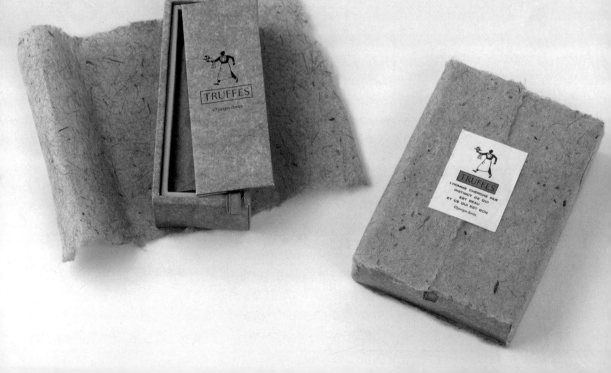

← Innocence
D: K note

Truffes
D: K note

↓ Juliette
D: K note

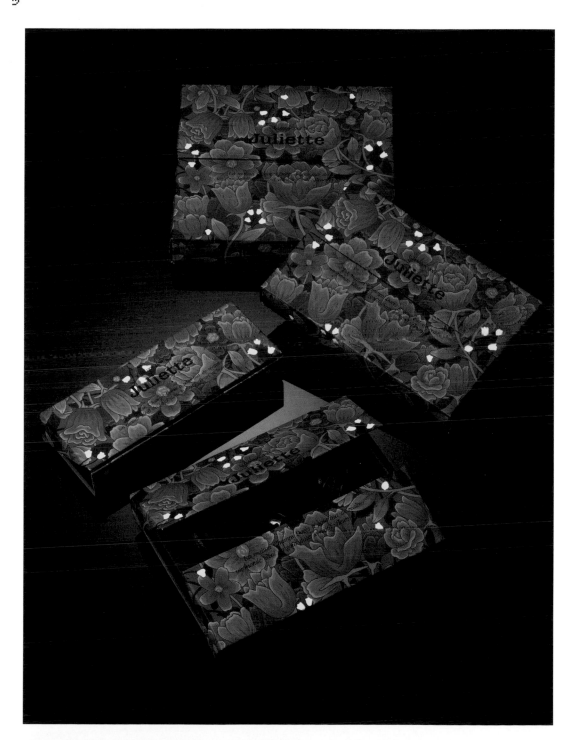

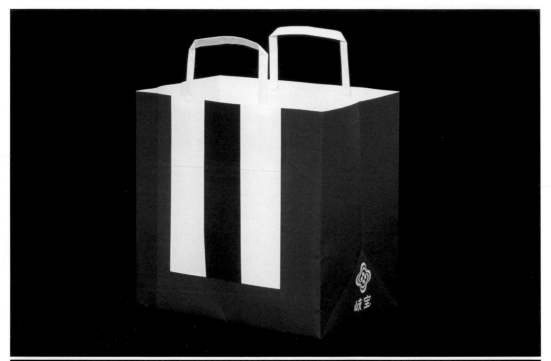

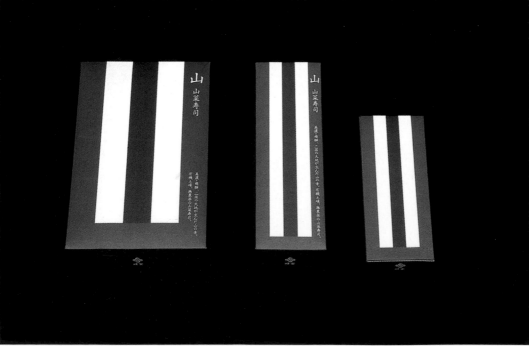

山 山菜寿司

美濃・飛騨、二国の大地が生んだ山の幸。有機土壌、無農薬の山菜寿司。

岐宝

川 鮎寿司

清流、長良川に育む川の宝、鮎。鵜匠から伝統的に受け継がれた鮎寿司。

岐宝

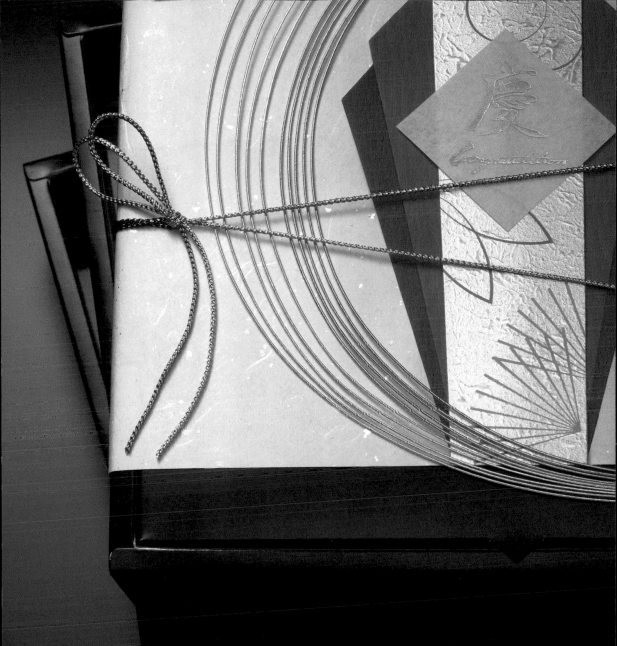

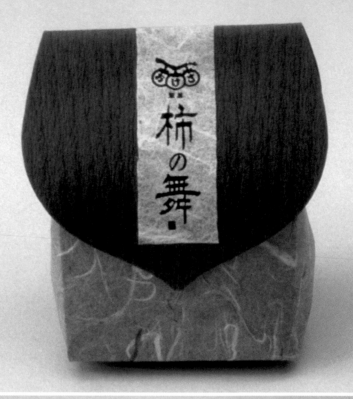

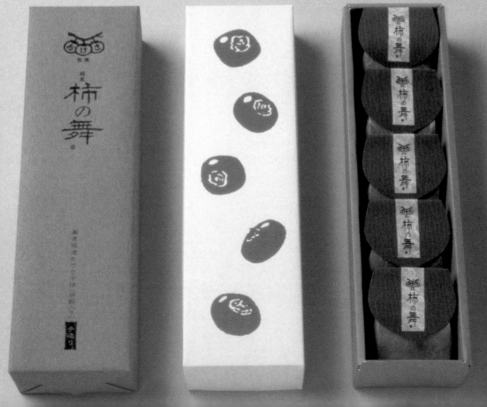

← Kaki no Mai
D: Taku Satoh

↓ Mos Burger Box
D: Yoshie Watanabe

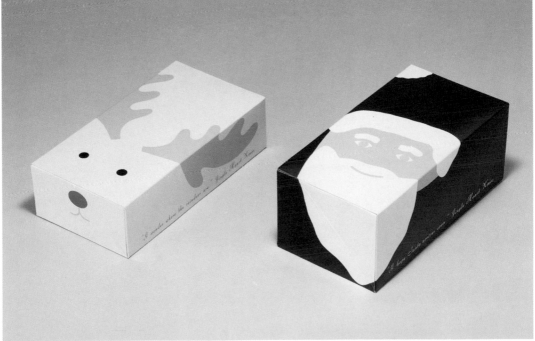

↓ Package for boiled fish pastes
 D: Takaaki Fujimoto
 cl: Awaji Kamaboko Akiyama
 d: Takaaki Fujimoto

→ Tokyo Azuki Glaces
 D: Taku Satoh

パッケージ 54

東京
あずき
グラッセ

Kirin Lager Beer
Soccer Design Can Package
D: Butterfly Stroke Inc.
cl: Kirin Brewery Co.,LTD.
cd+ad+d: Katsunori Aoki
cd: Hidenori Azuma
d: Kana Takakuwa
i: Bunpei Yorifuji

Kirin Maroyaka Kobo
D: Minato Ishikawa

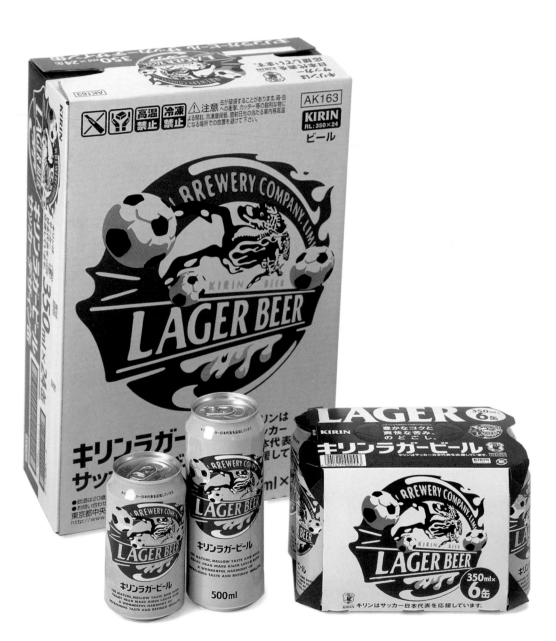

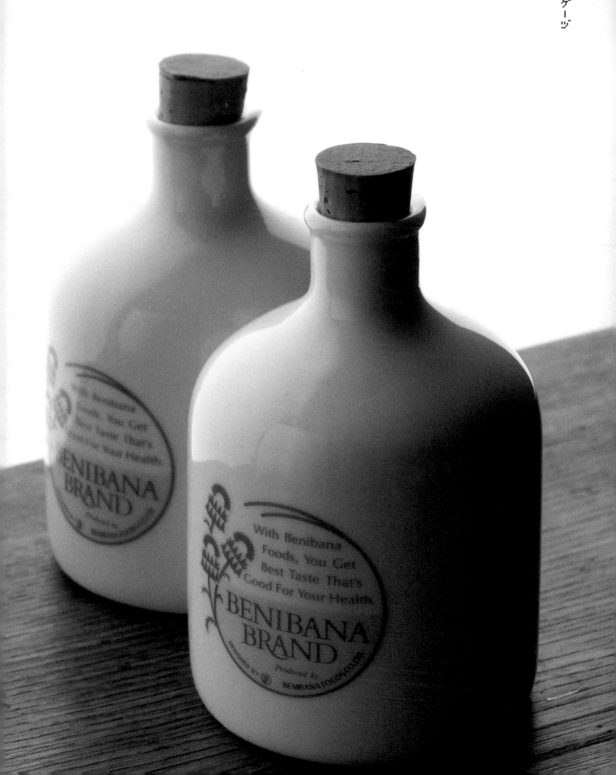

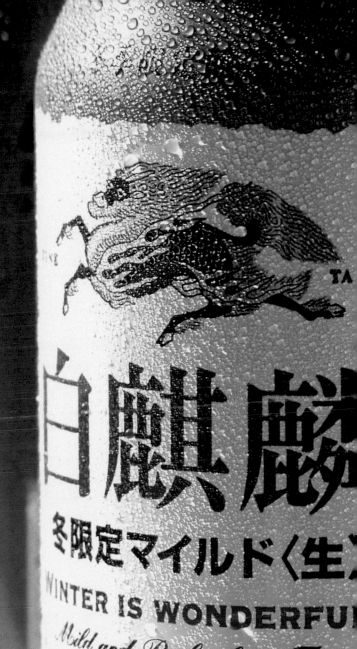

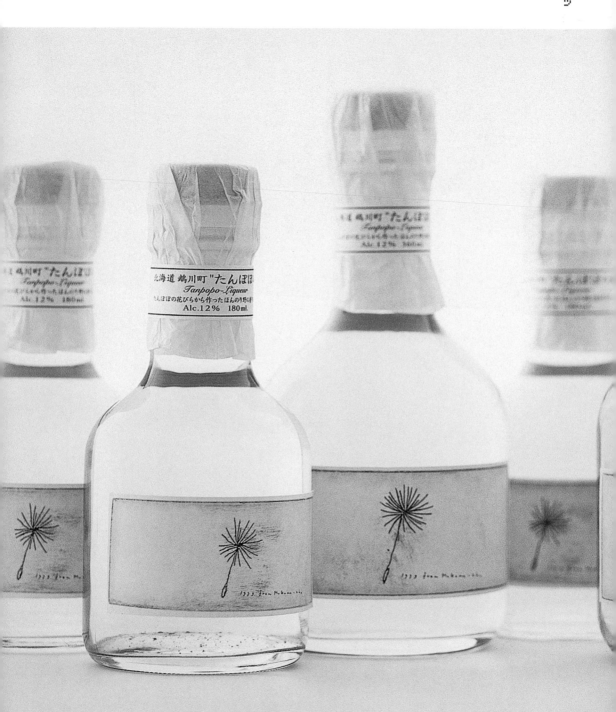

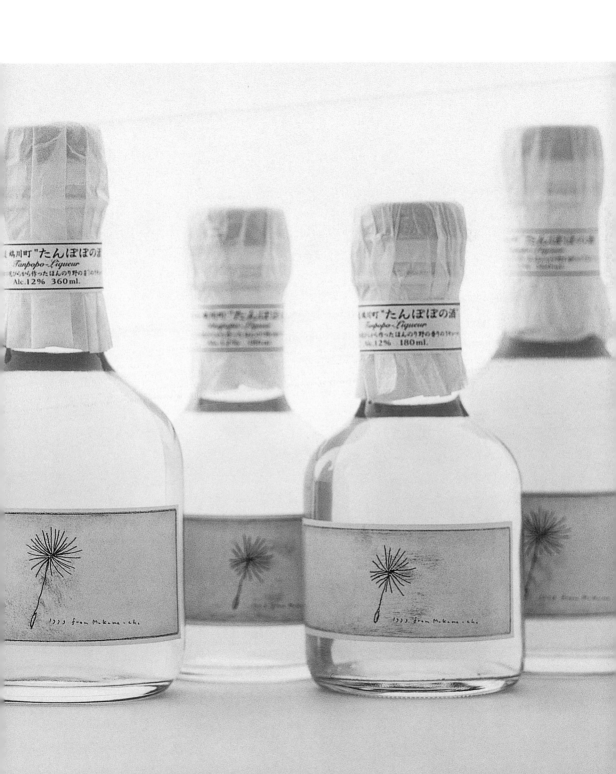

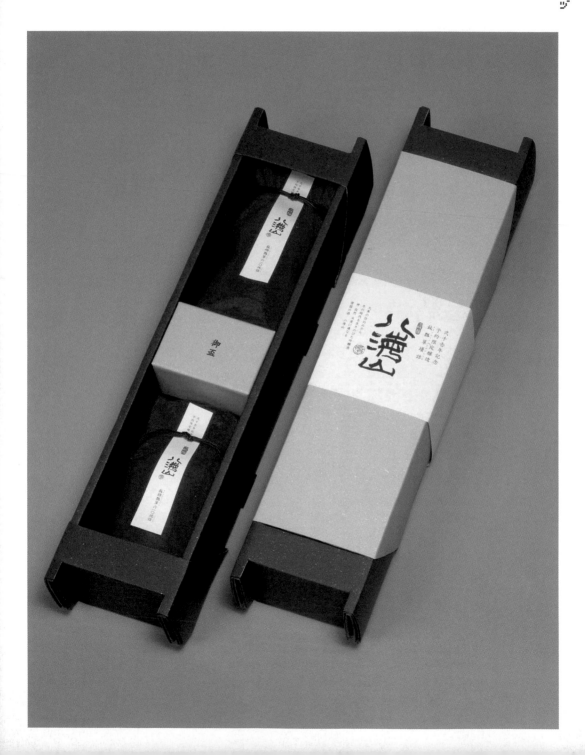

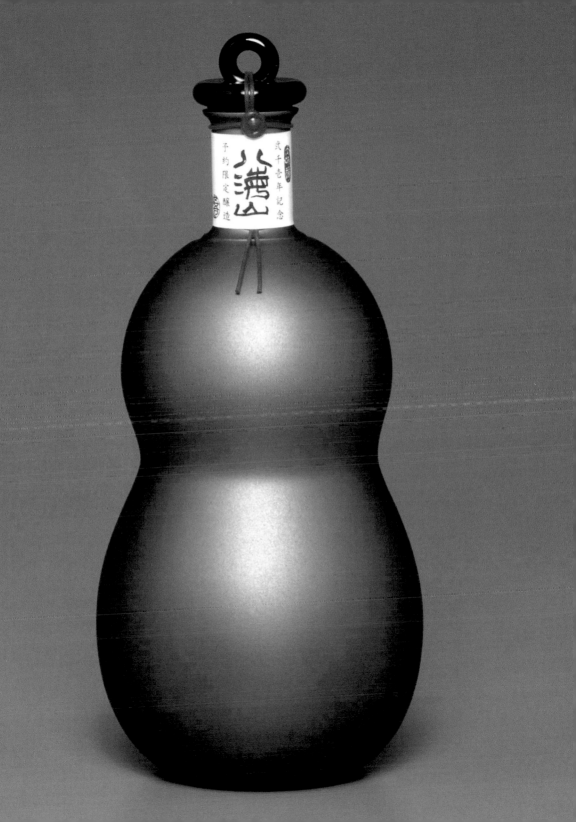

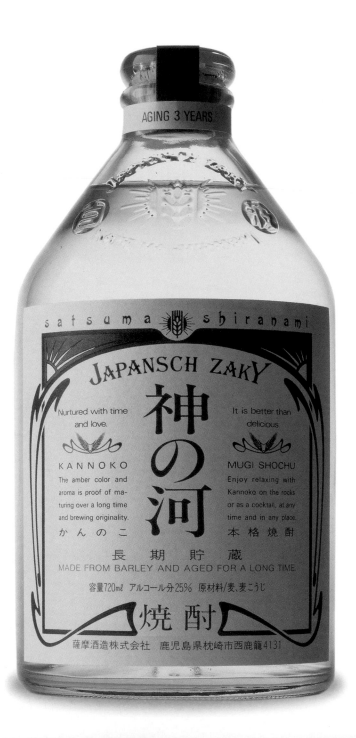

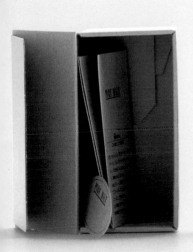
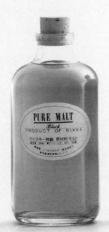
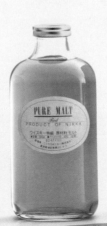

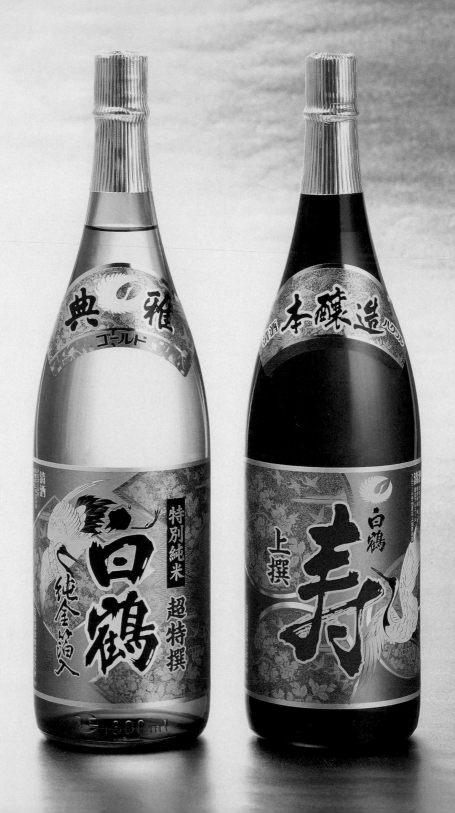

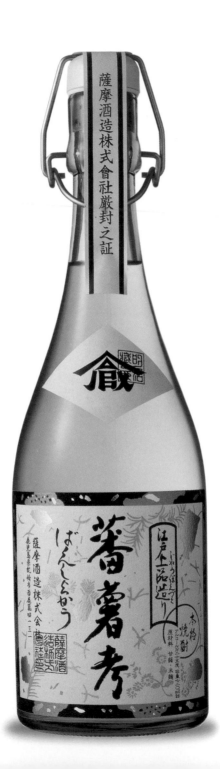

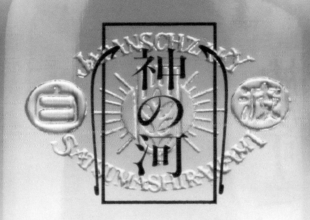

KANNOKO 焼酎 AGING 3 YEARS

MADE FROM BARLEY AND 原材料／麦、麦こうじ

PRESERVED FOR A LONG TIME. アルコール分25％、容量300㎖

本格焼酎 長期貯蔵

薩摩酒造株式会社鹿児島県枕崎市立神本町26

↓ Kei Japanese Sake
D: Sio Design Co., Ltd.

→ Hakkin Japanese rice wine
D: Kenya Hara
ad+d: Kenya Hara

パッケージ 70

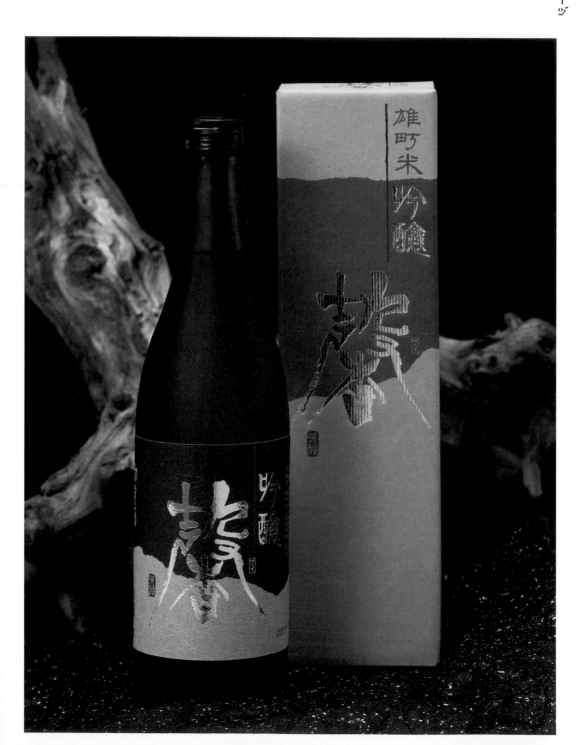

↓ Hakutsuru Sake Wafujin series
D: TCD
cl: Hakutsuru Sake Brewing Co., Ltd.

→ Hakutsuru Sake Jousen
D: TCD
cl: Hakutsuru Sake Brewing Co., Ltd.

Hakutsuru Sake Honnori kaoru
D: TCD
cl: Hakutsuru Sake Brewing Co., Ltd.

パッケージ 74

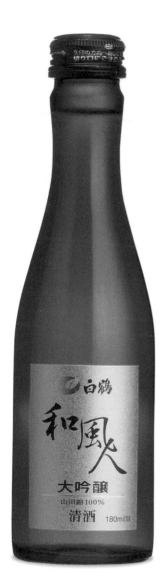
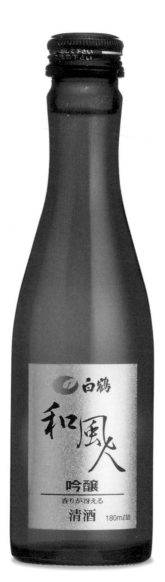
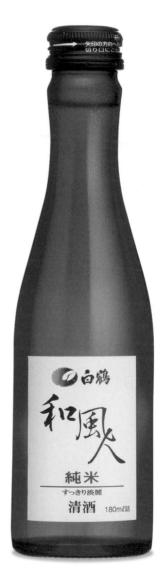

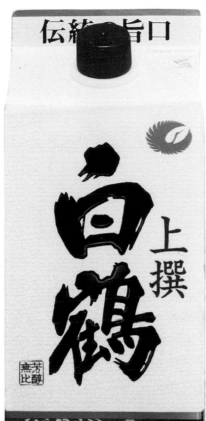

伝統の旨口

上撰

白鶴

芳醇無比

清酒 **2.0ℓ**

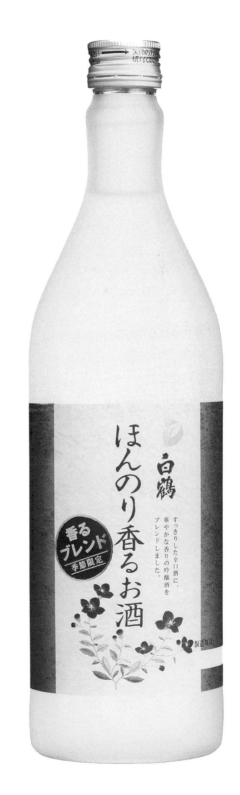

白鶴

ほんのり香るお酒

香るブレンド
季節限定

すっきりした辛口酒に、
華やかな香りの吟醸酒を
ブレンドしました。

製造年月

The Cup 200 Sake
D: Akio Okumura

→ Spirits: Isshasenri
D: Hiroshi Mitsuishi

Sake: Gekkeikan
D: Hiroshi Mitsuishi

パッケージ

76

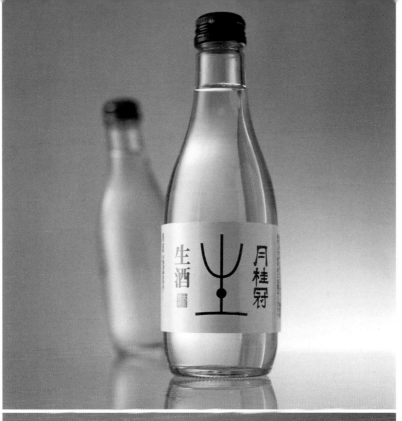
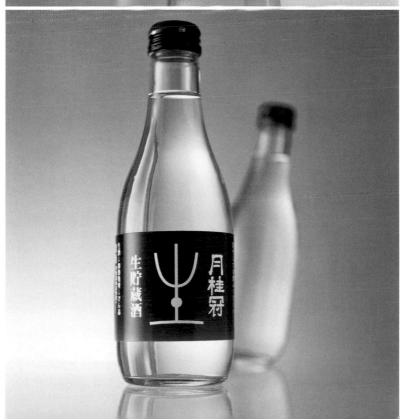

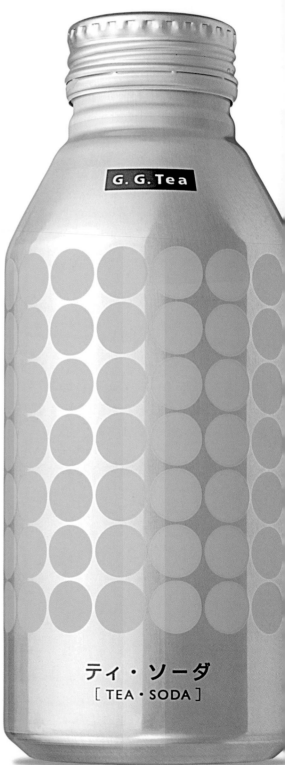

G.G.Tea

ソプラノ・ピーチ
[SOPRANO PEACH · TEA]

G.G.Tea

ティ・ソーダ
[TEA · SODA]

← Kirin Beverage G,G, Tea
D: TUGBOAT

↓ Kirin Coffe Can Fire
D: TUGBOAT

KIRIN

NAKED BEANS
Since 1999
QUALITY

FIRE

FIRE×CLASSICO
STANDARD COFFEE
WITH NAKED BEA

SINCE 1999

ファイア クラシコ
コーヒー

KIRIN

NAKED BEANS
Since 1999
QUALITY

FIRE

FIRE×VANILLA
BLENDED COFFEE
WITH NAKED BEANS

SINCE 1999

バニラ ファイア
コーヒー飲料

Beauté de Kosé
D: Kosé
ad: Fujio Hanawa

Rutína Vital Force
D: Kosé
ad: Fujio Hanawa

→ Stylism
D: Kosé
ad: Fujio Hanawa

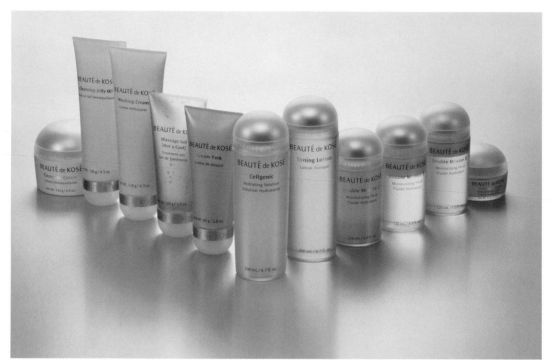

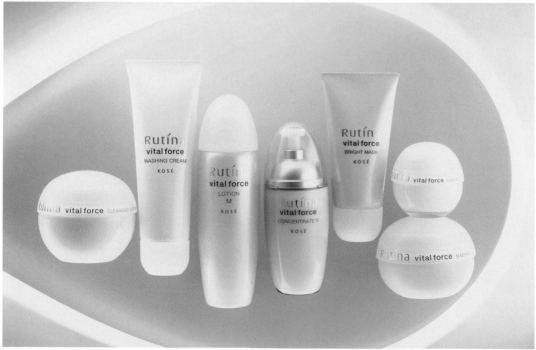

← Carté
D: Kosé
ad: Fujio Hanawa

↓ Cosme Decorte Celestial G
D: Kosé
ad: Fujio Hanawa

↓ Sekkisei Series
D: Kosé
ad: Fujio Hanawa

Selfconscious wéek-end estherapy
D: Kosé
ad: Fujio Hanawa

→ Beauté de Kosé
D: Kosé
ad: Fujio Hanawa

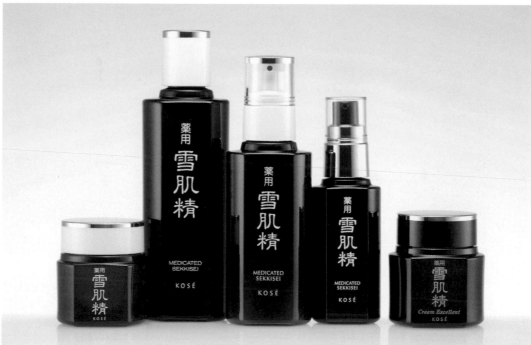

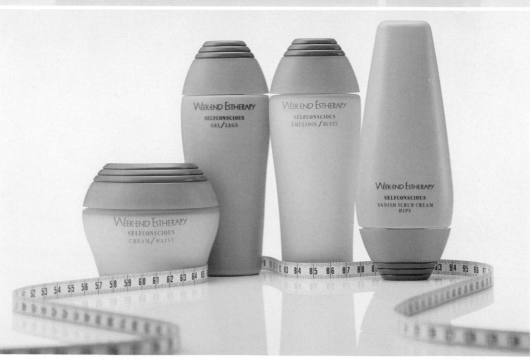

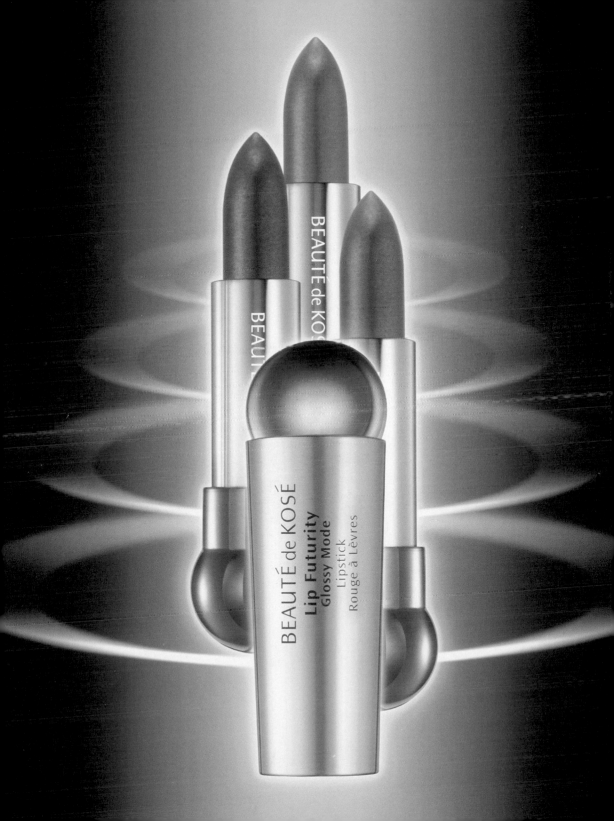

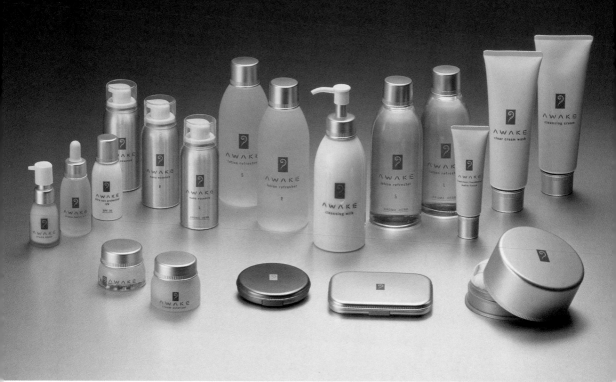

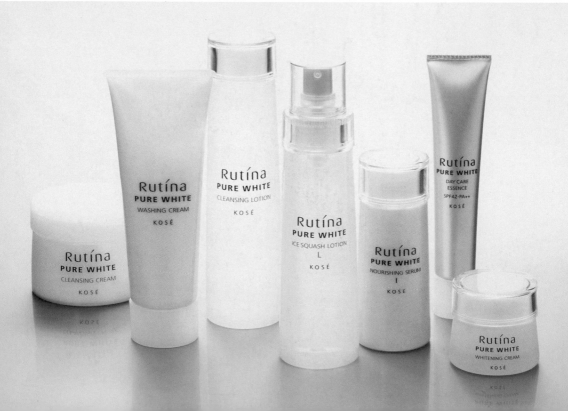

← Awake
D: Kosé
ad: Fujio Hanawa

Rutina Pure White
D: Kosé
ad: Fujio Hanawa

↓ Luminous
D: Kosé
ad: Fujio Hanawa

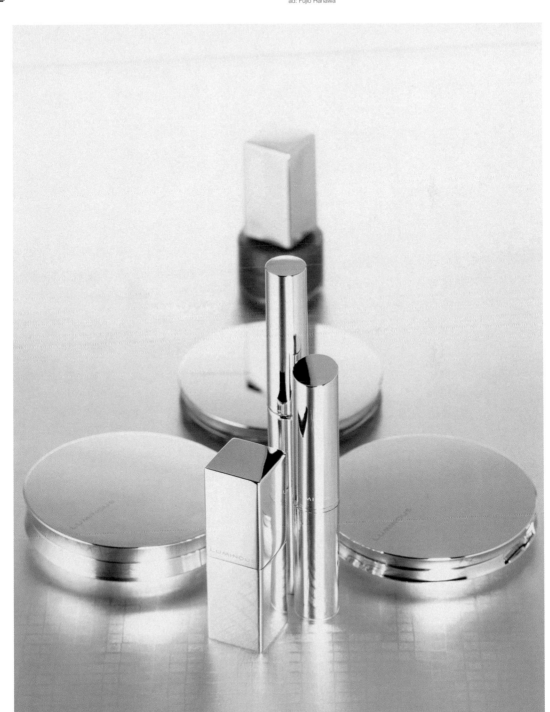

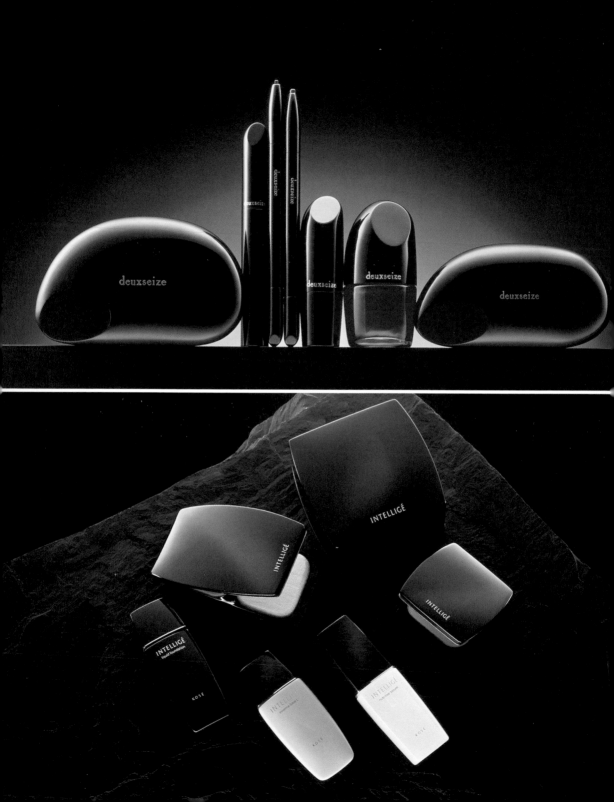

← Deuxseize
D: Kosé
ad: Fujio Hanawa

Intelligé
D: Kosé
ad: Fujio Hanawa

↓ Infinity
D: Kosé
ad: Fujio Hanawa

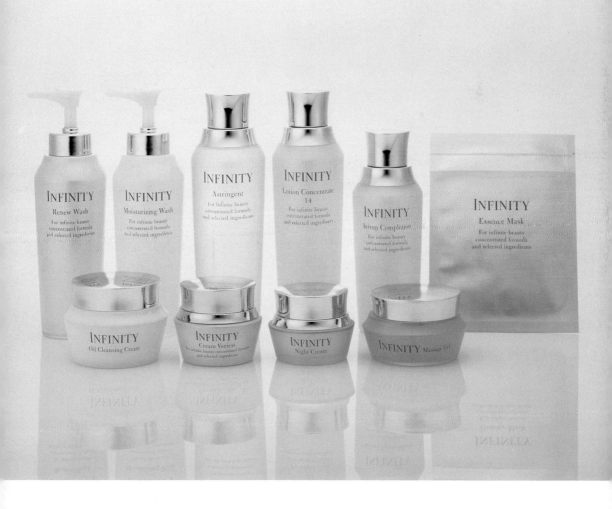

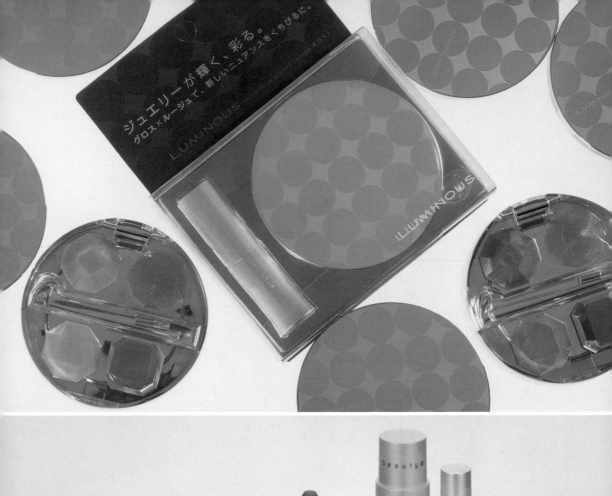

ジュエリーが輝く、彩る。
グロス×ルージュで、新しいニュアンスをくちびるに。

LUMINOUS

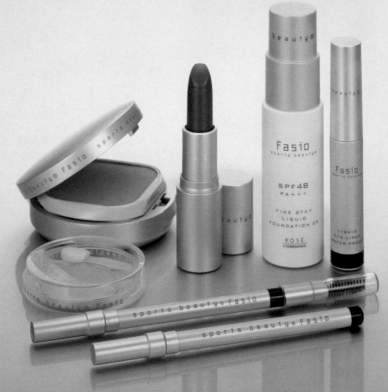

← Luminous
D: Kosé
ad: Fujio Hanawa

Fasio
D: Kosé
ad: Fujio Hanawa

↓ Phytorium
D: Kosé
ad: Fujio Hanawa

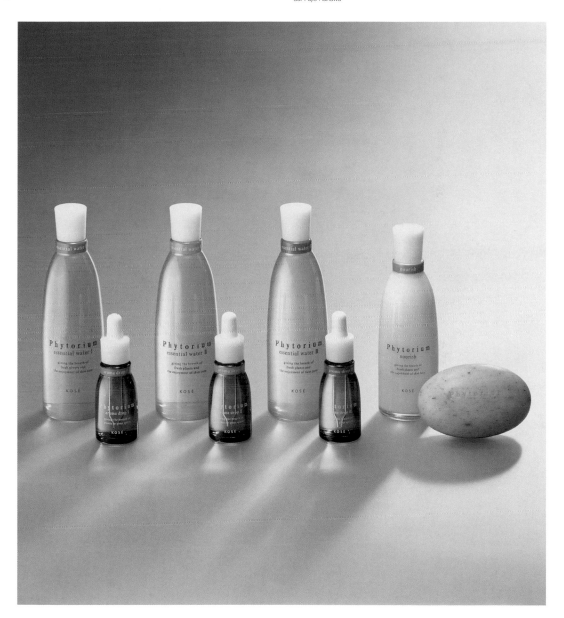

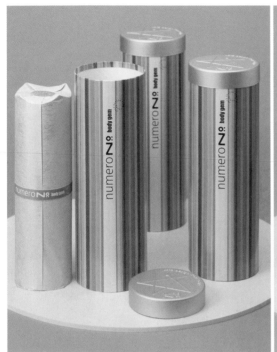

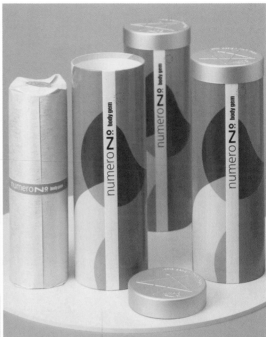

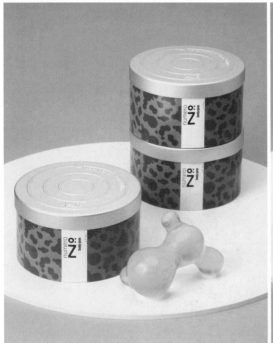

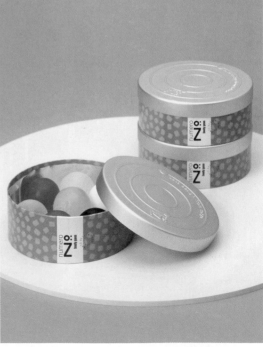

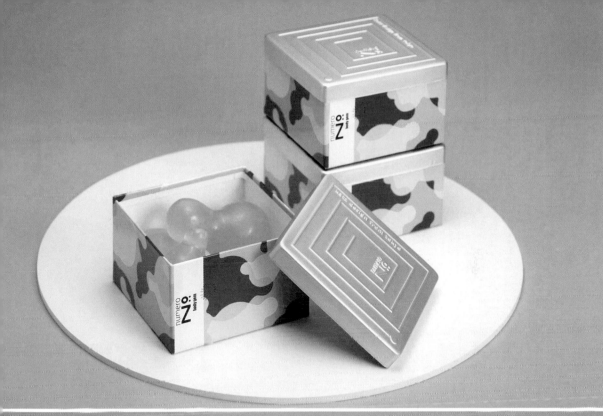

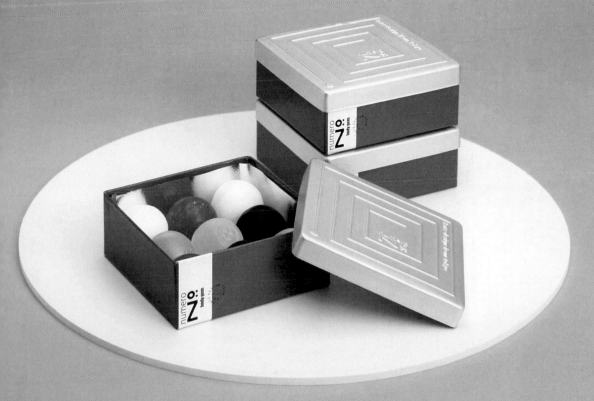

↓ Round box for confectionery gift
 D: Mihiko Hachiuma

Betty's Sweet sprinng gift
 D: Mihiko Hachiuma

→ Tomitaro Makino Museum shop
 D: Mihiko Hachiuma

パッケージ　98

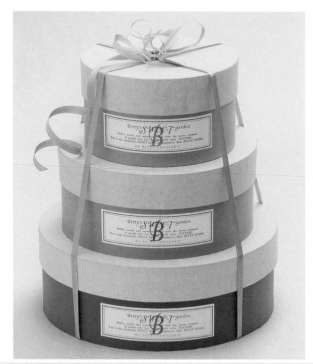

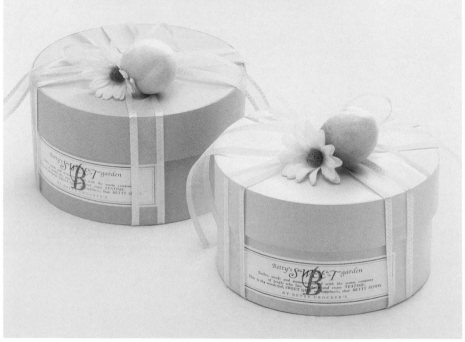

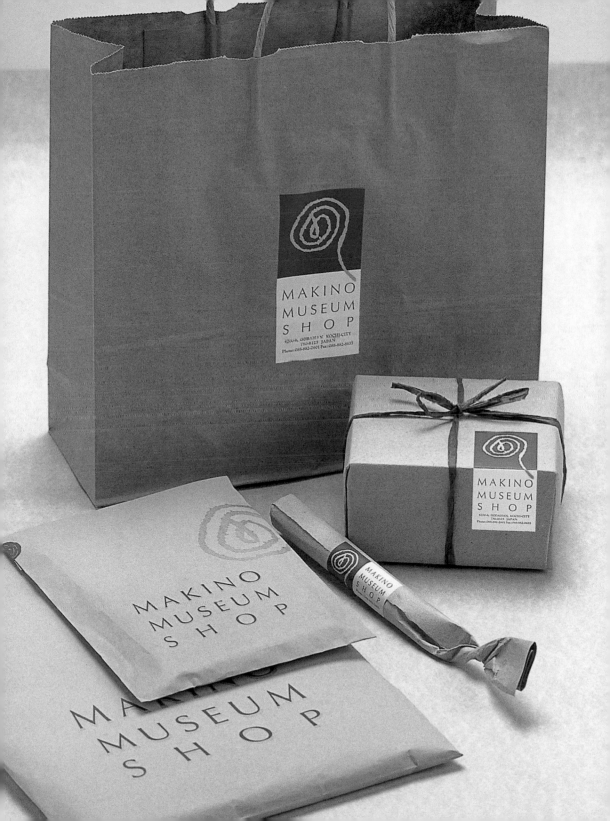

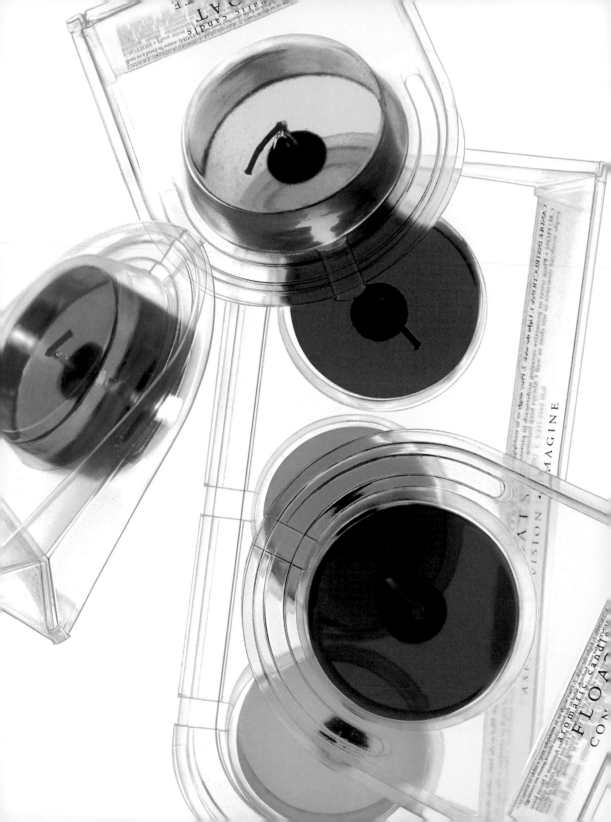

← Float
D: Sayuri Studio, Inc.

↓ Candle 0015/0017
D: Sayuri Studio, Inc.

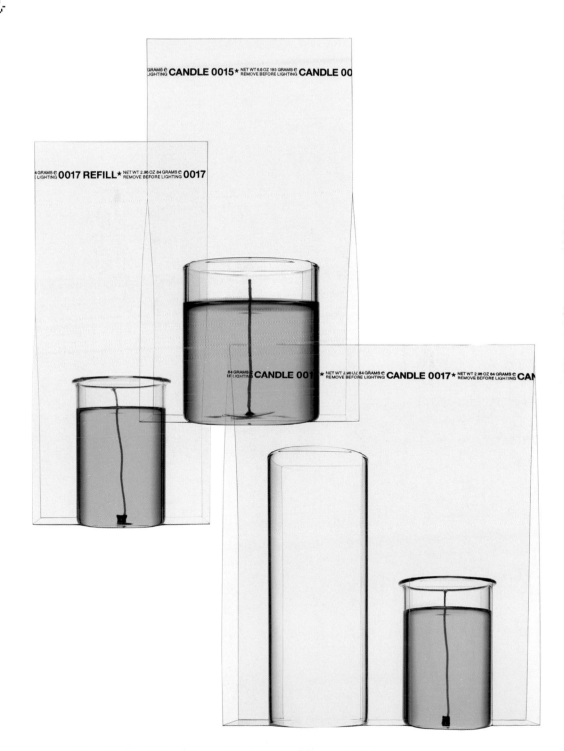

↓ H2O Fluid
D: Sayuri Studio, Inc.

→ Remede
D: Sayuri Studio, Inc.

Shiseido 5S
D: Sayuri Studio, Inc.

パッケージ　102

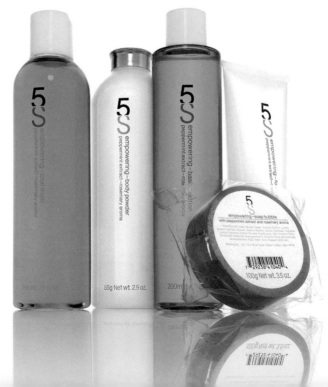

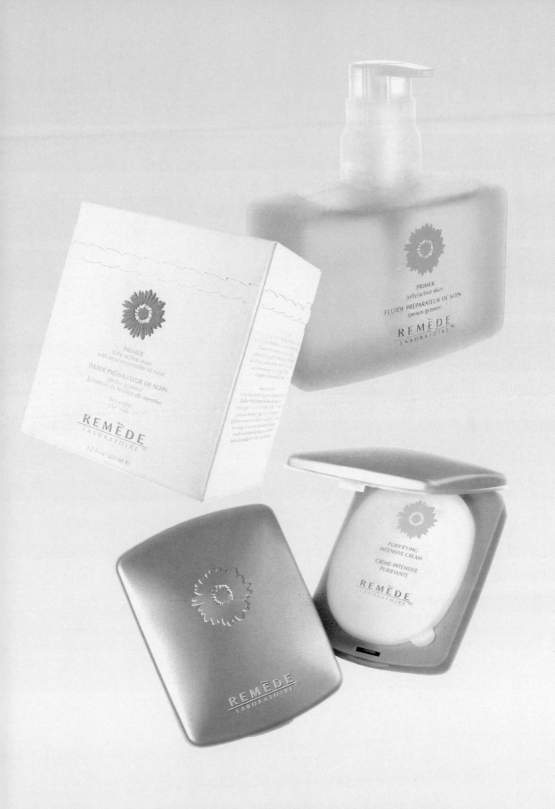

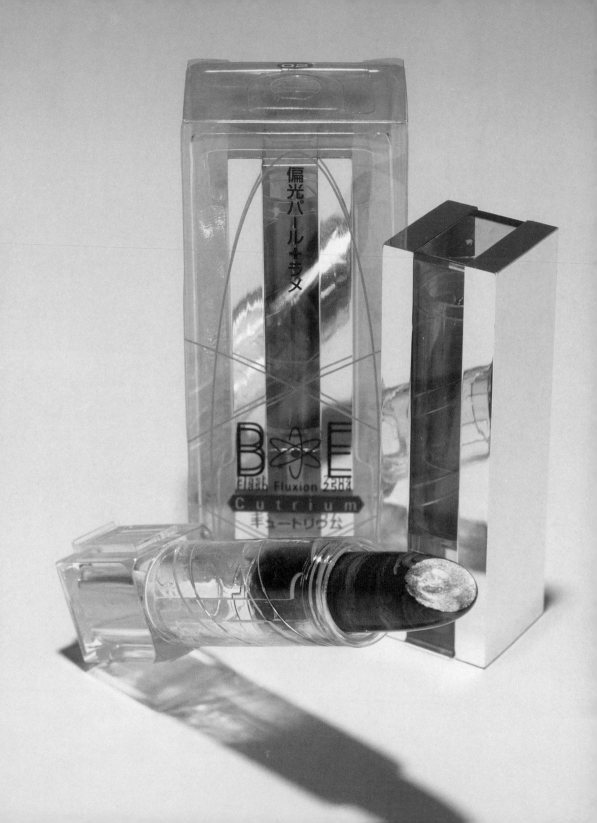

← B·E
D: TCD
cl: Naris Up Cosmetics Co., Ltd.

↓ Prirism
D: TCD
cl: Naris Up Cosmetics Co., Ltd.

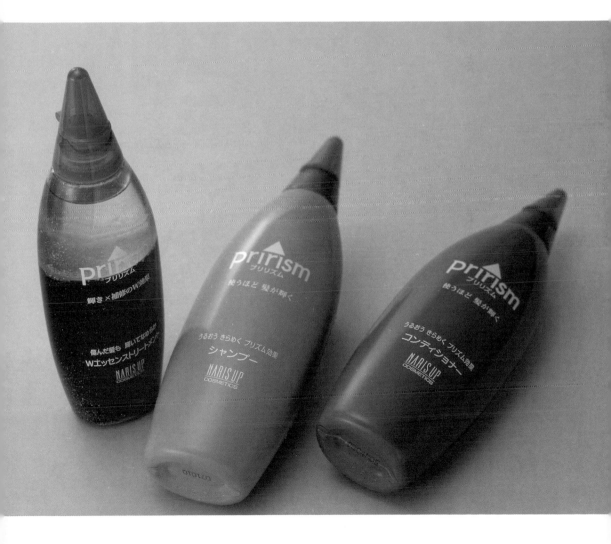

↓ Shiseido Relaxina, Fragrance water
D: Toru Ito
cd: Minoru Shiokawa

→ RMK skincare series
D: Taku Satoh

Taihei Chemical Industrial Co., Ltd.
Washing liquid for dentistries
D: TCD

パッケージ 108

RMK CLEANSING GEL

RMK CLEANSING OIL

RMK CLEANSING MILK

RMK SOAP BAR

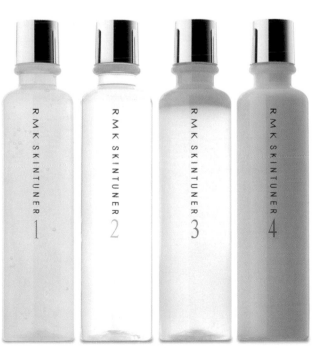

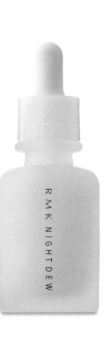

RMK SKINTUNER 1

RMK SKINTUNER 2

RMK SKINTUNER 3

RMK SKINTUNER 4

RMK NIGHTDEW

RMK CREAMYSOAP

← fec. Make-up series
D: Taku Satoh

↓ Bolty
D: Taku Satoh

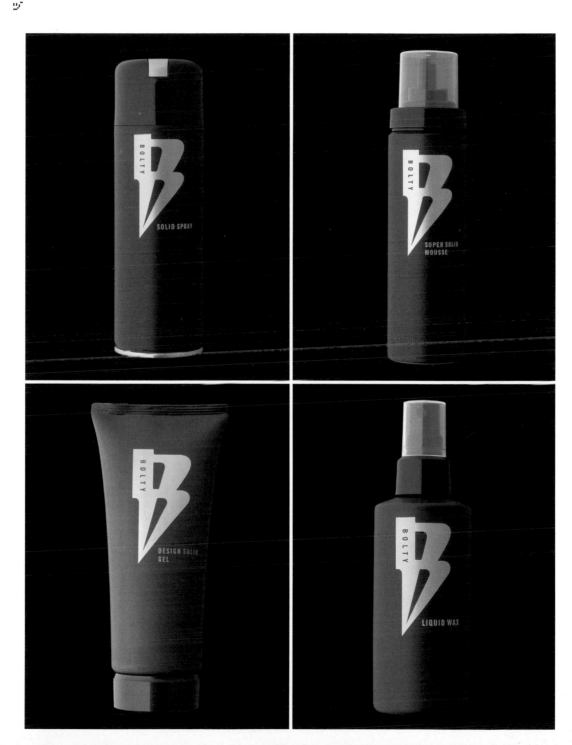

← Moisture, body lotion
D: Taku Satoh

↓ P.G.C.D Protection Integrale Tendre
D: Taku Satoh

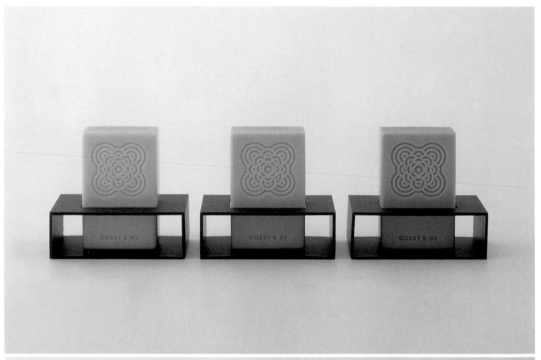

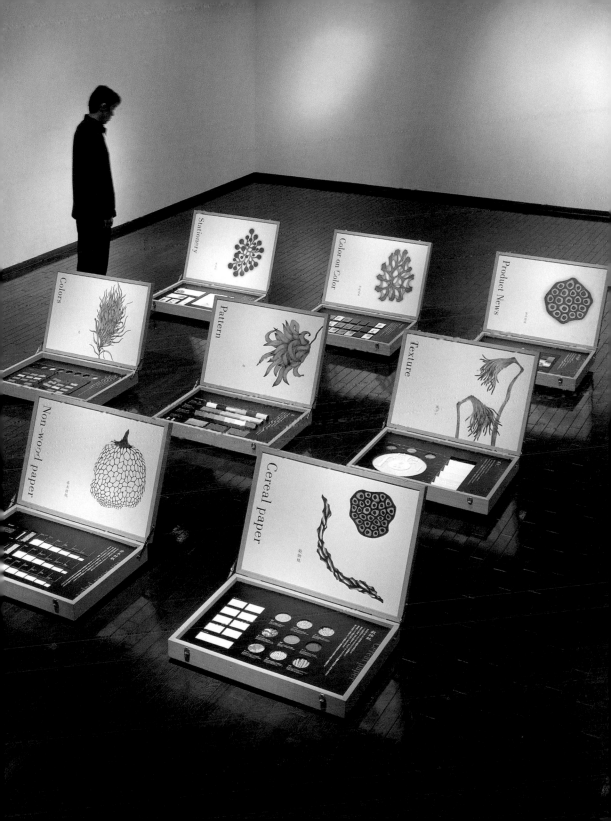

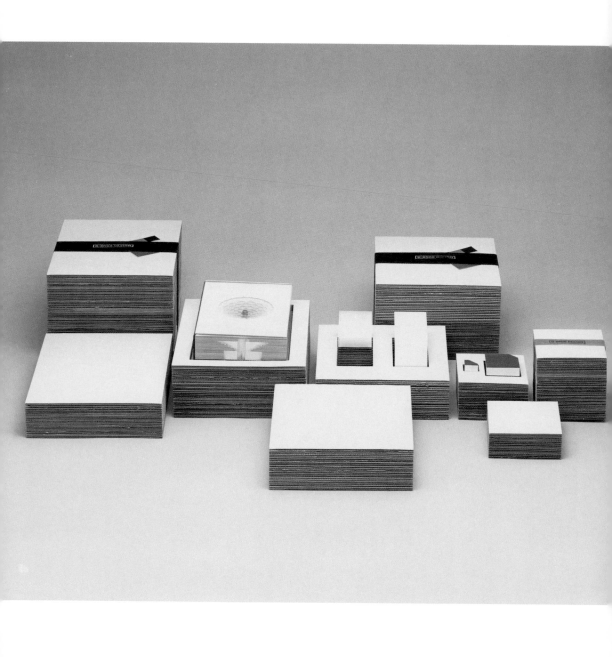

← D-Bros Package
D: Yoshie Watanabe

↓ Felissimo, Shipping carton design
D: Sayuri Studio, Inc.

コレクションの楽しさは
開けた瞬間からはじまります。

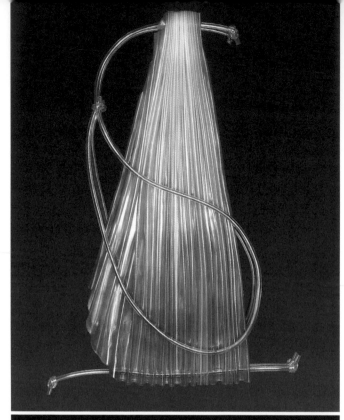
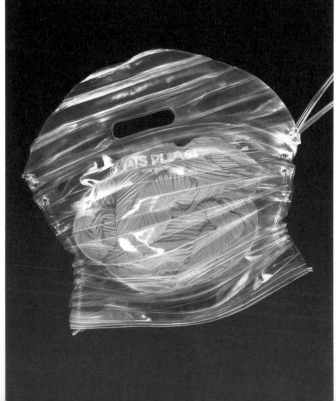

↓ Human Intellect
D: Akio Okumura

→ Shopping bag
D: Akio Okumura

Kintetsu
D: Akio Okumura

パッケージ 124

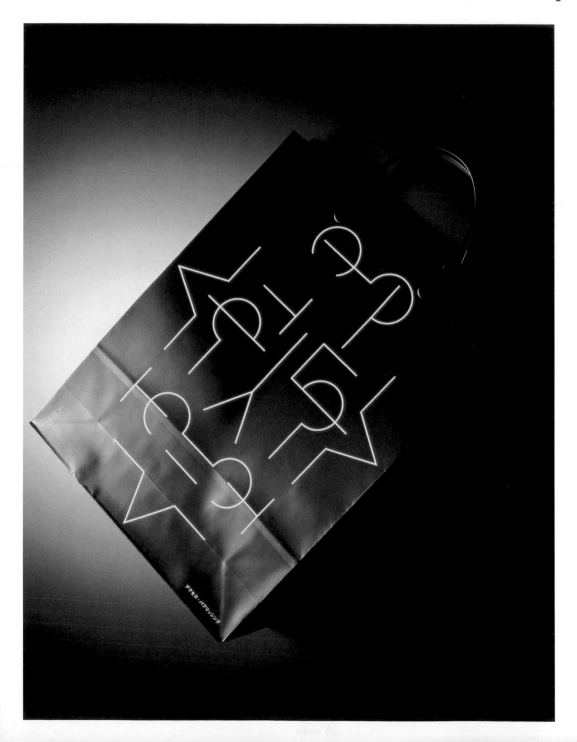

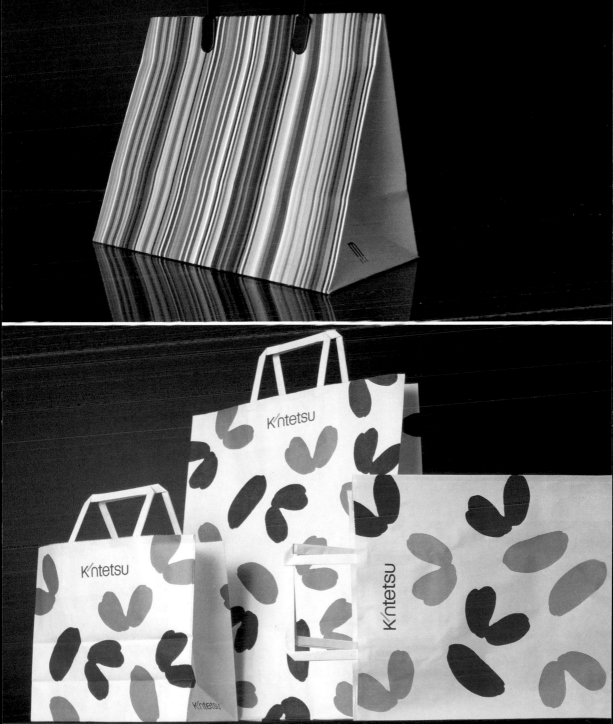

POSTERS
AND ADS

ポスター
と
広告

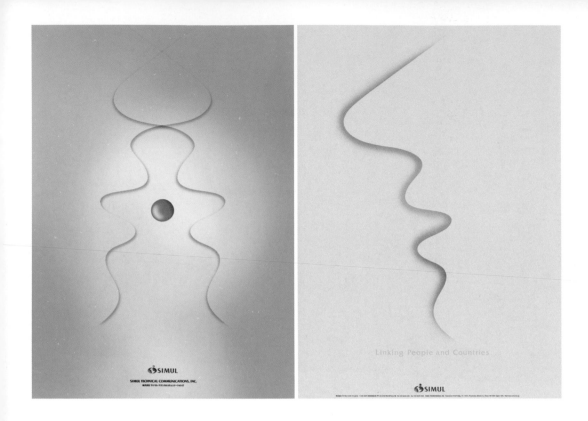

← Simul Technical
D: Gaku Ohsugi
ad+d: Gaku Ohsugi
d: Eiji Sunaga
cl: Simul Technical Communications

Linking people and countries
D: Gaku Ohsugi
ad+d: Gaku Ohsugi
d: Kenji Iwabuchi
cl: Simul International Inc.

↓ Linking people and countries
D: Gaku Ohsugi
ad+d: Gaku Ohsugi
d: Kenji Iwabuchi
cl: Simul International Inc.

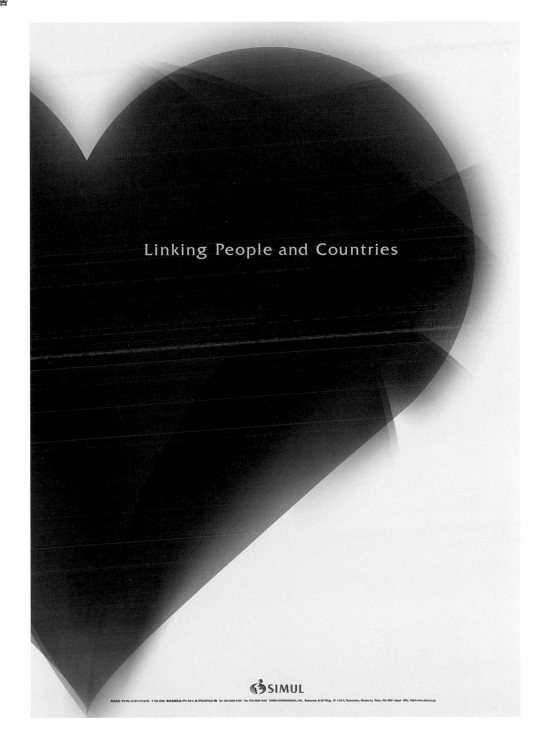

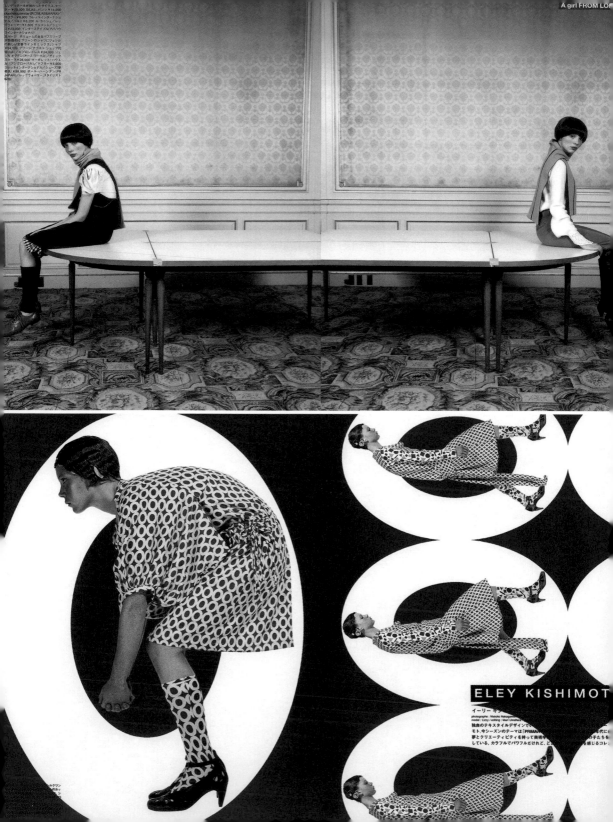

ー¥29,000 SEAS.パンツ¥14,000
Sophie by センター（RICOKISSMARKAN》
ミキラー¥6,900 コレジオ・インターナション
ジル・サンダー¥6,200 ルーモニッシュ／レン
ショー¥11,500 インターミスティブ（ババルウ
ルイントートジャケット
ストー ボリュームのある1Vスワープ
イント ルーロールーのあるグリーンのショップブラック
ワ半袖重ね着サマ重ミックスジョケ
¥34,309 グリーンのゴストショップ7玉
¥34,309 ジフロンドレス¥24,000 ジェ
アブロンドレス¥24,000 ジェ
スカート ¥26,000 サーガストートバック
ル ソングローバルレメプラー¥6,800
コレットイーターデャルメ／シューズ着
MAPAN/レックウォッサー／スタイリスト
62は

ELEY KISHIMOT[...]

イーリー ギン[...]
photography | Naoto Hasegawa[...]
model | Lizzy | editing | Mari Umeha[...]
独自のテキスタイルデザインで[...]
モト、今シーズンのテーマは「PRIMA[...]
夢とクリエーティビティを持って美術[...]
している。カラフルでパワフルだけれど、と[...]を感じるコレ[...]

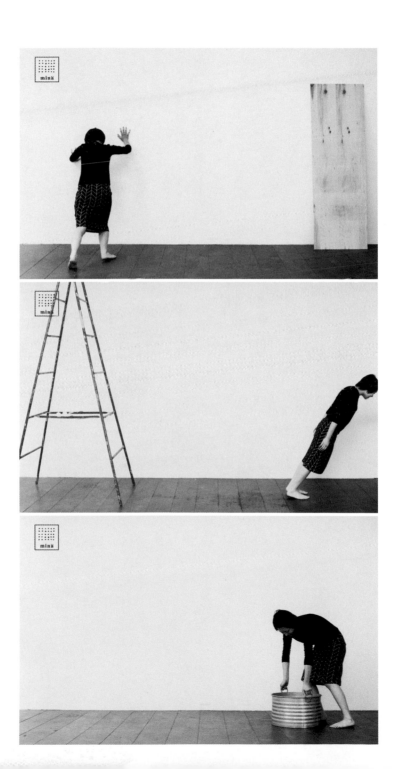

Is it beer cold at a refrigerator? Kanpai!!
LAGER
D: Butterfly Stroke Inc.
cl: Kirin Brewery Co.,LTD.
cd+ad+d: Katsunori Aoki
cd+c: Hidenori Azuma
d: Kana Takakuwa
i: Bunpei Yorifuji

Kanpai!! LAGER
D: Butterfly Stroke Inc.
cl: Kirin Brewery Co.,LTD
cd+ad+d: Katsunori Aoki
cd+c: Hidenori Azuma
d: Kana Takakuwa
i: Bunpei Yorifuji

Kanpai!! LAGER TOKIO Version
D: Butterfly Stroke Inc.
cl: Kirin Brewery Co.,LTD
cd+ad+d: Katsunori Aoki
cd+c: Hidenori Azuma
d: Yuji Sakai
i: Bunpei Yorifuji

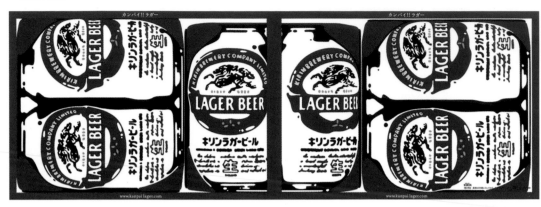

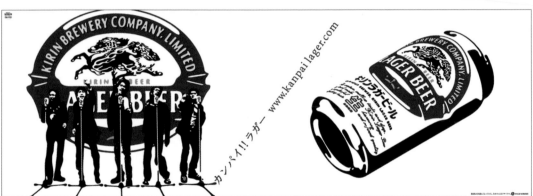

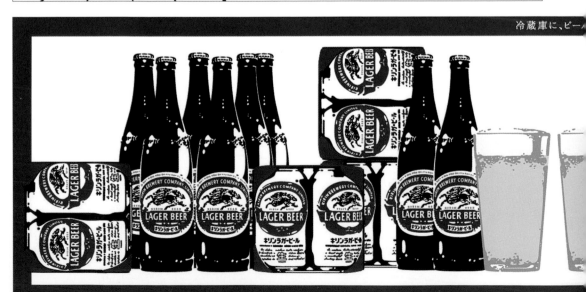

↓ Kanpai!! LAGER Hirosue Version1.
D: Butterfly Stroke Inc.
cl: Kirin Brewery Co.,LTD.
cd+ad+d: Katsunori Aoki
cd+c: Hidenori Azuma
d: Yuji Sakai
p: Kaoru Ijima/Hiroyoshi Koyama
i: Bunpei Yorifuji
p: Tomoyuki Inoue

Kanpai!! LAGER Hirosue Version2.
D: Butterfly Stroke Inc.
cl: Kirin Brewery Co.,LTD.
cd+ad+d: Katsunori Aoki
cd+c: Hidenori Azuma
d: Yuji Sakai

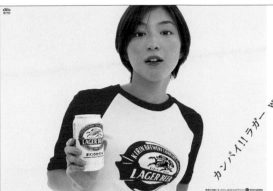
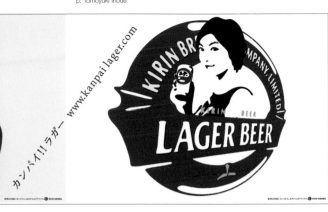

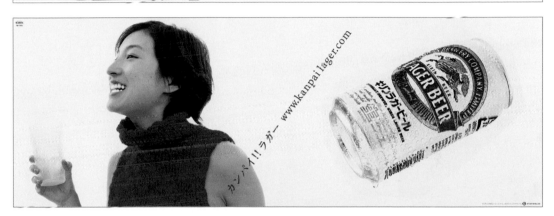

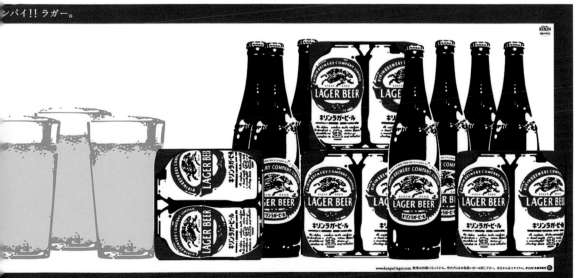

Laforet Grand Bazar '96 Spring
D: Butterfly Stroke Inc.
cd+ad+d+c: Katsunori Aoki
cd+c+cg: Ichiro Tanida

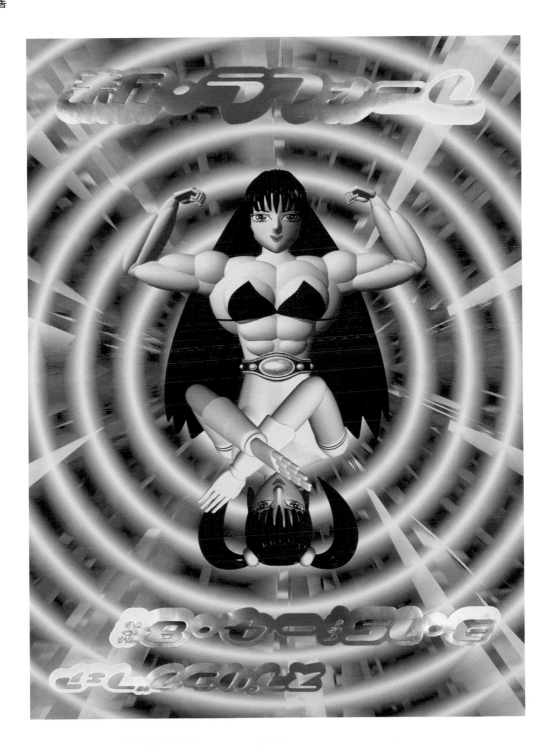

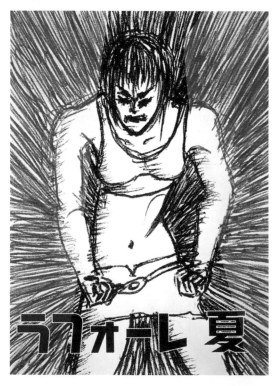

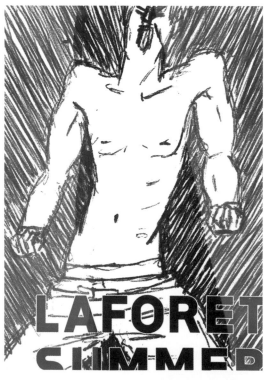

← Laforet Grand Bazar '97 Summer
D: Butterfly Stroke Inc.
cl: Laforet Harajuku
cd: Katsunori Aoki/
Ichiro Tanida / Yasuhiko Sakura
ad+d: Katsunori Aoki
cg: Ichiro Tanida

↓ Tokyo Art Directors Club Annual Exhibition '99
D: Butterfly Stroke Inc.
cl: Tokyo Art Directors Club
ad+d: Katsunori Aoki
i: Bunpei Yorifuji

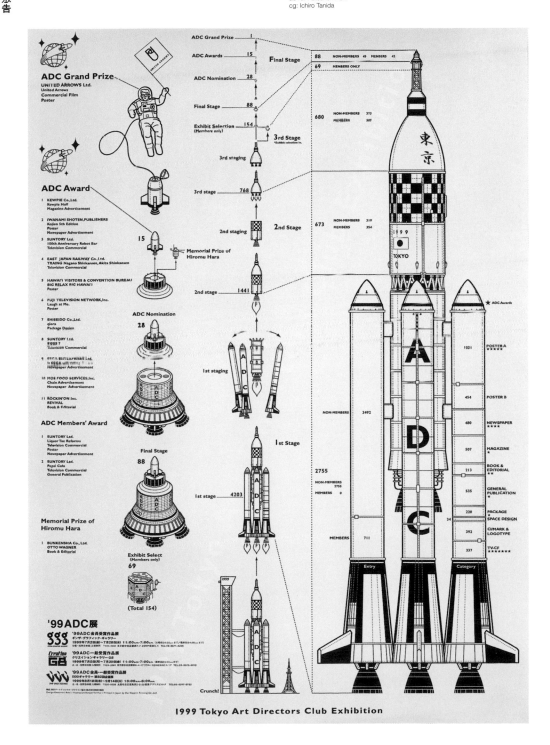

1999 Tokyo Art Directors Club Exhibition

↓ VenusFort Bargain
D: Butterfly Stroke Inc.
cl: VenusFort
cd+c: Masashi Taniyama
ad+d: Katsunori Aoki
art w+p: Jean-Pierre Khazem

Laforet Grand Bazar '96 Summer
D: Butterfly Stroke Inc.
cl: Laforet Harajuku
cd: Katsunori Aoki/ Ichiro Tanida/
Yasuhiko Sakura
ad+d: Katsunori Aoki
cg: Ichiro Tanida

→ Laforet Grand Bazar '96 Winter
D: Butterfly Stroke Inc.
cl: Laforet Harajuku
cd: Katsunori Aoki/
Ichiro Tanida / Yasuhiko Sakura
ad+d+c: Katsunori Aoki
c+cg: Ichiro Tanida

138

ポスターと広告

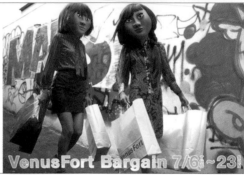

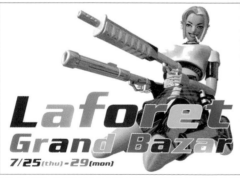

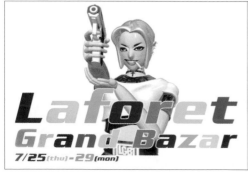

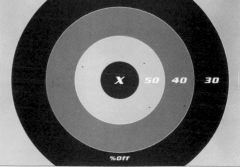

Okamoto Benetton Condom
D: Butterfly Stroke Inc.
cl: Okamoto Industries, Inc.
cd+c: Hiroshi Hasegawa
ad+d: Katsunori Aoki
p: Yoshihito Imaizumi

D: Butterfly Stroke Inc.
cl: Okamoto Industries, Inc.
cd+c: Hiroshi Hasegawa
ad+d: Katsunori Aoki
i: Bunpei Yorifuji
p: Yukihiro Onodera

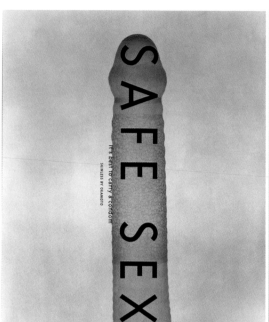

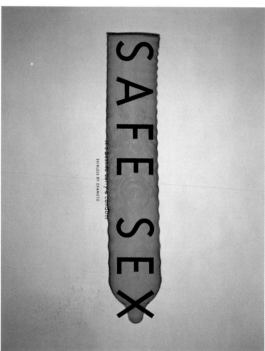

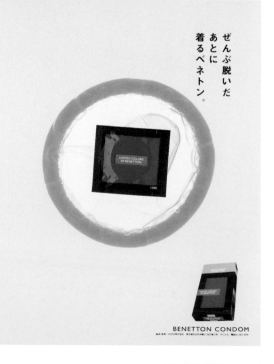

BENETTON CONDOM

BENETTON CONDOM

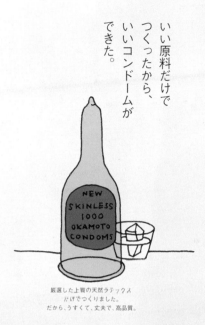

いい原料だけで
つくったから、
いいコンドームが
できた。

厳選した上質の天然ラテックス
だけでつくりました。
だから、うすくて、丈夫で、高品質。

うすさ、新鮮。
NEW SKINLESS!!

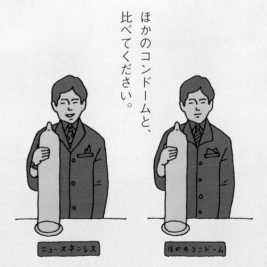

ほかのコンドームと、
比べてください。

ニュースキンレス　　　　ほかのコンドーム

Q：どこがちがっているでしょう？

厳選した上質の天然ラテックス
だけでつくりました。
だから、うすくて、丈夫で、高品質。

うすさ、新鮮。
NEW SKINLESS!!

↓ Fields
Pachinco Hall Design Competition 2002
D: Butterfly Stroke Inc.
cl: Fields co.,Ltd.
cd+ad+d: Katsunori Aoki
d: Kana Takakuwa
i: Bunpei Yorifuji

→ Nike Total Performance Leadership '98
D: Butterfly Stroke Inc.
cl: Nike Japan
cd: Larry Fry
ad+d: Katsunori Aoki
d+i: Seijiro Kubo
c: Naoki Morita
p: Kouichi Ikegame pr: Dan Odagiri

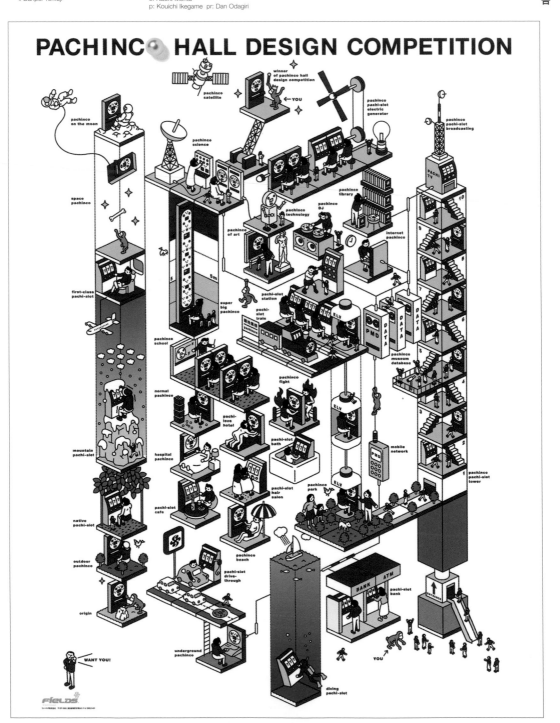

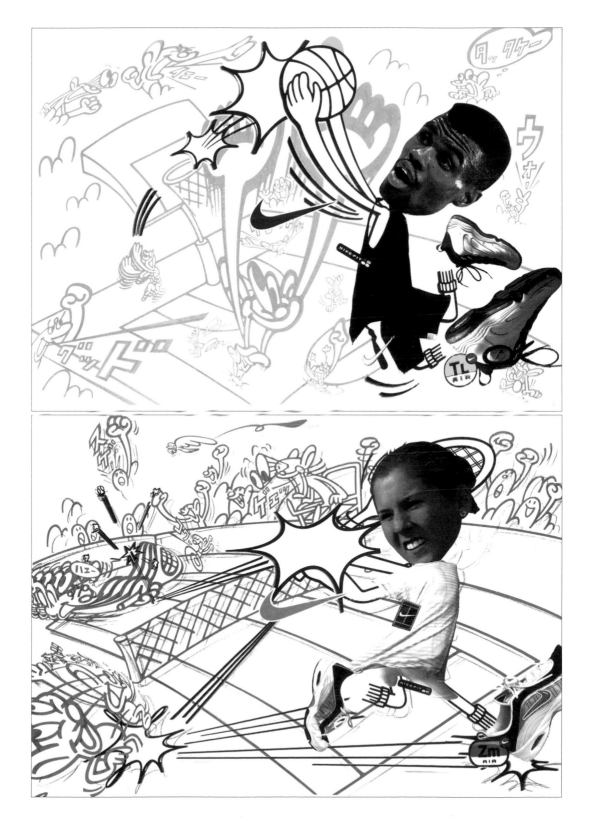

↓ Enjoy 100%, AIWA
→ D: Butterfly Stroke Inc.
cl: Sony Marketing inc.
cd+ad+d: Katsunori Aoki
cd: Masao Oshima
c: Kensho Yoshitani
i: Seijiro Kubo

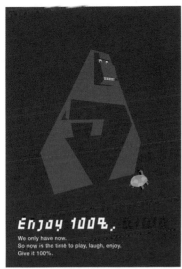

EnJoY 100%. aiwa

We only have now.
So now is the time to play, laugh, enjoy.
Give it 100%.

EnJoY 100%. aiwa

We only have now.
So now is the time to play, laugh, enjoy.
Give it 100%.

EnJoY 100%. aiwa

We only have now.
So now is the time to play, laugh, enjoy.
Give it 100%.

EnJoY 100%. aiwa

We only have now.
So now is the time to play, laugh, enjoy.
Give it 100%.

EnJoY 100%. aiwa

We only have now.
So now is the time to play, laugh, enjoy.
Give it 100%.

EnJoY 100%. aiwa

We only have now.
So now is the time to play, laugh, enjoy.
Give it 100%.

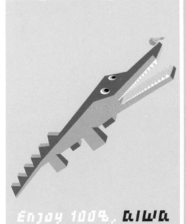

EnJoY 100%. aiwa

We only have now.
So now is the time to play, laugh, enjoy.
Give it 100%.

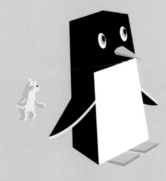

EnJoY 100%. aiwa

We only have now.
So now is the time to play, laugh, enjoy.
Give it 100%.

EnJoY 100%. aiwa

We only have now.
So now is the time to play, laugh, enjoy.
Give it 100%.

↓ Balance On
 D: Creative Power Unit

→ Mainichi Kajitsu & Balance On
 D: Creative Power Unit

ポスターと広告

146

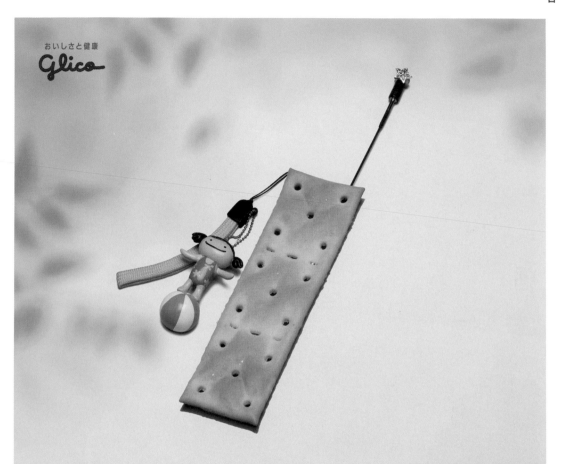

おいしさと健康
glico

もう、手ばなせナイ モード。

新しく、スリムなったからいつでもどこでも
食事がわりにサクッとイケる。しかも、栄養バランスが
いいのにカロリーひかえ目。今どきの女の子の必需品。

カジュアルタイプになって食べやすく、携帯しやすくなった「バランスオン」は、
あっさりおいしい塩味と、香りも味わえるミックスハーブ味の2タイプ。
1箱に5種のビタミン・カルシウム・鉄分が1日に必要な量の3分の1、
バランスよく含まれています。しかも、カロリーはうれしい180kcal.
何かと忙しいけど、栄養もカロリーも気になるあなたにピッタリなのです。

[バランスオン] NEW

○カルシウム233mg〔牛乳約1本分／200cc〕 ○鉄4mg〔ほうれん草約3枚分〕 ○食物繊維3.4g〔レタス約1個分〕 ※10枚当たり、当社分析値 ●グリコホームページの
栄養成分ナビゲーターでは、食品の栄養成分情報の検索ができます。バランスの良い食生活づくりにお役立て下さい。 〔アドレス〕http://www.glico.co.jp

 江崎グリコ株式会社

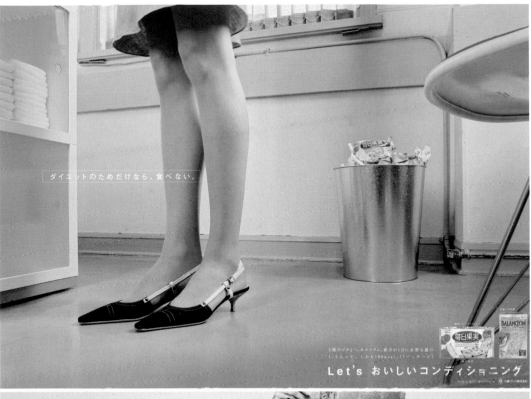

ダイエットのためだけなら、食べない。

Let's おいしいコンディショニング

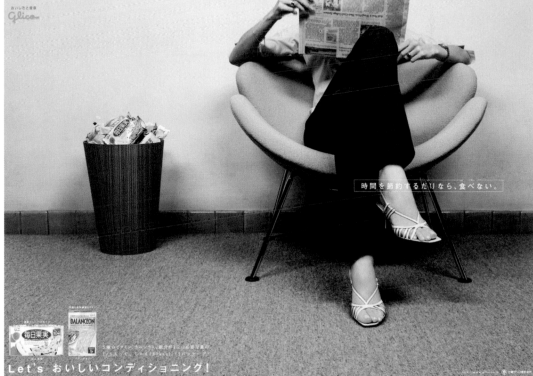

時間を節約するだけなら、食べない。

Let's おいしいコンディショニング！

↓ Art space PR poster in Narita Airport.
→ D: D-Net Co., Ltd.

ポスターと広告

148

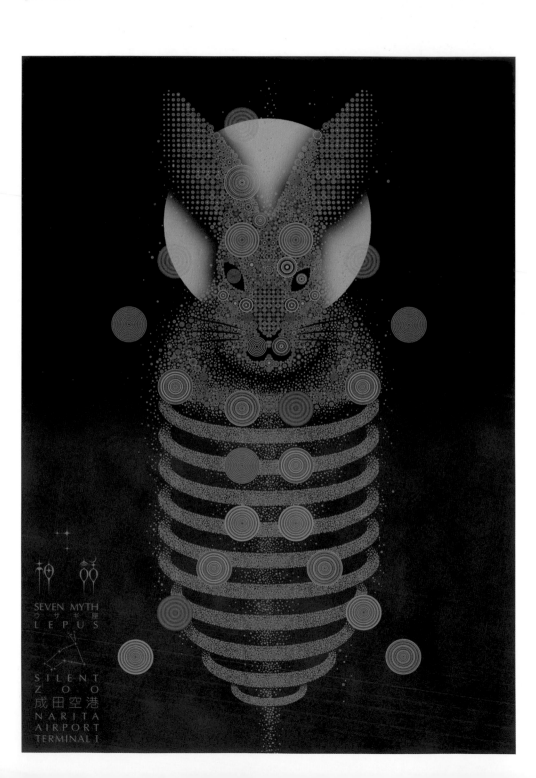

SEVEN MYTH
ウサギ 歴
LEPUS

SILENT
ZOO
成田空港
NARITA
AIRPORT
TERMINAL I

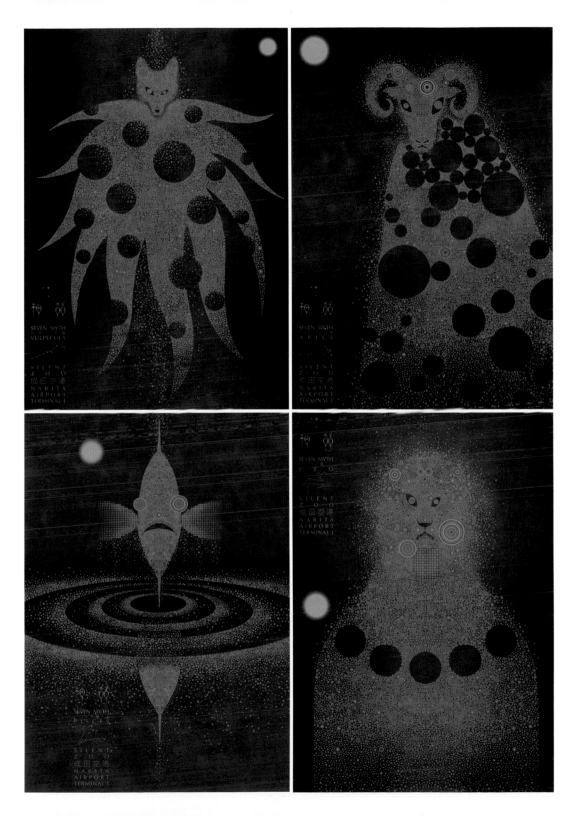

MasaakiTsuji
Glass Exhibition 5 July20-31,2000 Gallery Tsukuda

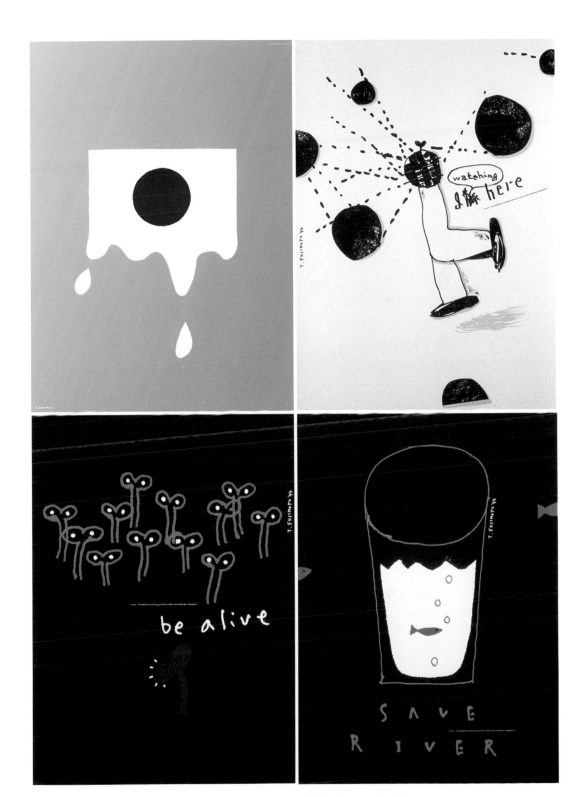

↓ Japan
 D: Wataru Hasegawa

→ We love NY
 D: Wataru Hasegawa

ポスターと広告

152

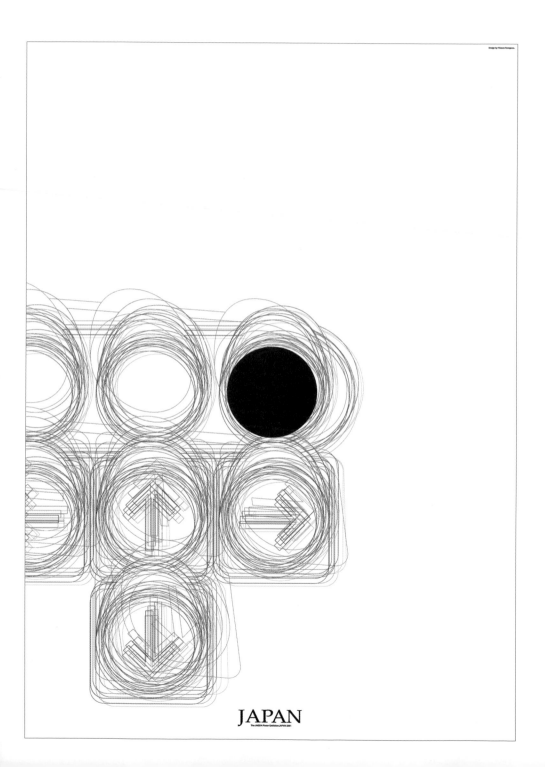

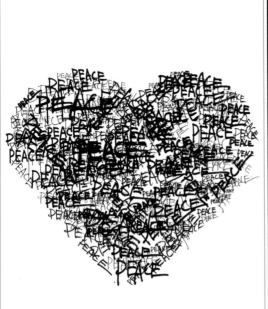

We love NY.

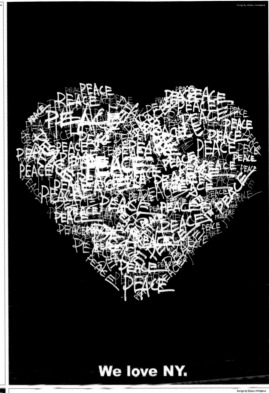

We love NY.

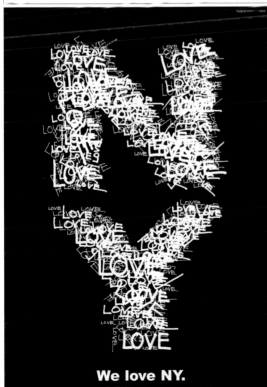

We love NY.

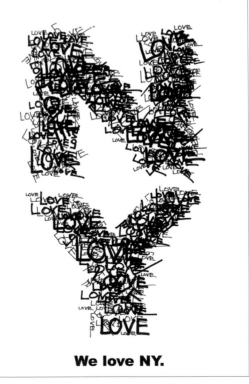

We love NY.

↓ The Tosei
D: Hiroshige Fukuhara

→ The Tosei
D: Hiroshige Fukuhara

154

ポスターと広告

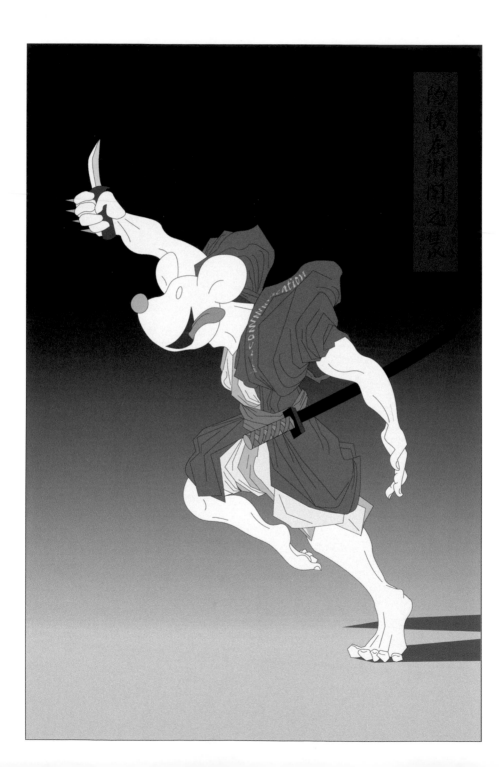

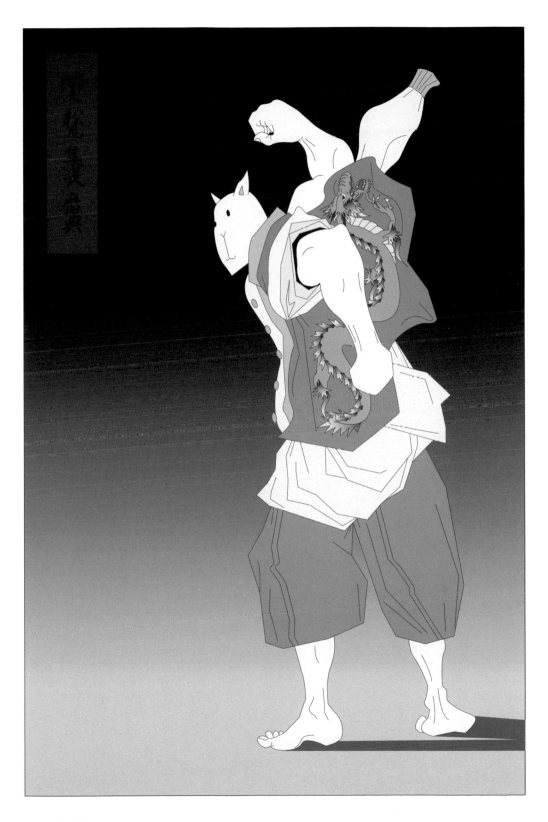

Poster for the Expo 2005 Aichi
D: Kenya Hara
ad+d: Kenya Hara
i: Shunzan Takagi / Takashi Ohno

ポスターと広告　156

EXPO 2005
JAPAN

2005年日本国際博覧会　新しい地球創造：自然の叡智
THE 2005 WORLD EXPOSITION, JAPAN　BEYOND DEVELOPMENT: REDISCOVERING NATURE'S WISDOM

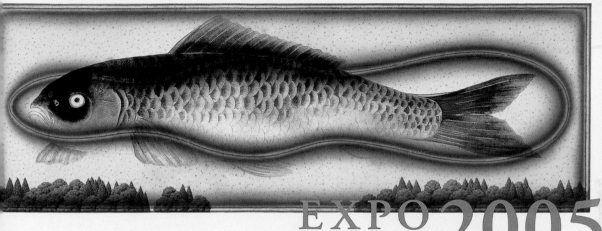

EXPO JAPAN 2005

2005年日本国際博覧会　新しい地球創造：自然の叡智
THE 2005 WORLD EXPOSITION, JAPAN　BEYOND DEVELOPMENT: REDISCOVERING NATURE'S WISDOM

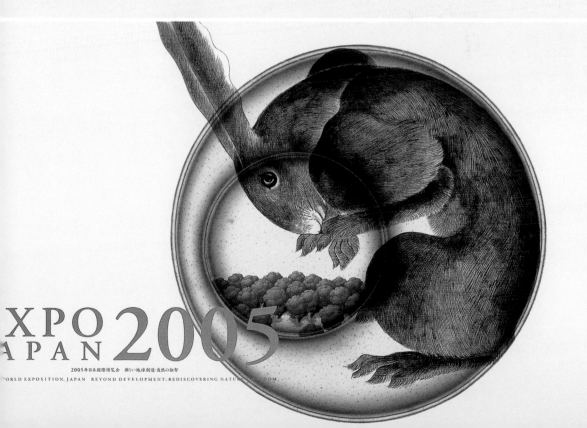

XPO JAPAN 2005

2005年日本国際博覧会　新しい地球創造：自然の叡智
WORLD EXPOSITION, JAPAN　BEYOND DEVELOPMENT: REDISCOVERING NATU OM.

↓ Kazumasa Ohhira Exhibition series
D: Takaaki Fujimoto
p: Akira Yonezu

→ J-PHONE J-N03II
D: Creative Power Unit

ポスターと広告

158

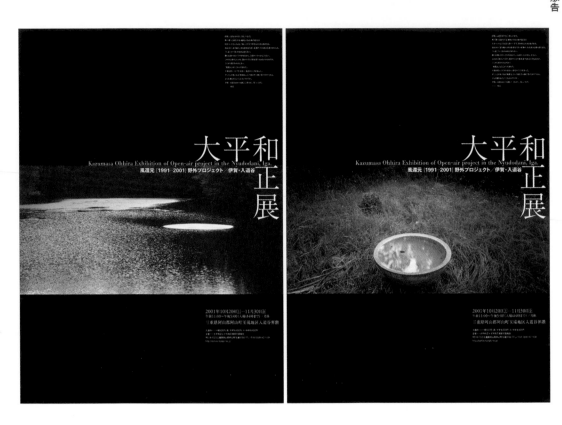

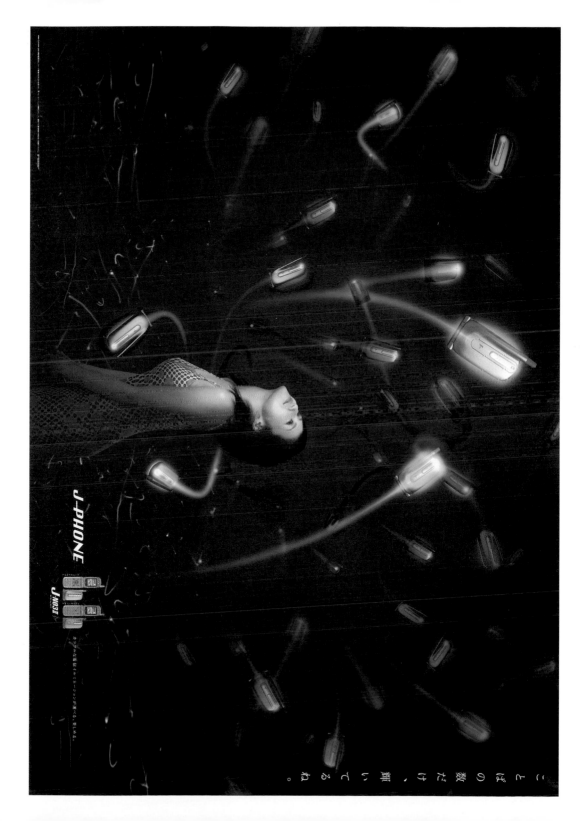

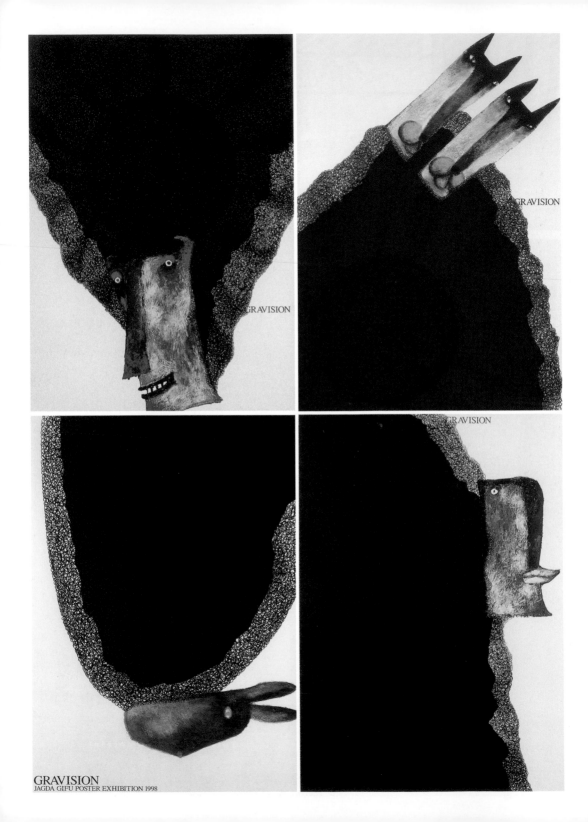

GRAVISION
JAGDA GIFU POSTER EXHIBITION 1998

← Graphic + Vision
D: D-Net Co., Ltd.

↓ "im product"
D: Kenya Hara
ad+d: Kenya Hara
p: Tamotsu Fujii

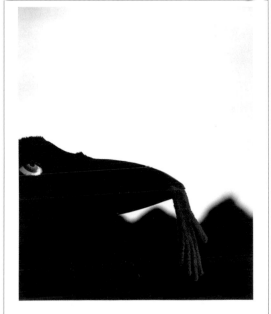

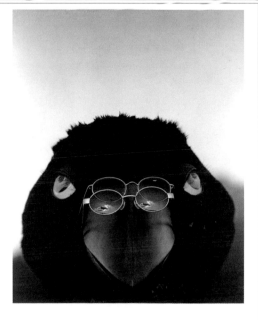

↓ MUJI
　D: Kenya Hara
　ad+d: Shinnoske sugisaki Hara
　d: Yukie Inoue / Izumi Suge
　p: Tamotsu Fujii

→ MUJI
　D: Kenya Hara
　ad+d: Kenya Hara
　d: Yukie Inoue / Izumi Suge
　p: Tamotsu Fujii

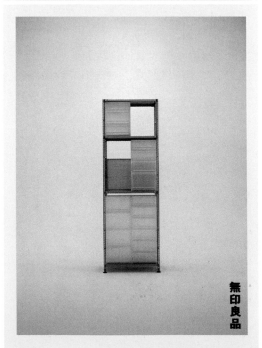

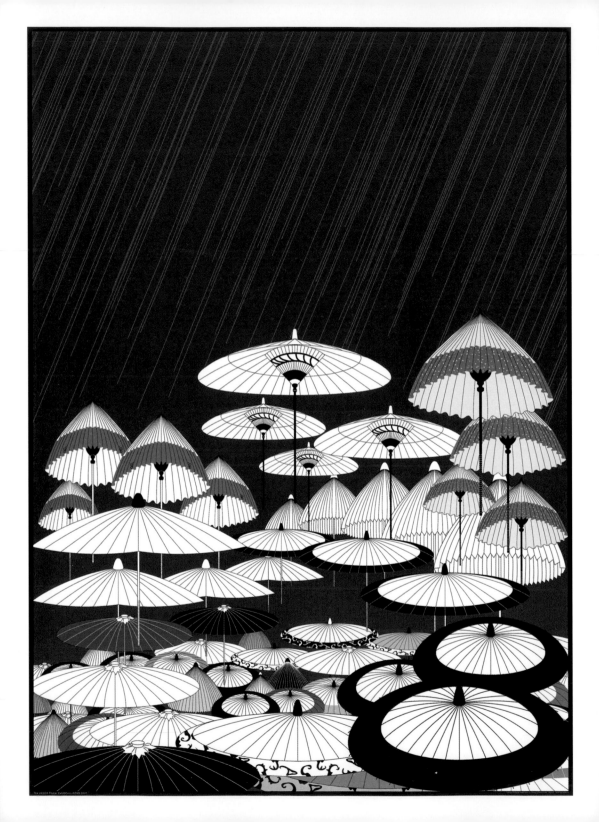

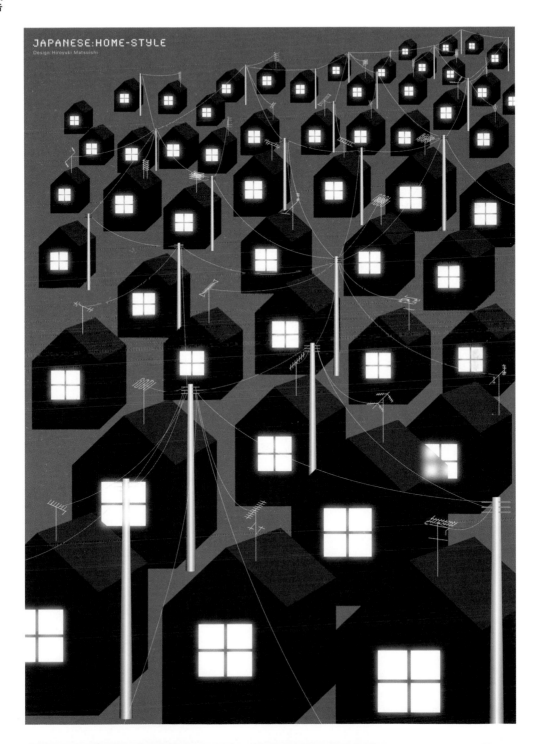

↓ Recycle factory
D: Hiroyuki Matsuishi

→ Recycle robot
D: Hiroyuki Matsuishi

ポスターと広告

166

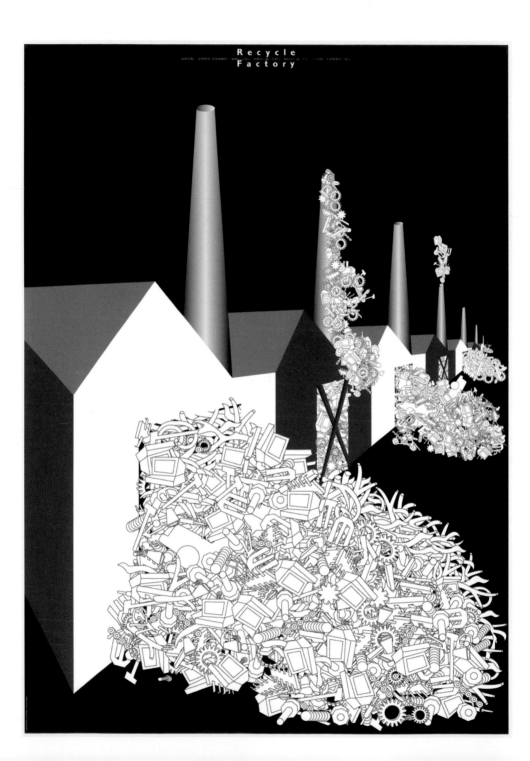

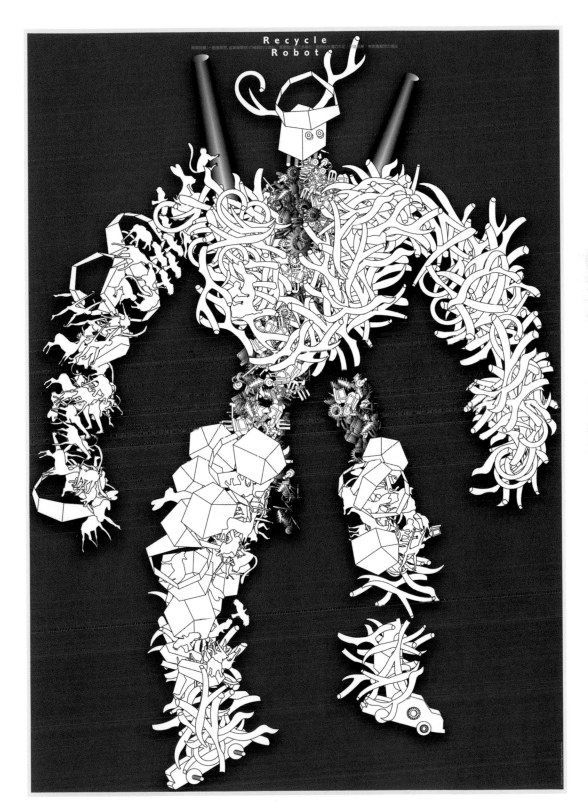

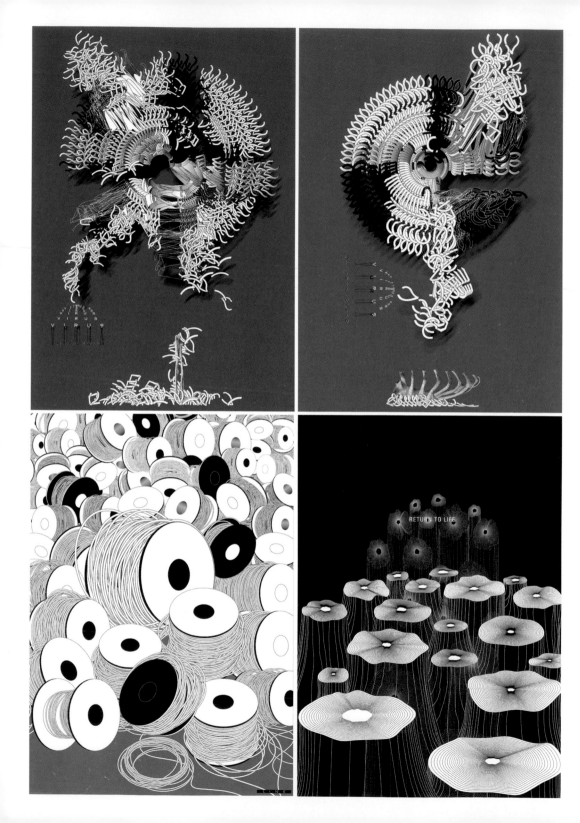

← Virus-1
D: Hiroyuki Matsuishi

Link
D: Hiroyuki Matsuishi

Virus-2
D: Hiroyuki Matsuishi

Return to life
D: Hiroyuki Matsuishi

↓ Universal Design
D: Hiroyuki Matsuishi

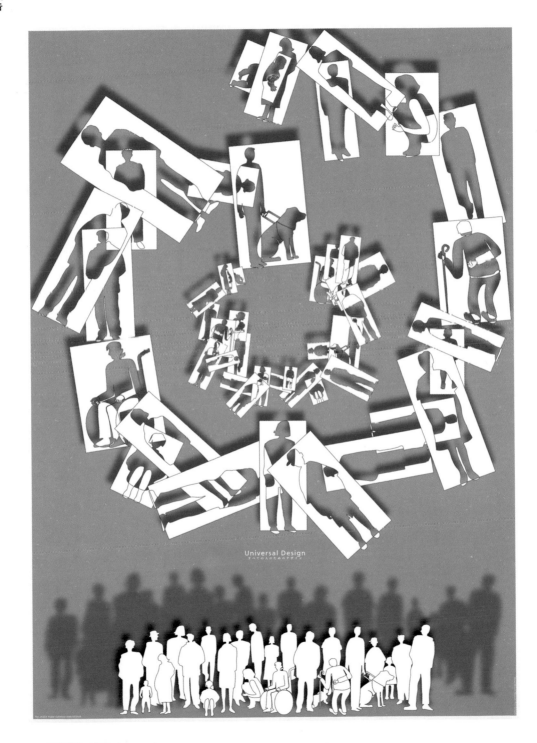

Youseki Miki Exhibition
D: Hiroyuki Matsuishi

→ Hiromichi Nakano
D: Butterfly Stroke Inc.
cl: Hiromichi Nakano Design Office
Company Limited.
cd: Hiromichi Nakano
ad+d: Katsunori Aoki
i: Seijiro Kubo

ポスターと広告 170

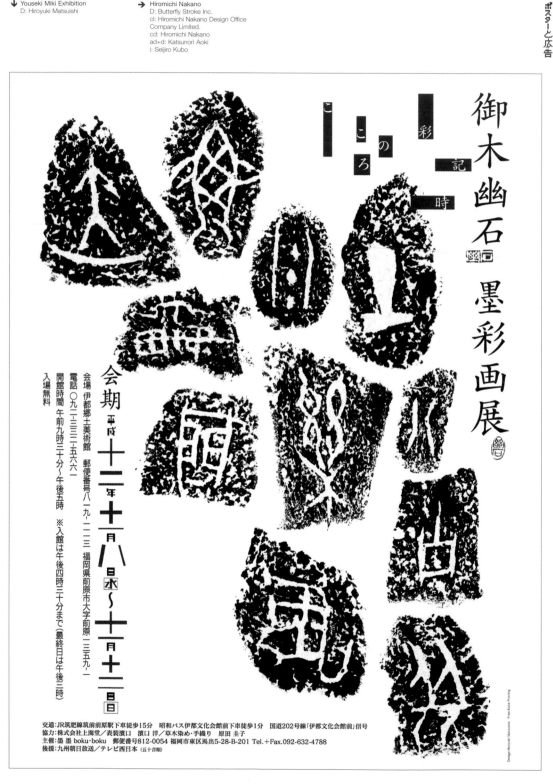

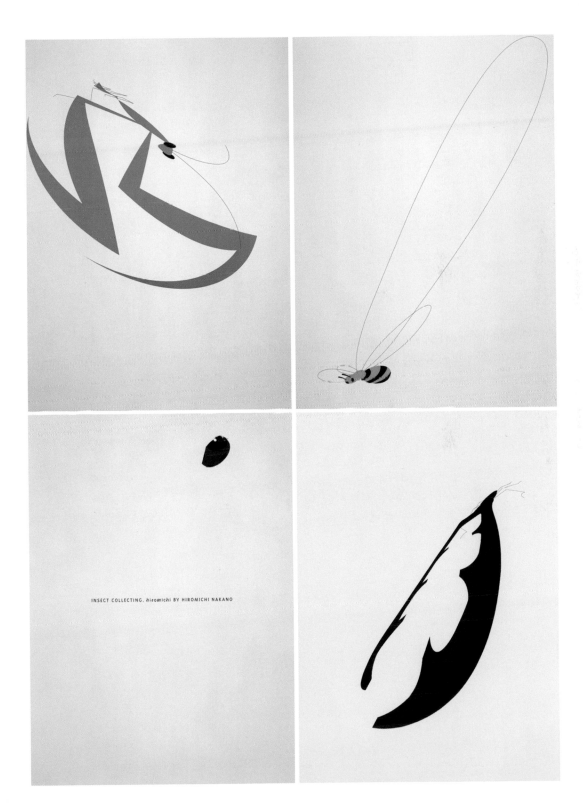

INSECT COLLECTING, *hiromichi* BY HIROMICHI NAKANO

↓ Osaka Aquarium Ring Of Fire
Striped Beakperch
D: Itakura Design Institute Inc.

→ Osaka Aquarium Ring Of Fire
Green Seaturtle
D: Itakura Design Institute Inc.

Osaka Aquarium Ring Of Fire
Longhorn Cowfish
D: Itakura Design Institute Inc.

Osaka Aquarium Ring Of Fire
Rockhopper Penguin
D: Itakura Design Institute Inc.

Osaka Aquarium Ring Of Fire
Jellyfish
D: Itakura Design Institute Inc.

172

ポスターと広告

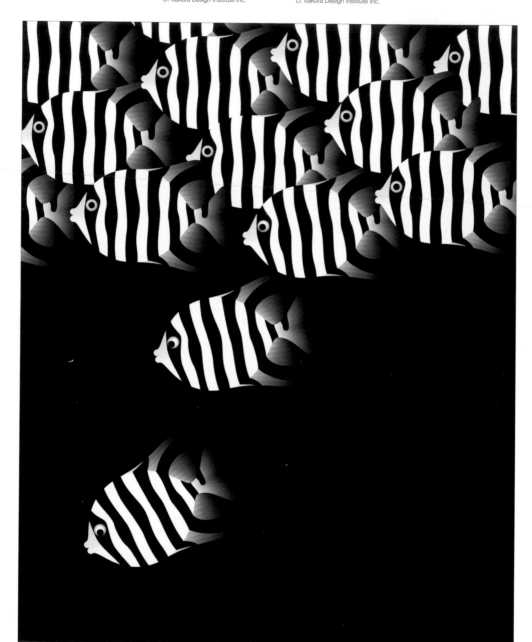

 「磯の王様」と呼ばれるくらい、磯釣りではなかなか釣れない魚の代表格。
イシダイは何故か幼魚の時にははっきりとした7本の縞があり、シマダイとも呼ばれています。
成長につれてこの縞は徐々に薄くなり老成魚では無くなります。ところで、この縞模様縦縞と思いますか?
それとも横縞?一般的には縦縞に思えるのですが、魚の世界では横縞と呼んでいます。
頭を上にして縞模様を見るからなのです。それはよこしまな?と言わないでくださいね。
少しだまし絵風ですが、何に見えますか。皆さんで想像してくださいね。

 海遊館

地下鉄中央線 大阪港駅下車徒歩5分 大阪市港区海岸通1-1-10 TEL06-6576-5500-5501

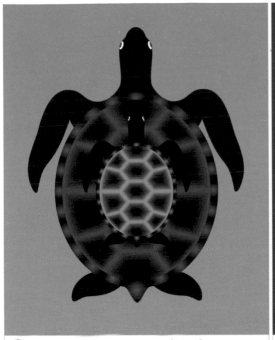

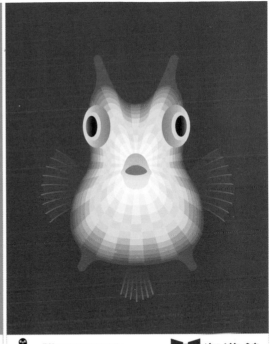

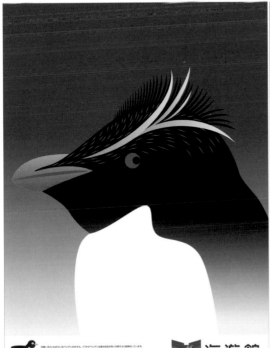

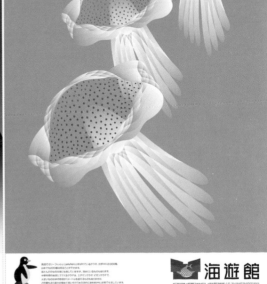

↓ Mix Nuts [CD poster]
D: Minato Ishikawa

→ 3D Poster [Display]: Nissan Elgrand
D: Minato Ishikawa

ポスターと広告

174

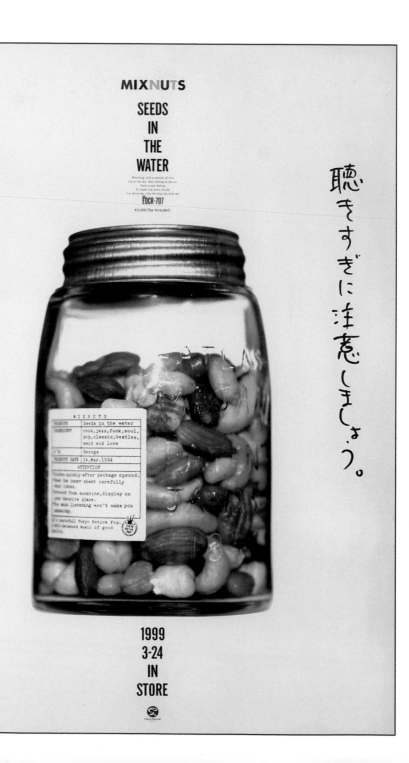

EXPLORATION

NATURE DYNAMISM

STRONG DADDY

CONTINENTAL SCALE

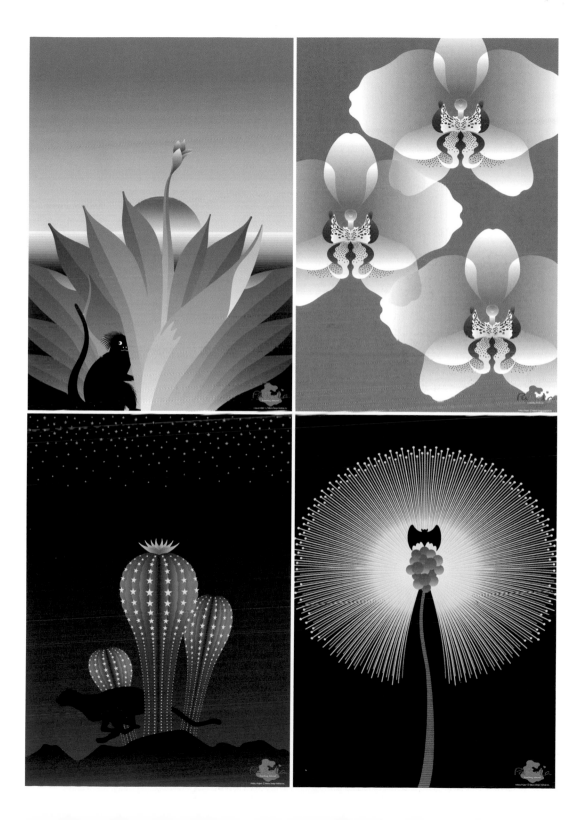

↓ Toyobo
D: Katachi

→ Toyobo
D: Katachi

ポスターと広告

178

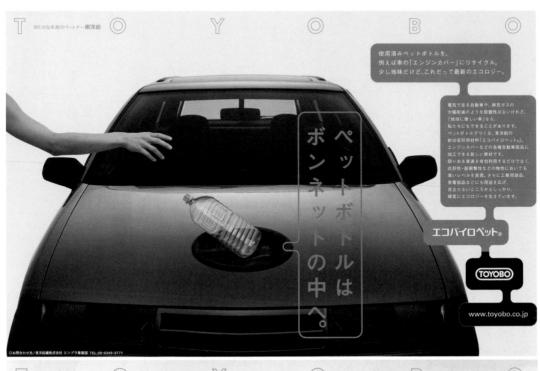

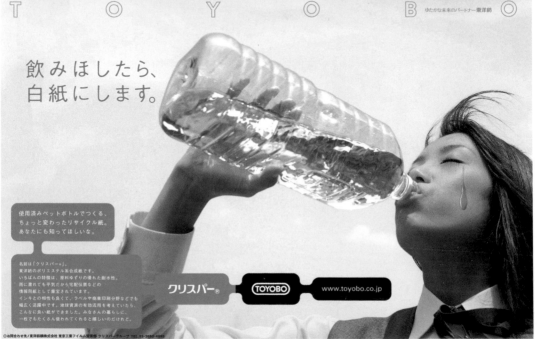

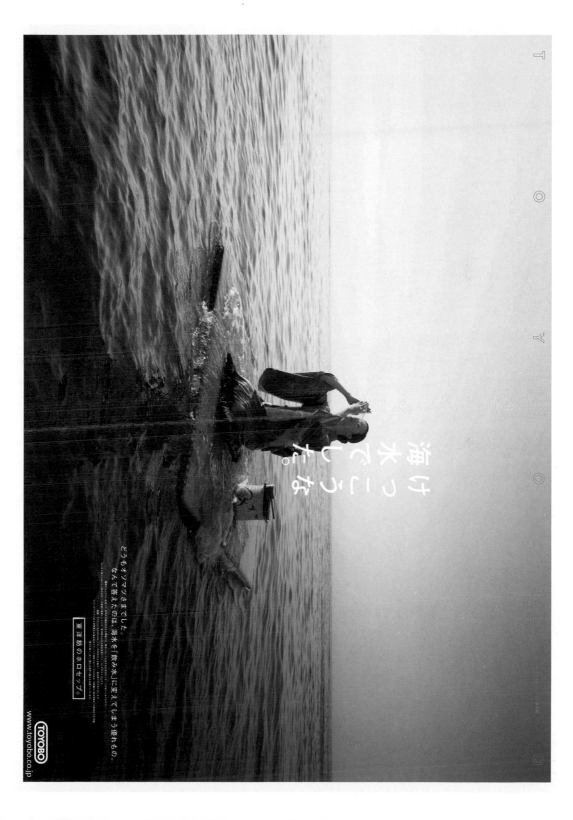

Toyobo
D: Katachi

Toyobo
D: Katachi

ポスターと広告

180

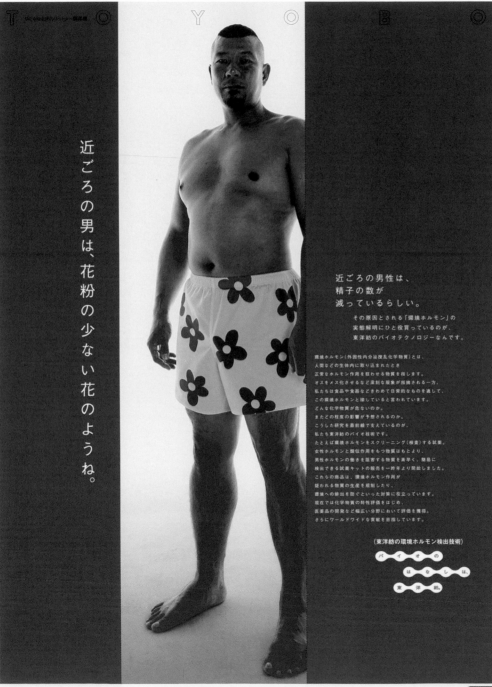

近ごろの男は、
花粉の少ない花のようね。

精液の様子が違っているらしい。その原因とされる
「環境ホルモン」の実態解明にひと役買っているのが、東洋紡の検出技術です。

（東洋紡の環境ホルモン検出技術）

TOYOBO www.toyobo.co.jp

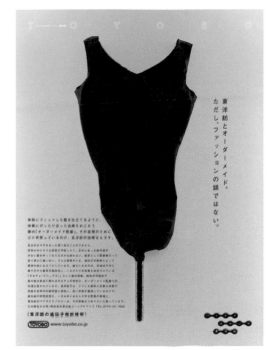

東洋紡とオーダーメイド。
ただし、ファッションの話ではない。

身体にフィットした服を仕立てるように、
身体にぴったり合った治療をおこなう
夢の「オーダーメイド医療」、その実現のために
ひと役買っているのが、東洋紡の技術なんです。

（東洋紡の遺伝子解析技術）

TOYOBO www.toyobo.co.jp

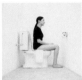
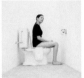
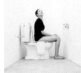
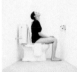

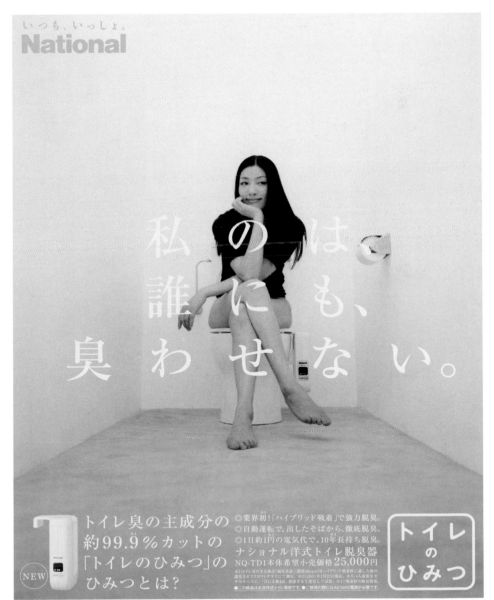

いつも、いっしょ。

National

私 の は 誰 に も、臭 わ せ な い。

トイレ臭の主成分の
約99.9％カットの
「トイレのひみつ」の
ひみつとは？

NEW

◎業界初！「ハイブリッド吸着」で強力脱臭。
◎自動運転で、出したそばから、徹底脱臭。
◎1日約1円の電気代で、10年長持ち脱臭。
ナショナル洋式トイレ脱臭器
NQ-TD1本体希望小売価格 **25,000円**

トイレ
の
ひみつ

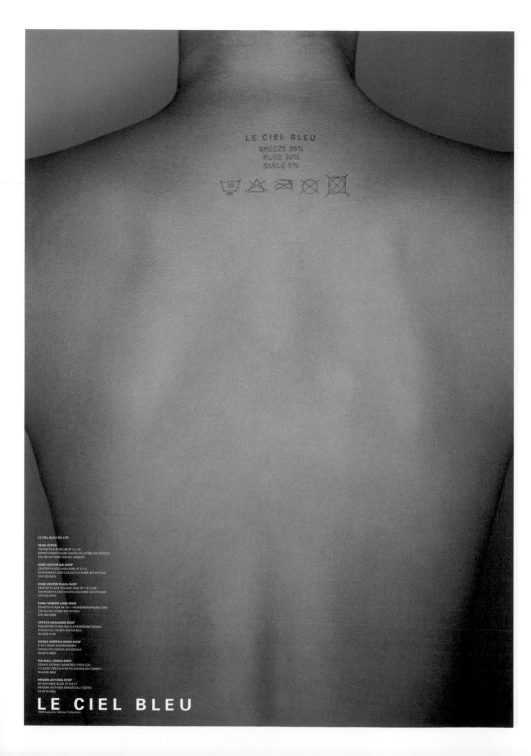

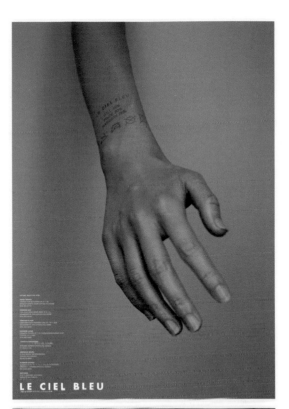

LE CIEL BLEU

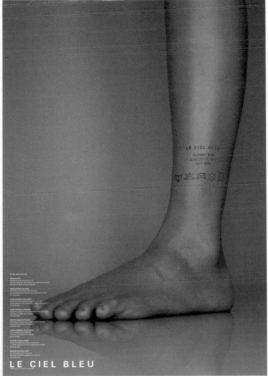

LE CIEL BLEU

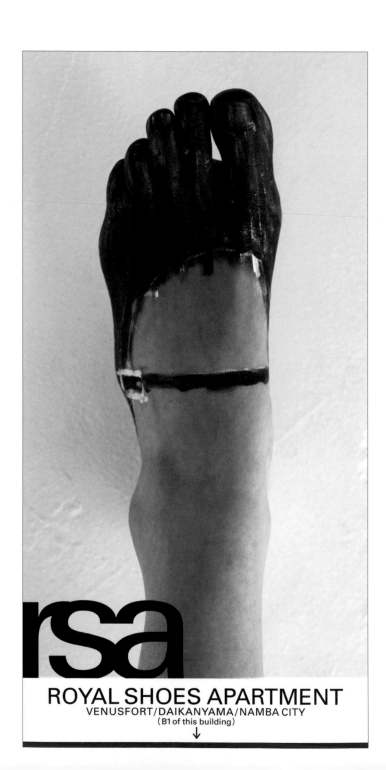

ROYAL SHOES APARTMENT
VENUSFORT/DAIKANYAMA/NAMBA CITY
（B1 of this building）
↓

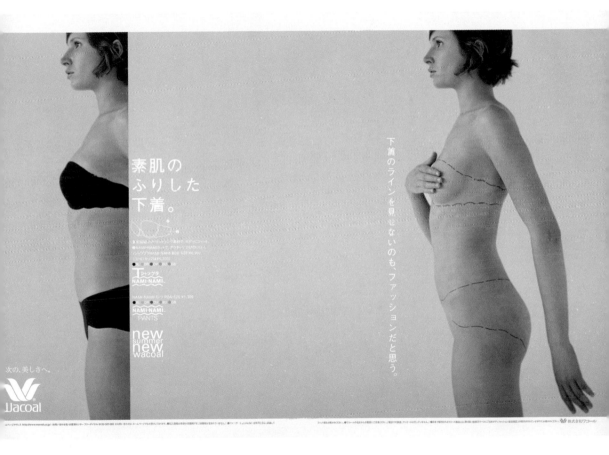

↓ Gekkeikan
D: Katachi

→ Wakayama Sightseeing Association
D: Katachi

188

ポスターと広告

お酒は20歳になってから。お酒はおいしく適量を。

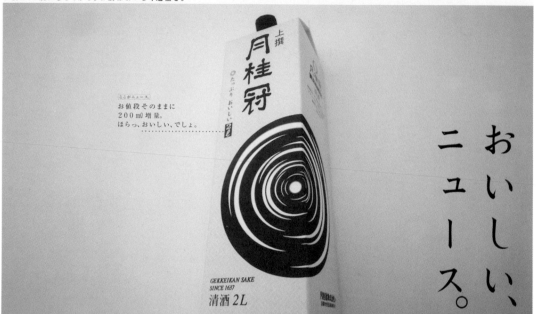

月桂冠上撰さけパック2L誕生。月桂冠上撰さけパック2L 1,816円 ※価格はメーカー希望小売価格（消費税別）○お問い合わせは、お客様相談室TEL.075-623-2040（9:00～17:00平日のみ）○インターネットホームページアドレス http://www.gekkeikan.co.jp　月桂冠株式会社

お酒は20歳になってから。お酒はおいしく適量を。

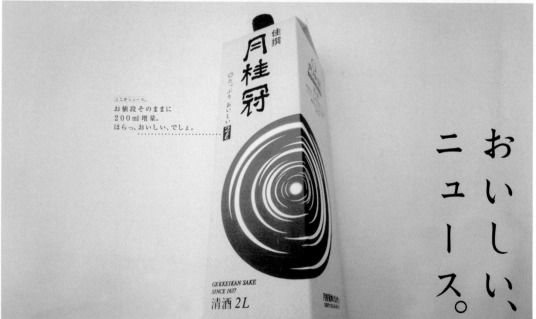

月桂冠佳撰グリーンパック2L誕生。月桂冠佳撰グリーンパック2L 1,573円 ※価格はメーカー希望小売価格（消費税別）○お問い合わせは、お客様相談室TEL.075-623-2040（9:00～17:00平日のみ）○インターネットホームページアドレス http://www.gekkeikan.co.jp　月桂冠株式会社

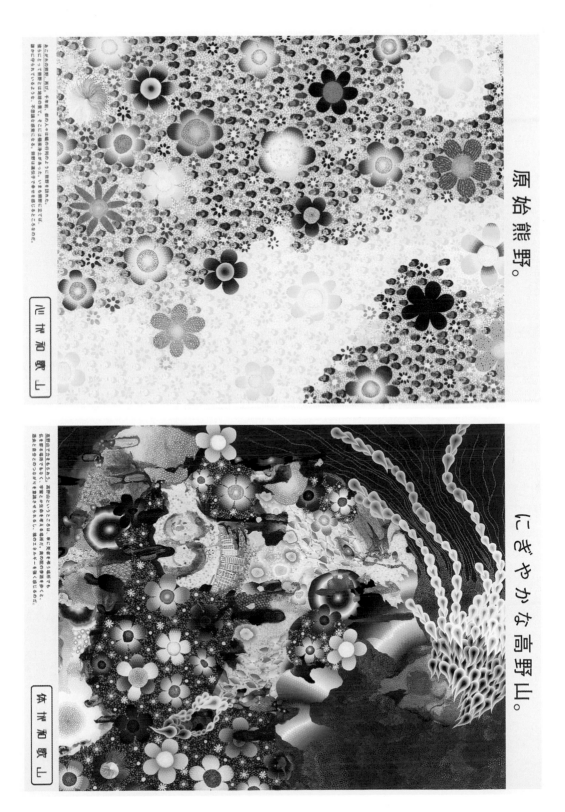

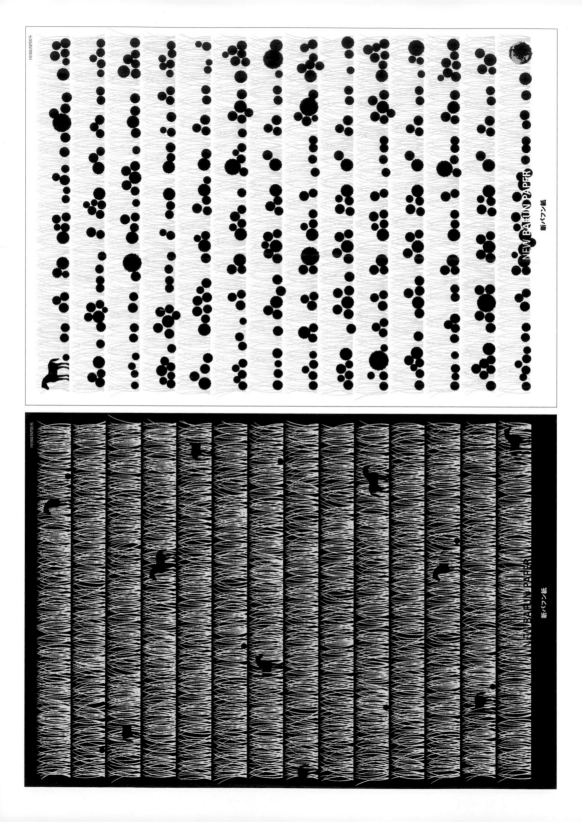

↓ Heiwa's Peace
D: Ken Miki & Associates

→ Heiwa's Peace
D: Ken Miki & Associates

ポスターと広告

192

HEIWA's PEACE

HEIWA's PEACE

HEIWA's PEACE

HEIWA's PEACE

HEIWA's PEACE

↓ Suntory Collection
 D: Ken Miki & Associates

→ Suntory Collection
 D: Ken Miki & Associates

ポスターと広告

196

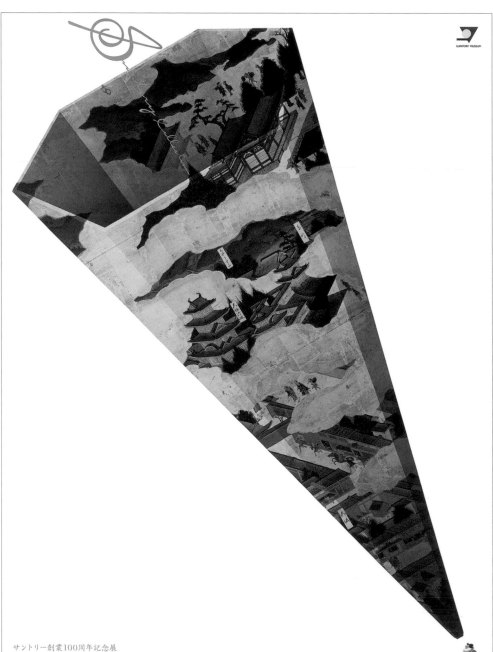

サントリー創業100周年記念展
サントリーコレクション−夢回廊
LIFE AND BEAUTY FROM JAPAN AND THE WEST
日本の生活美と西洋絵画・印象派から現代まで

会期／1999年11月20日（土）−2000年1月16日（日）　会場／サントリーミュージアム［天保山］ギャラリー

開館時間／10:30-19:30(最終入場は19:00まで)　入場料／大人1000円(900円)　高・大学生700円(630円)　小・中学生400円(360円)　()は前売入場券です。チケットぴあ、ローソンチケット、CNプレイガイドで発売しております。
休館日／毎週月曜日及び12月31日(11月22日、2000年1月3日・10日は開館いたします)　主催／サントリーミュージアム［天保山］、サントリー美術館　〒552-0022 大阪市港区海岸通1-3-10 Telephone 06-6577-0001　http://www.suntory.co.jp/culture/smt/

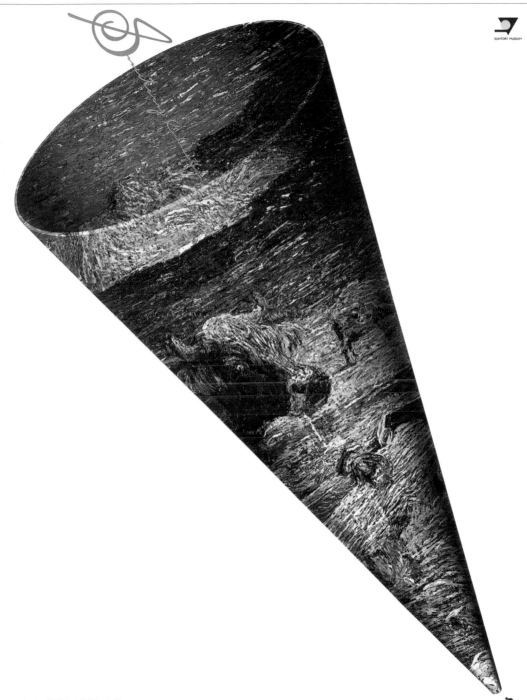

サントリー創業100周年記念展

サントリーコレクション — 夢回廊　LIFE AND BEAUTY FROM JAPAN AND THE WEST
日本の生活美と西洋絵画・印象派から現代まで

会期／1999年11月20日(土)—2000年1月16日(日)　会場／サントリーミュージアム［天保山］ギャラリー

開催時間／10:30-19:30(最終入場は19:00まで)　入場料／大人1000円(900円)　高・大学生700円(630円)　小・中学生400円(360円)　()は前売入場券です。チケットぴあ、ローソンチケット、CNプレイガイドで発売しております。

休館日／毎週月曜日及び12月31日(11月22日、2000年1月3日・10日は開館いたします)　主催／サントリーミュージアム［天保山］、サントリー美術館　〒552-0022 大阪市港区海岸通1-5-10 Telephone 06-6577-0001 http://www.suntory.co.jp/culture/smt/

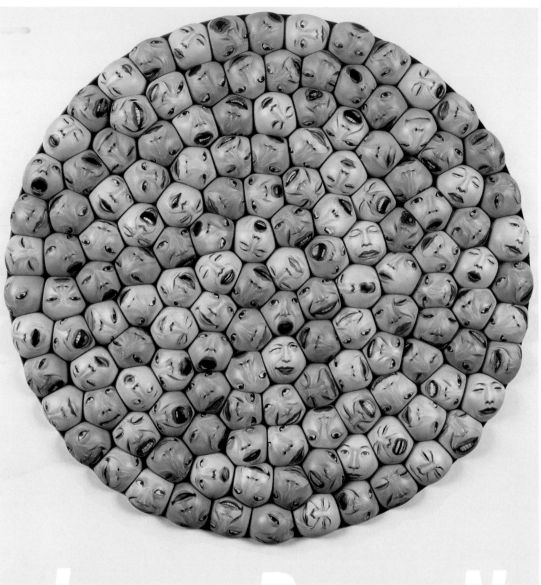

JPN
2001

ポスターと広告

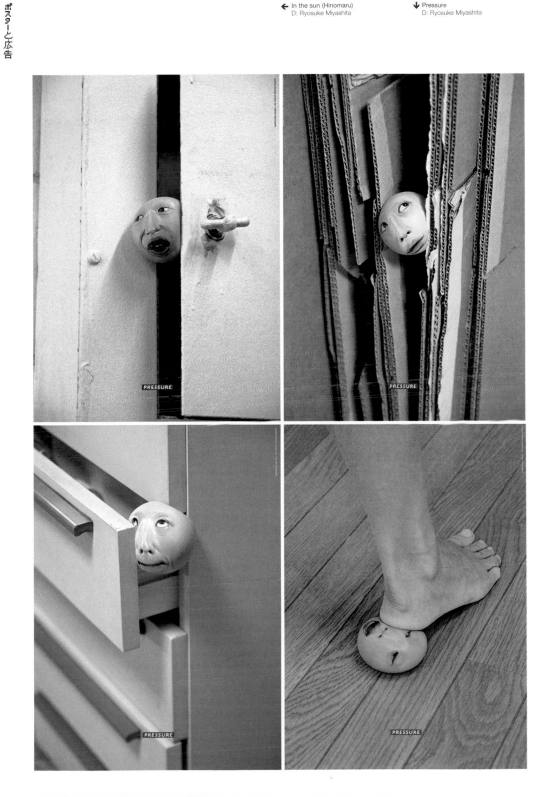

ISSEY MIYAKE

← Issey Miyake 2000 Autumn/Winter
D: Hideki Nakajima

↓ Via Bus Stop 2003 Spring/Summer
D: Hideki Nakajima

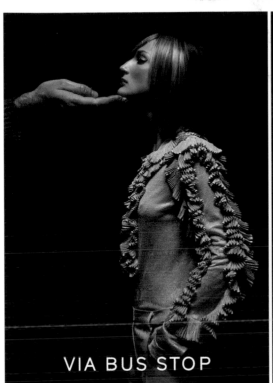

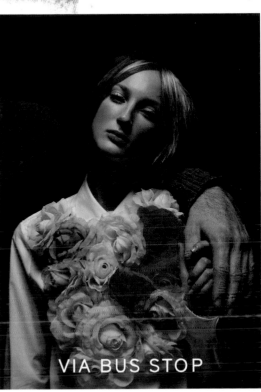

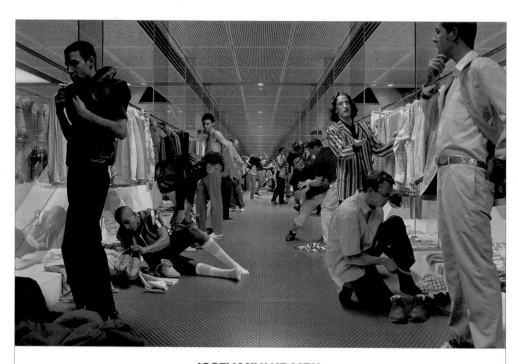

ISSEY MIYAKE MEN

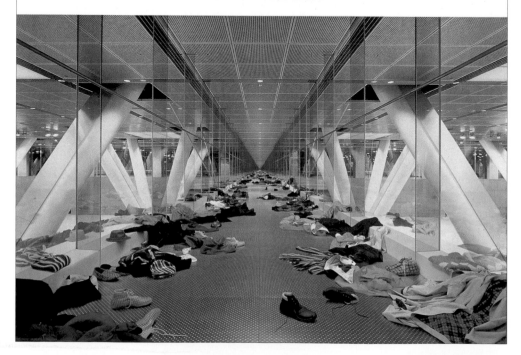

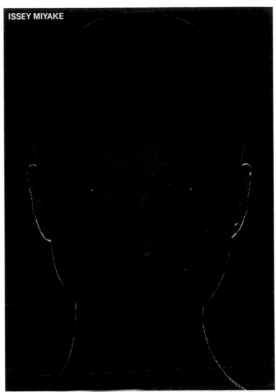

ISSEY MIYAKE

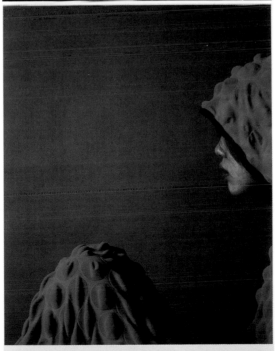

ISSEY MIYAKE

↓ S/N
D: Hideki Nakajima

→ I Love Japan
D: MooN Project

ポスターと広告

204

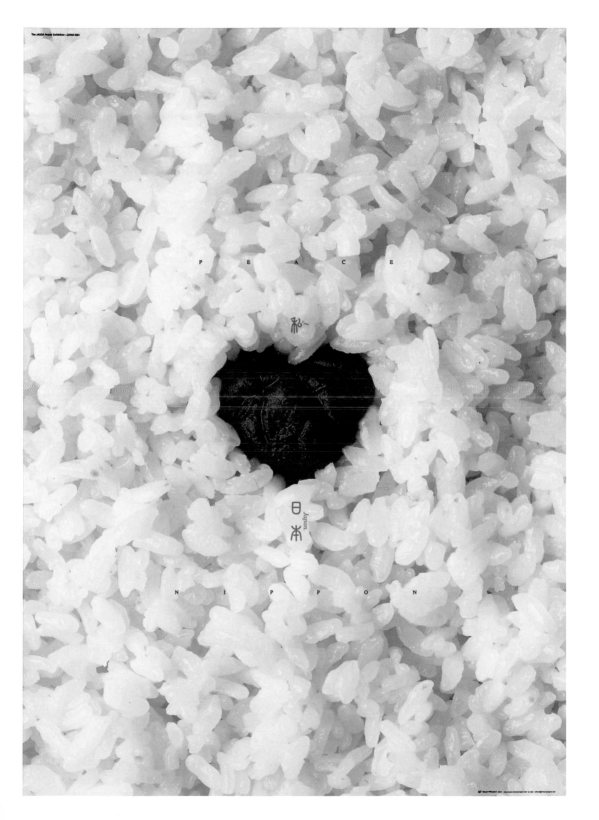

↓ Sony Music Art Audition
Sony Music Entertainment Inc.
D: Norio Nakamura

→ Close-Up of Japan in São Paulo
D: Norio Nakamura

Toy "Pootiki"
Cube Co., Ltd (c)anchovy2000
D: Norio Nakamura

206 ポスターと広告

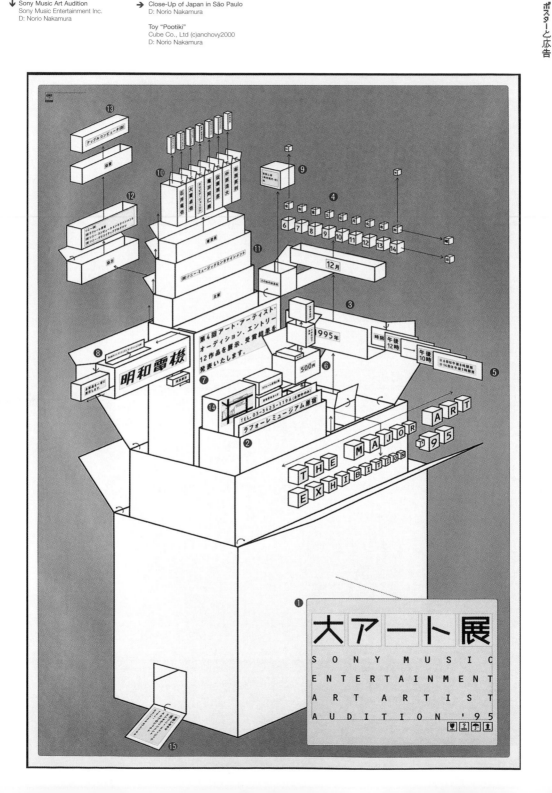

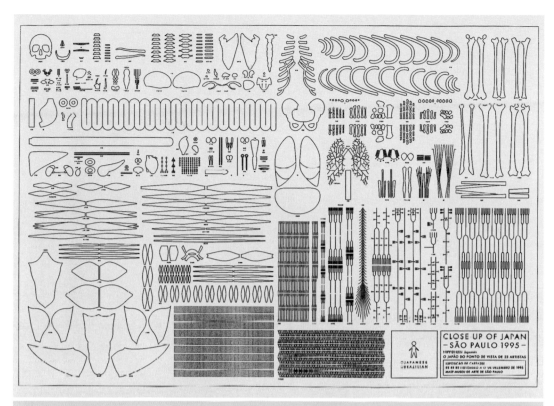

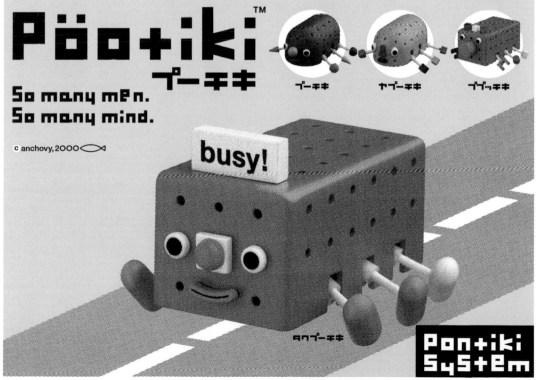

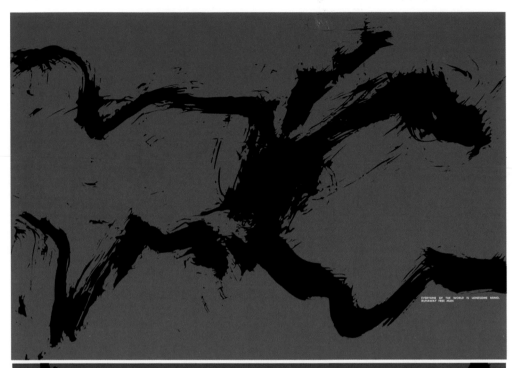

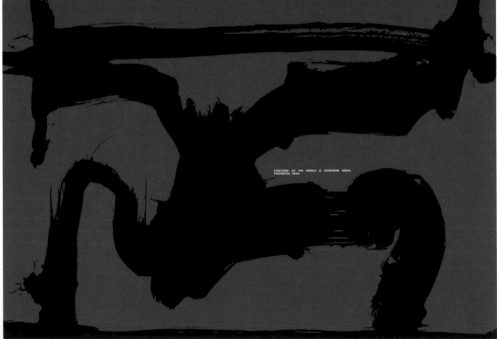

↓ HELP vol.1
D: Koshi Ogawa

HELP vol.2
D: Koshi Ogawa

Why!
D: Koshi Ogawa

Is that the earth where you are?
D: Koshi Ogawa

ポスターと広告

210

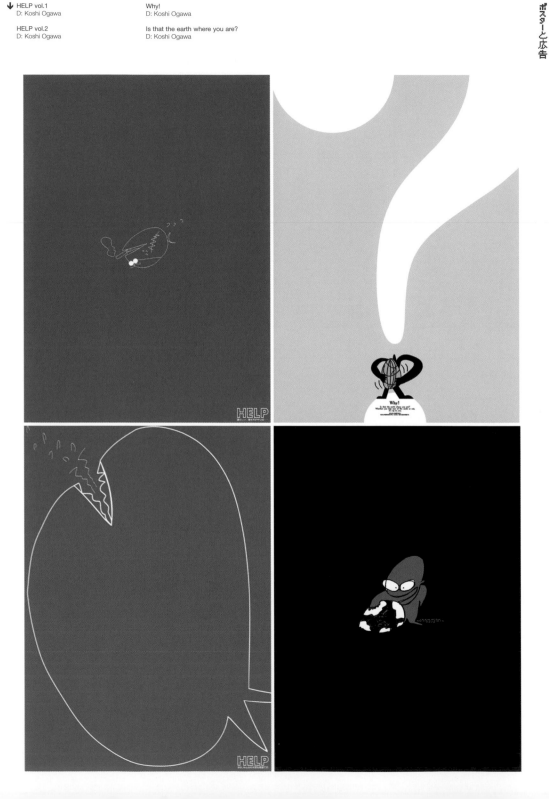

The 3th Enshu Yokosuka-kaido
Cultural Exhibition
D: Koshi Ogawa

Froid
D: Koshi Ogawa

Kyizin butik UN vol.2
D: Koshi Ogawa

Kyizin butik UN vol.1
D: Koshi Ogawa

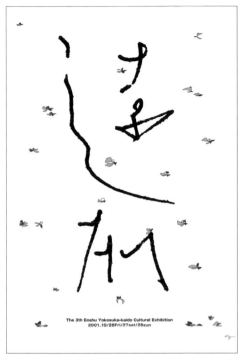

ア の連続

芸術と科学の
（アート）（サイエンス）
交差点

欲 「アート界の新庄」が 3人 しい！！

芸術筋を 鍛える アスレチックジム

↓ Okumura Akio Match
D: Akio Okumura

Kyoto University Of Art
D: Akio Okumura

Oji Paper Gallery Ginza
D: Akio Okumura

Kyoto University Of Art
D: Akio Okumura

⬇ Make yourself comfortable
D: Rocketdesign

➔ Rain Boys
D: Rocketdesign

Manmanman
D: Rocketdesign

ポスターと広告　214

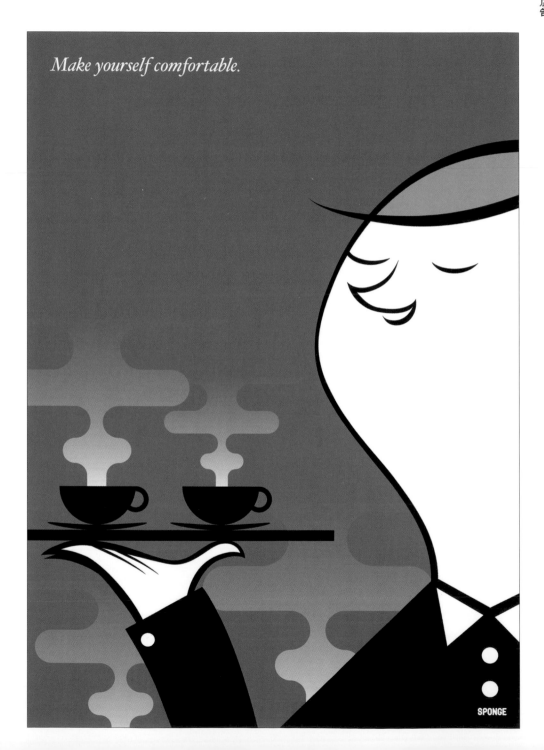

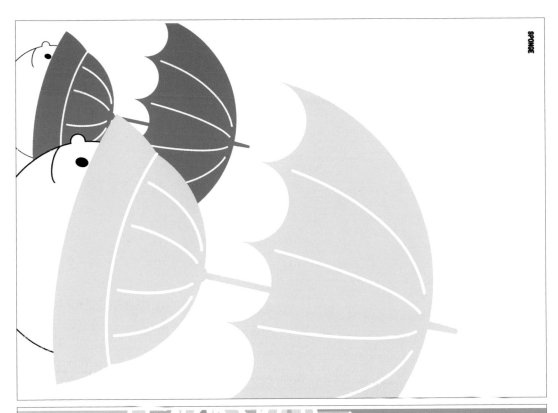

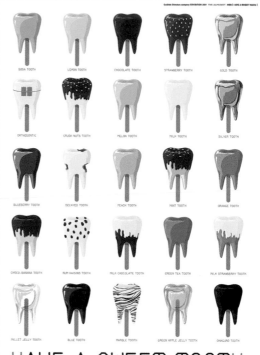

HAVE A SWEET TOOTH

← Poster O / Poster P / Poster H / Poster Y
D: Osamu Sato /
Outside Directors Company Ltd.
ad+d: Osamu Sato
d: Shintaro Minami
cg: Noboru Iizuka
c: Hiroko Nishikawa

↓ Poster for Tokyo Academy
of Hairdressing and Beauty
D: Osamu Sato /
Outside Directors Company Ltd.
ad+d: Osamu Sato
d: Shintaro Minami
cg: Noboru Iizukac and Hiroko Nishikawa

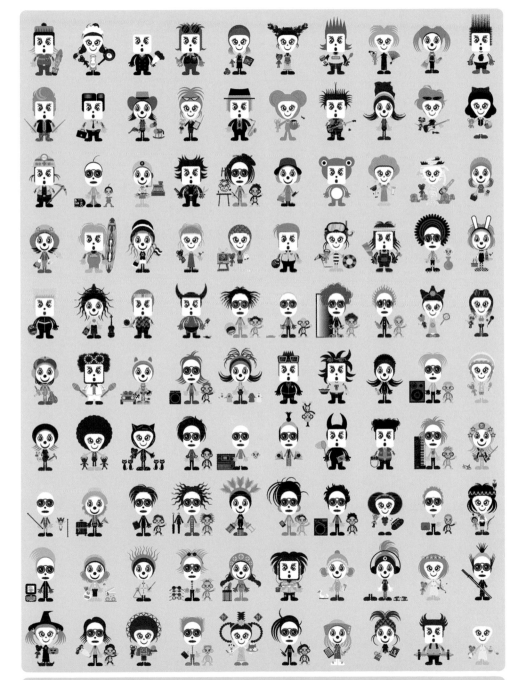

学 校 法 人
田中芸術学園 東京美容専門学校 TOKYO ACADEMY OF HAIRDRESSING & BEAUTY
〒161-8557 東京都新宿区下落合1-2-4 ☎ 0120-344276 http://www.tahb.ac.jp/

↓ Honda Motor's Step Wgn Whitee!
"Dinosaur"

Honda Motor's Step Wgn Whitee! "Fish"

Honda Motor's Step Wgn Deluxee!
"Robot"
D: Samurai

→ Honda Motor's Step Wgn Launching
Champaign "Where shall we go with the
kids?"

Honda Motor's Step Wgn "Woolen
Yarn"
D: Samurai

218

ポスターと広告

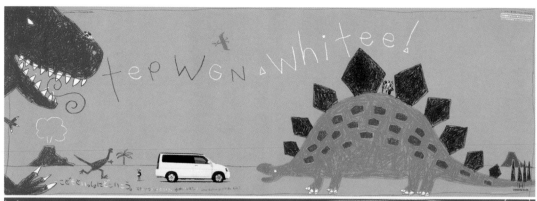

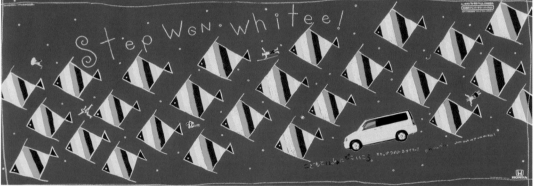

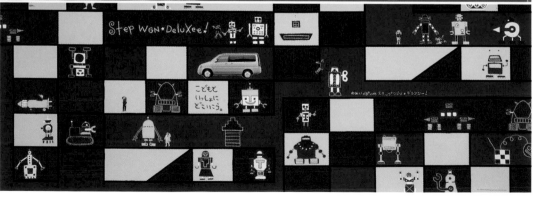

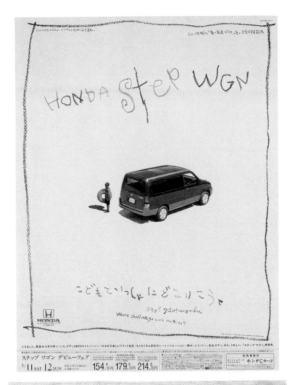

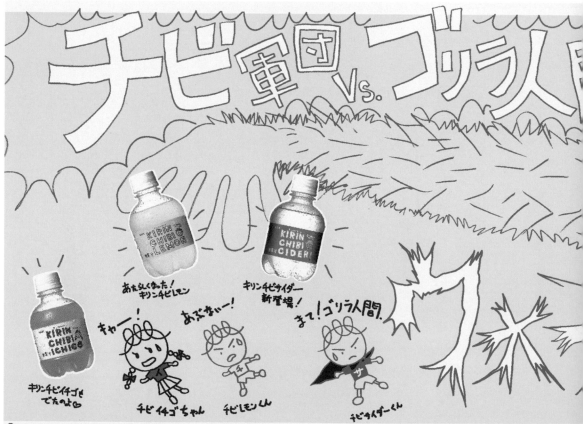

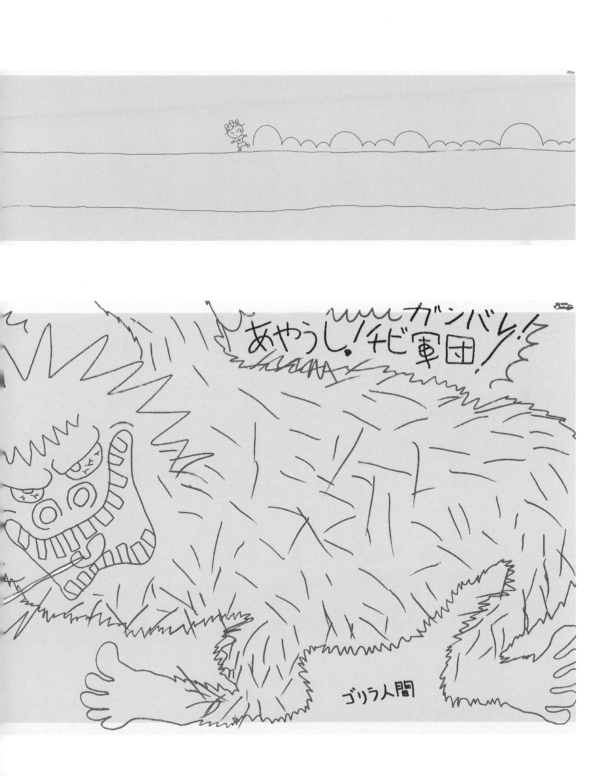

海の魚は、森に育てられる。

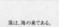

藻は、海の巣である。

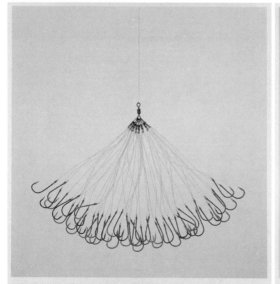

魚の子孫までが、獲られている。

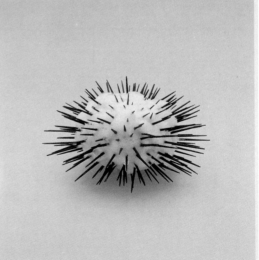

きれいにする洗剤が、海を汚している。

Sea Fishes are nurtured by the forest
D: Norito Shinmura
ad: Norito Shinmura c: Motoharu Sakata
p: Teiichi Ogata adv: Yamaguchi Fisherics Cooperative
Associations

Catching fishes even their posterity
ad: Norito Shinmura
c: Masakazu Nifuji p: Ko Hosokawa
adv: Yamaguchi Fisheries Cooperative Associations

The seaweed is a nest of the sea
D: Norito Shinmura
au: Norito Shinmura
c: Masakazu Nifuji p: Ko Hosokawa
adv: Yamaguchi Fisheries Cooperative Associations

The cleanser which makes things clean pollutes the sea
ad: Norito Shinmura
c: Masakazu Nifuji p: Ko Hosokawa
adv: Yamaguchi Fisheries Cooperative Associations

Japan for Ecology
D: Norito Shinmura
ad: Norito Shinmura
c: Hiroshi Uehara
p: Kogo Inoue
adv: JAGDA

Be a Happy Camper
D: Norito Shinmura
ad: Norito Shinmura
c: Hiroyuki Nakazaki
p: Masahiro Soga
cl: MUJI

ポスターと広告

224

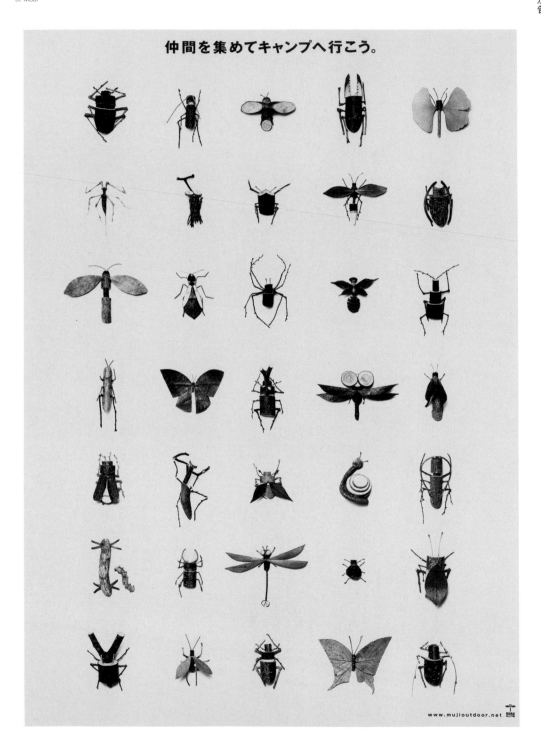

↓ Be a Happy Camper
D: Norito Shinmura
ad: Norito Shinmura
c: Hiroyuki Nakazaki
p: Kogo Inoue
cl: MUJI

自然の笑顔に逢いに行こう。

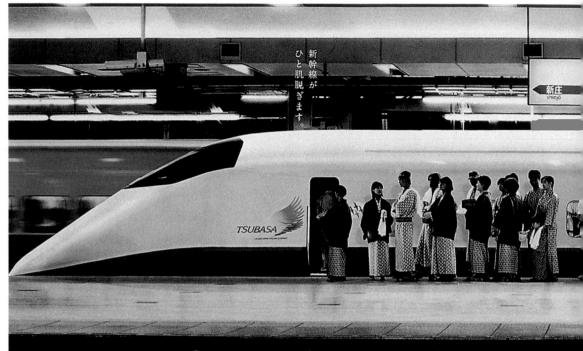

新庄
shinjo

新幹線が
ひと肌脱ぎます。

TSUBASA

♨ 温泉新幹線 12月

《お得なきっぷのご案内》 ◎東京庄内2WAY回数券 酒田〜鶴岡から都区内まで48,000円（1枚あたり12,000円）。羽越本線及上越新幹線の経路もご利用可能です。12月4日より発売・利用開始します。 ◎つばさ回数券（6枚

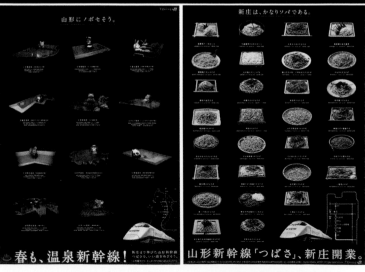

山形にノボセそう。

新庄は、かなりソバである。

春も、温泉新幹線！ 山形新幹線「つばさ」、新庄開業。

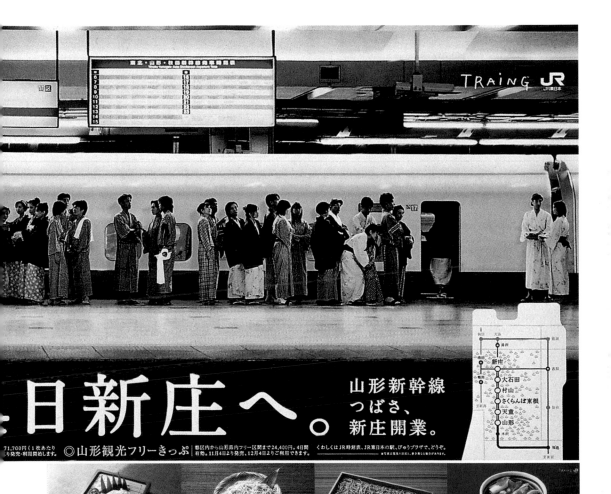

…日新庄へ。　山形新幹線
つばさ、
新庄開業。

71,700円（1枚あたり）◎山形観光フリーきっぷ　都区内から山形県内フリー区間まで24,400円。4日間　くわしくはJR時刻表、JR東日本の駅、びゅうプラザで、どうぞ。
り発売・利用開始します。　有効。11月4日より発売、12月4日よりご利用できます。

新庄は、かなりソバである。山形新幹線「つばさ」、12月4日新庄開業。

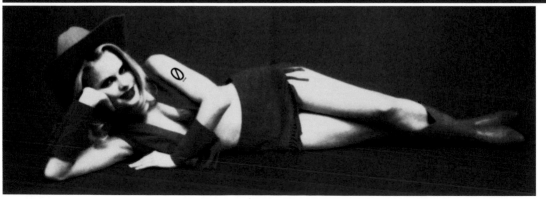

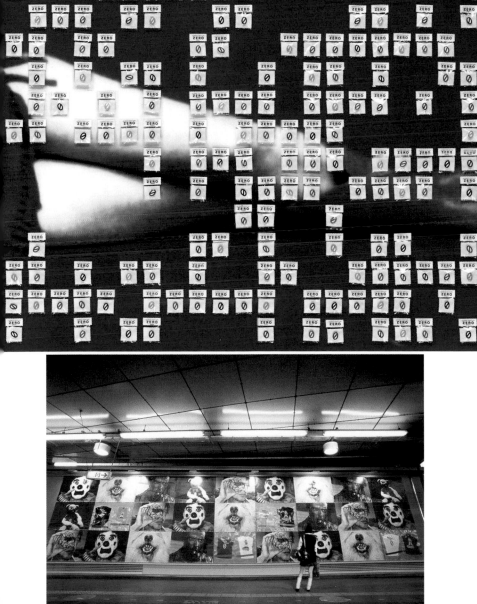

↓ Sega ch@b
D: TUGBOAT

→ JR East JR Snow
D: TUGBOAT

230

ポスターと広告

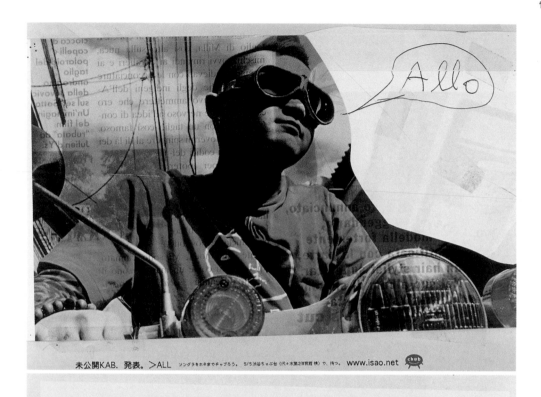

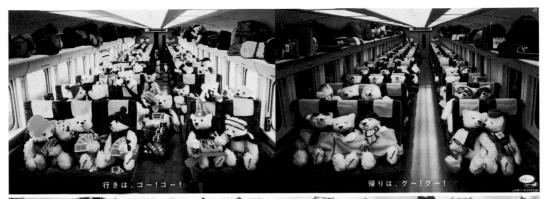

行きは、ゴー！ゴー！　　　　　　　　　帰りは、グー！グー！

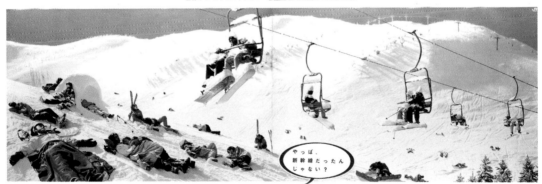

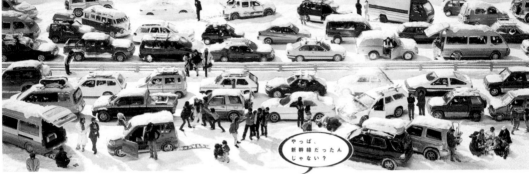

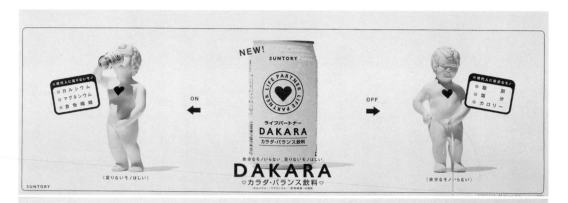

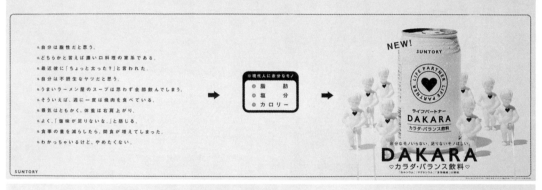

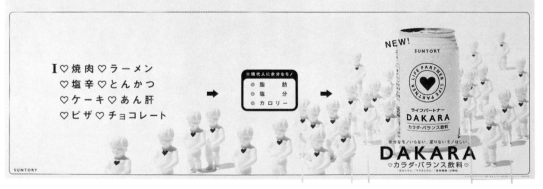

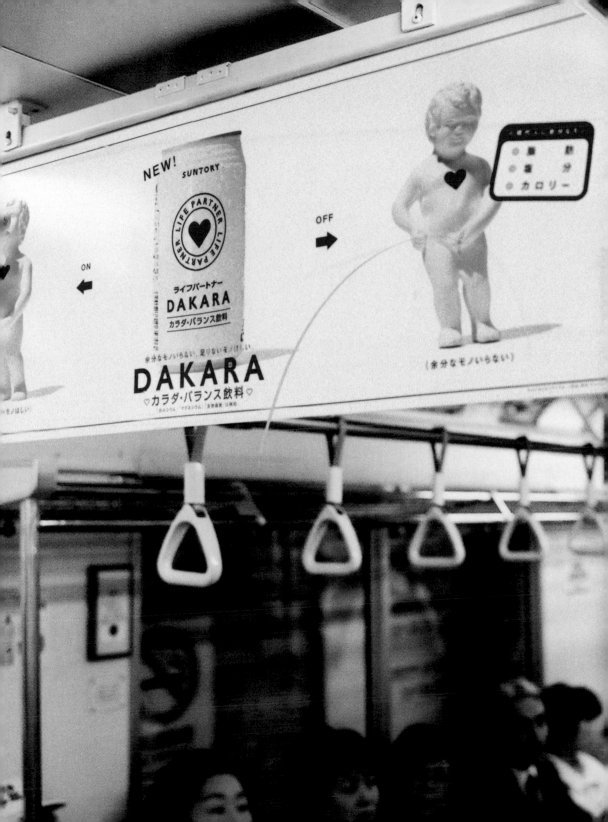

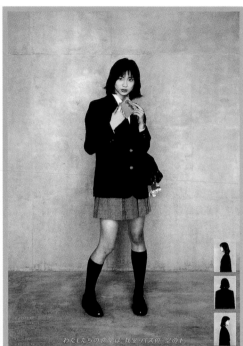

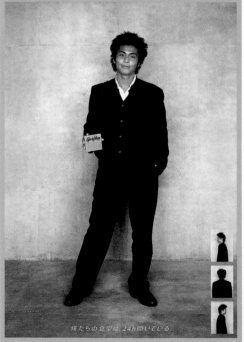

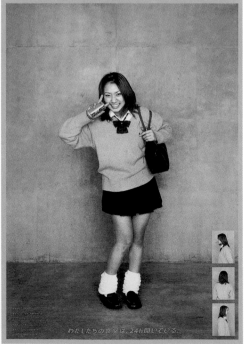

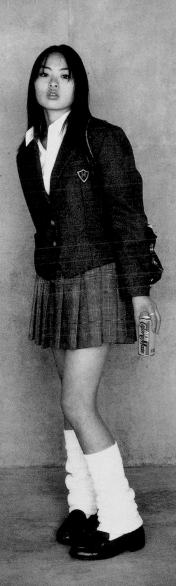

わたしたちの食堂は、24h開いている。

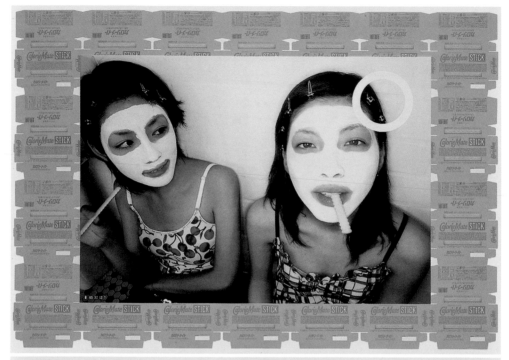

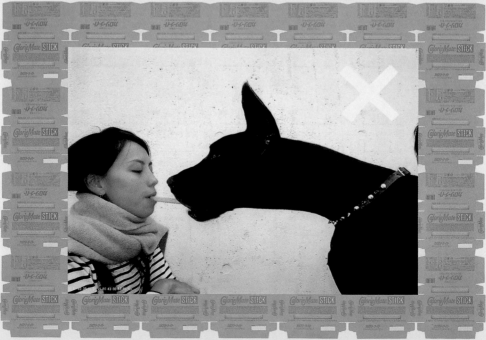

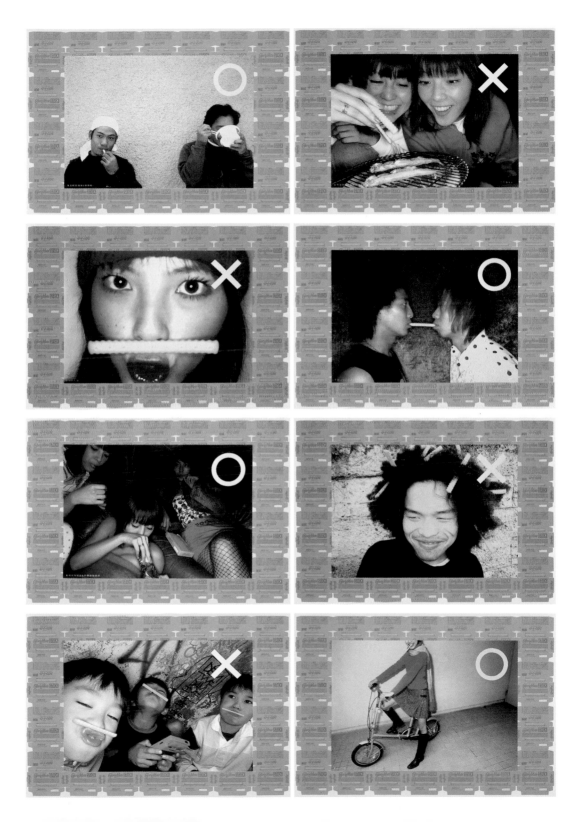

↓ Sega Dreamcast
D: TUGBOAT

→ Global warming
AD: Norito Shinmura
C: Hiroyuki Koyama
P: Ko Hosokawa
ADV: Mainichi News paper

ポスターと広告

238

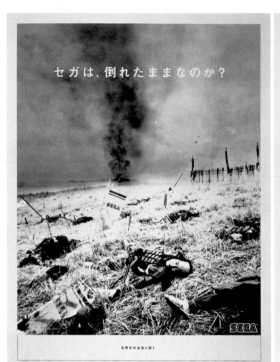

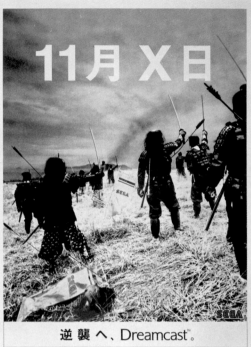

ほどの豊かさが本当に必要なのでしょうか？ 地球温暖化
がこのまま進むと、海水の膨張や氷河の融解により、21世
紀末には海面が15〜95cm上昇します。日本では、海面以下
の地域が2.7倍にひろがり、人口4□□万人が危険にさらされ

Franc franc DESIGN

The 10th anniversary presentation

Franc franc DESIGN

www.francfranc.com

Franc franc DESIGN

バカンスなんかに行かなくても楽しめるリゾートデザインが欲しい。 www.francfranc.com

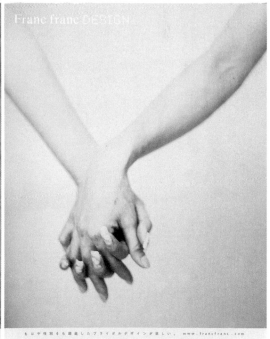

Franc franc DESIGN

もはや性別をも超越したブライダルデザインが欲しい。 www.francfranc.com

↓ Elementism, Multiple Square
D: Shinnoske Sugisaki

→ Elementism Crop Circle
D: Shinnoske Sugisaki

<<<98
D: Shinnoske Sugisaki

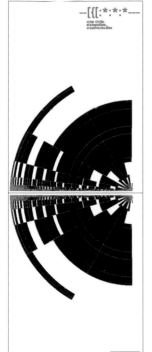

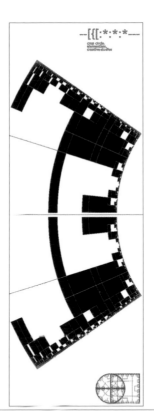

Live in Japan 2001

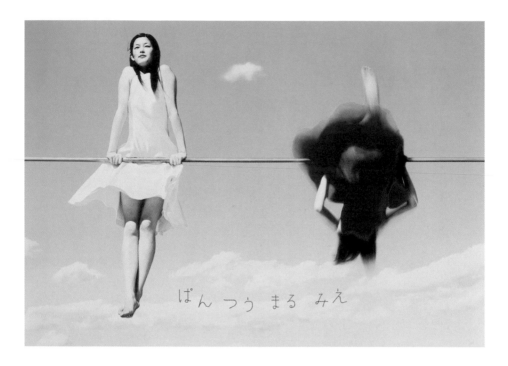

ぱ ん つ う ま る み え

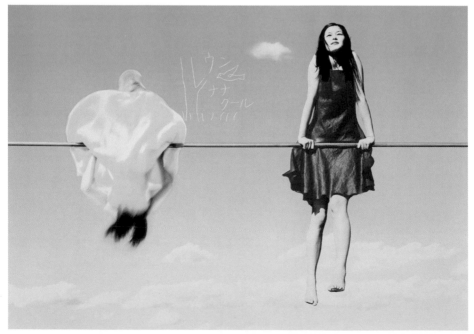

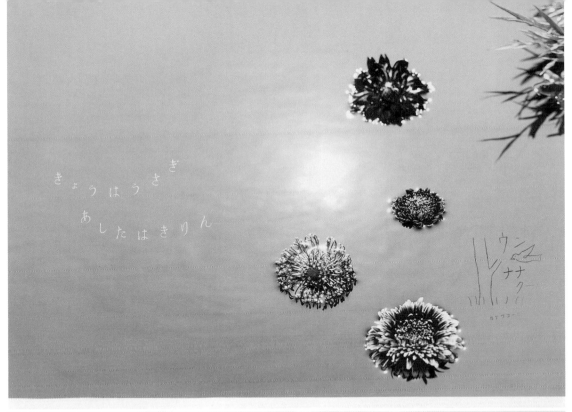

きょうはうさぎ
あしたはきりん

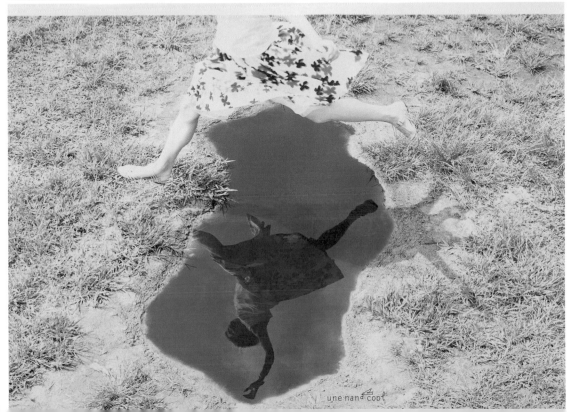

une nana cool

↓ Tamala 2010
Licensor : Kinetique Inc. Catty & Co. Division
d: t.o.L

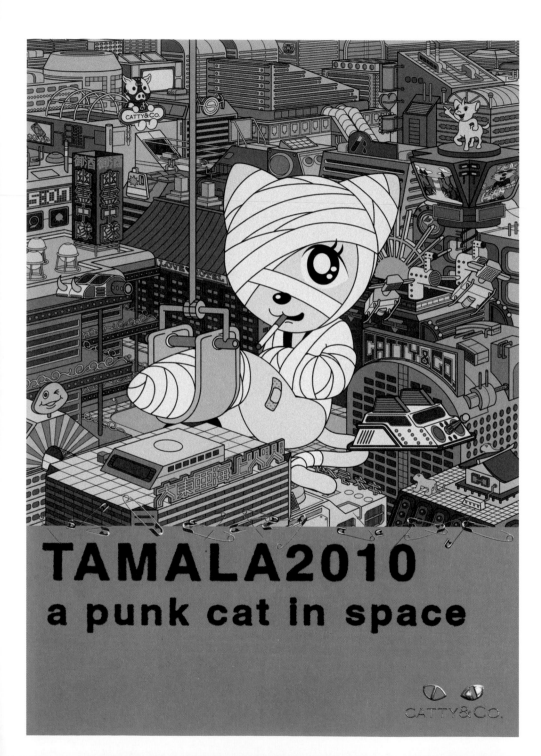

TAMALA 2010 A PUNK CAT IN SPACE

NEKO EARTH MEGURO-CITY supported by むねこちゃん and CATTY&CO.

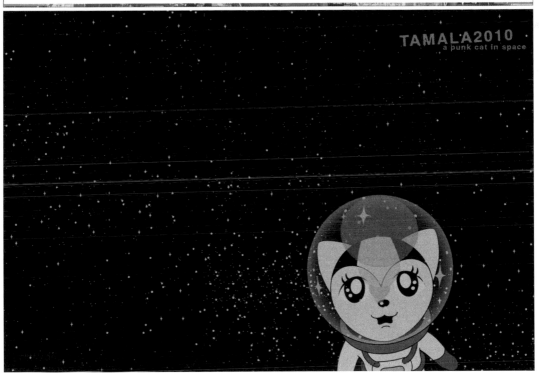

↓ Poster for competition
D: Toshihiro Watanabe

→ Save energy
D: U.G.Sato

Japanese Sake "Ippin"
D: U.G.Sato

Where can Japan go?
D: U.G.Sato

Visual communication
D: U.G.Sato

ポスターと広告

250

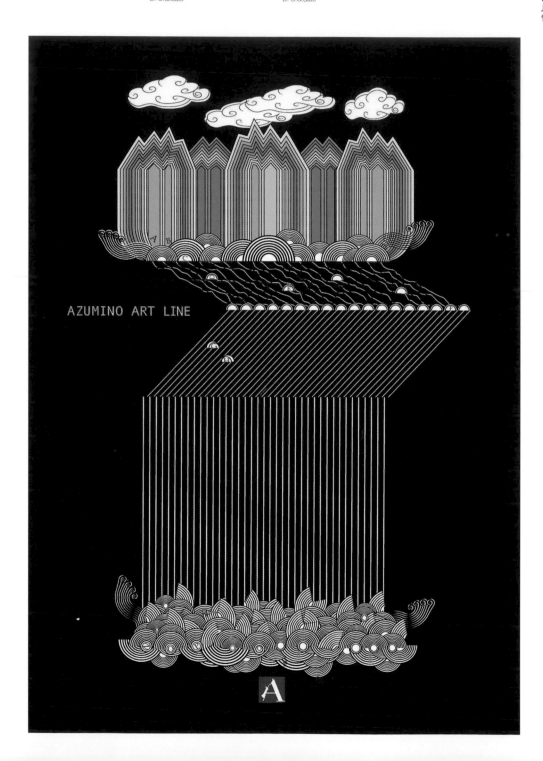

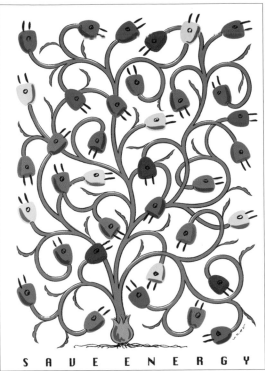

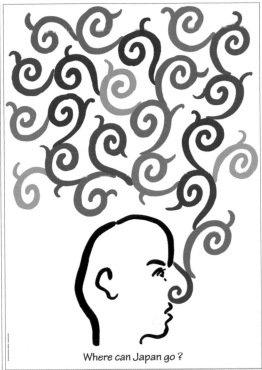

Where can Japan go ?

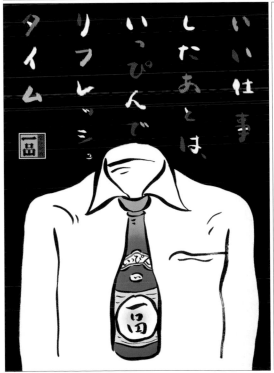

SAVE ENERGY

VISUAL COMMUNICATION

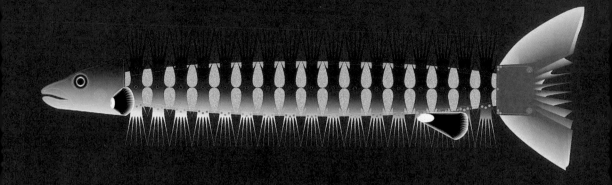

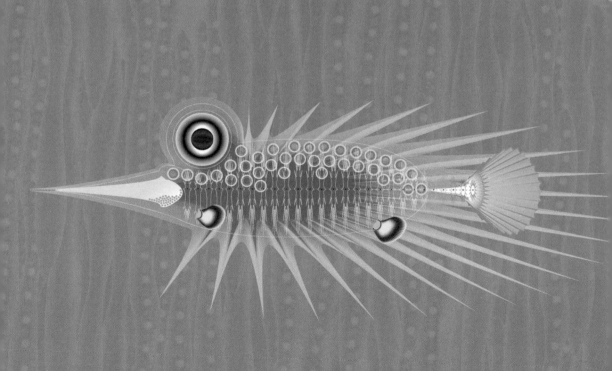

← Fish001

Fish005
D: Toshihiro Watanabe

↓ Jellyfish
D: Toshihiro Watanabe

Catfish
D: Toshihiro Watanabe

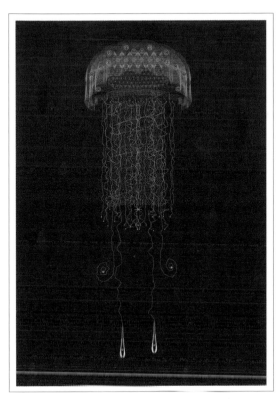

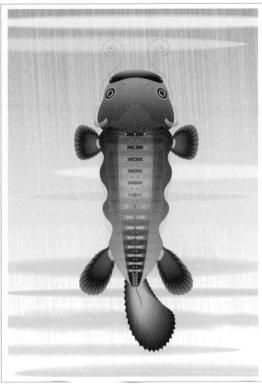

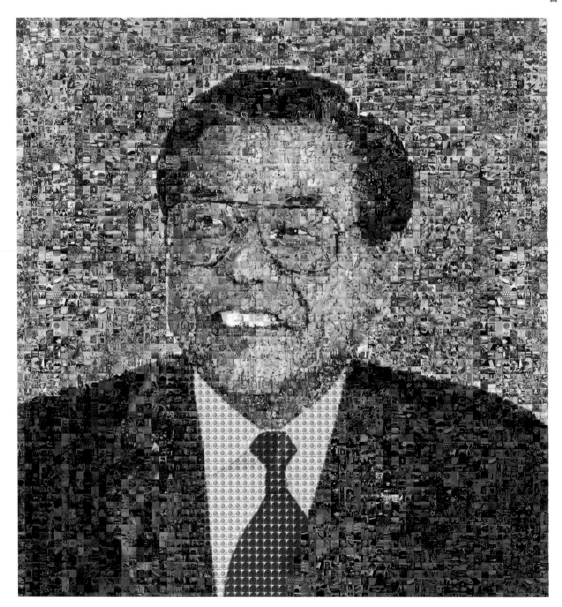

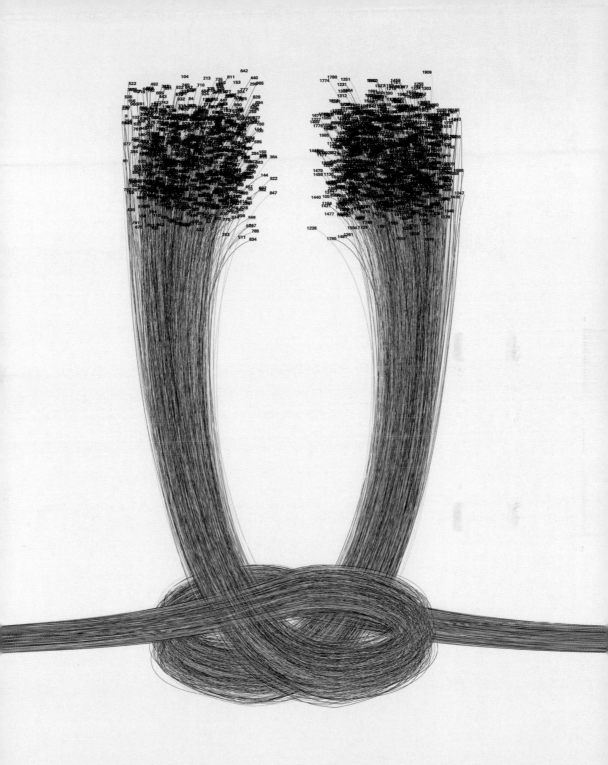

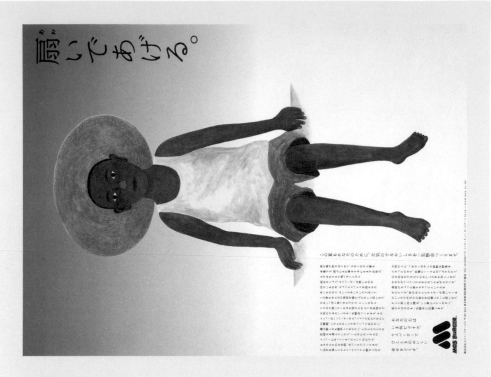

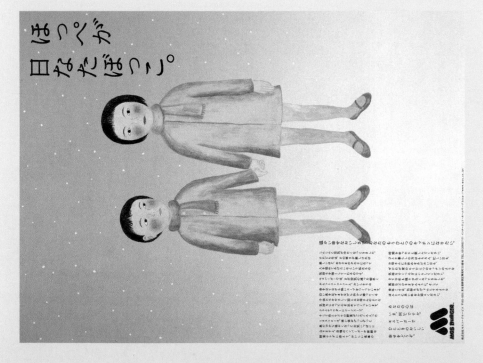

← Mos Burger Summer NP
 D: Yoshie Watanabe

↓ Caslon Quoits
 D: Yoshie Watanabe

Caslon Bamboo dragonfly
D: Yoshie Watanabe

Mos Burger Summer NP
D: Yoshie Watanabe

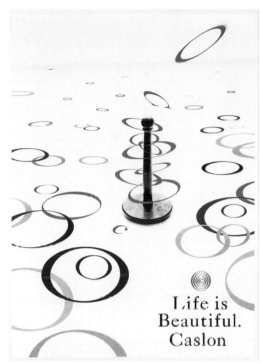

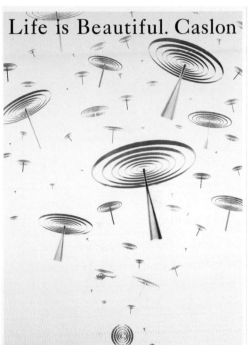

Act Now
D: Hakuhodo Inc.
cl: World Wide Fund for Nature Japan

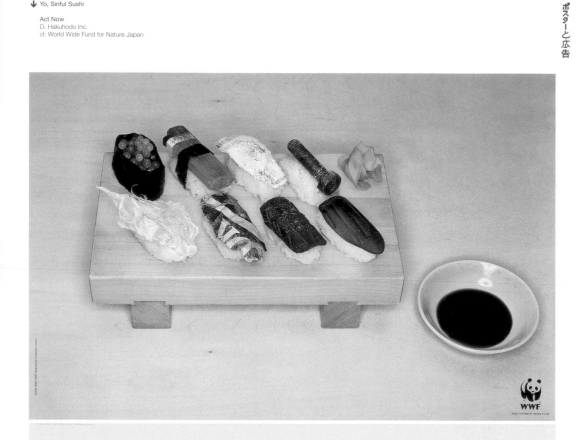

↓ Let's go to Toshimaen

Toshimaen Pool
D: Hakuhodo Inc.
cl: Toshimaen Co., Ltd

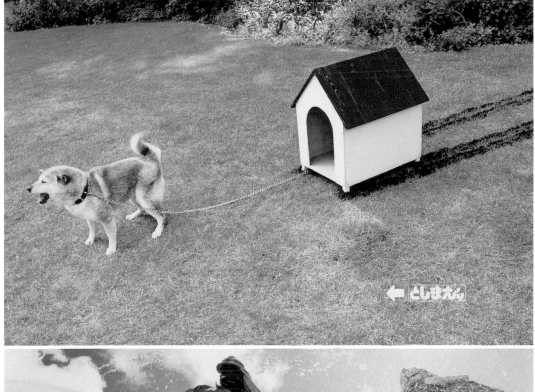

Toshimaen
Pool

↓ Insight (the economical car)
D: Hakuhodo Inc.
cl: Honda Motor Co., Ltd.

ポスターと広告

262

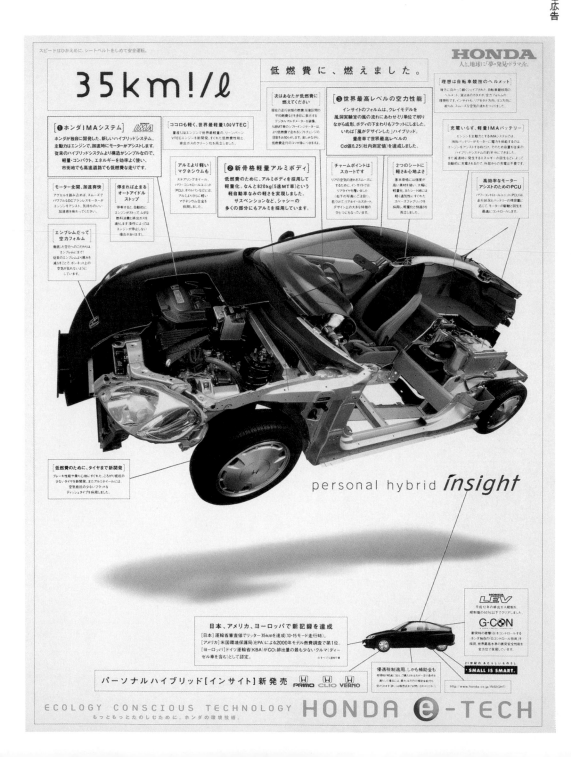

スピードはひかえめに、シートベルトをしめて安全運転。

人と、地球に「夢・発見・ドラマ」を。

35km!/ℓ

世界記録を、世界発売。

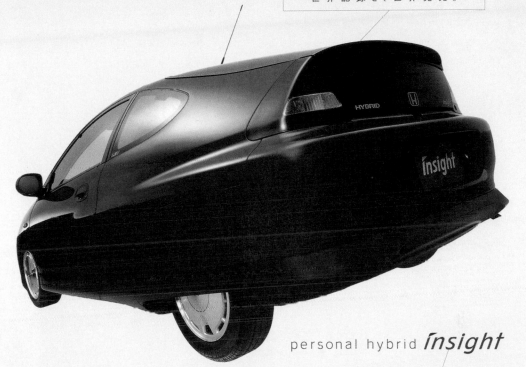

HYBRID

Ínsight

personal hybrid *Ínsight*

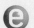

パーソナル ハイブリッド［インサイト］新発売

インサイトは、量産ガソリン車で世界一の低燃費リッター35km を達成（10・15モード、5速MT車）。アメリカ、ヨーロッパ、アジアでも順次発売。

ECOLOGY CONSCIOUS TECHNOLOGY **HONDA ⊖-TECH**

もっともっとたのしむために。ホンダの環境技術。

Let's Make a Baby, Now
D: Hakuhodo Inc.
cl: Takarajimasha Inc.

→ Ballon (Light Weight)

Breast (Safety)
D: Hakuhodo Inc.
cl: Japan Glass Bottle Association

ポスターと広告

264

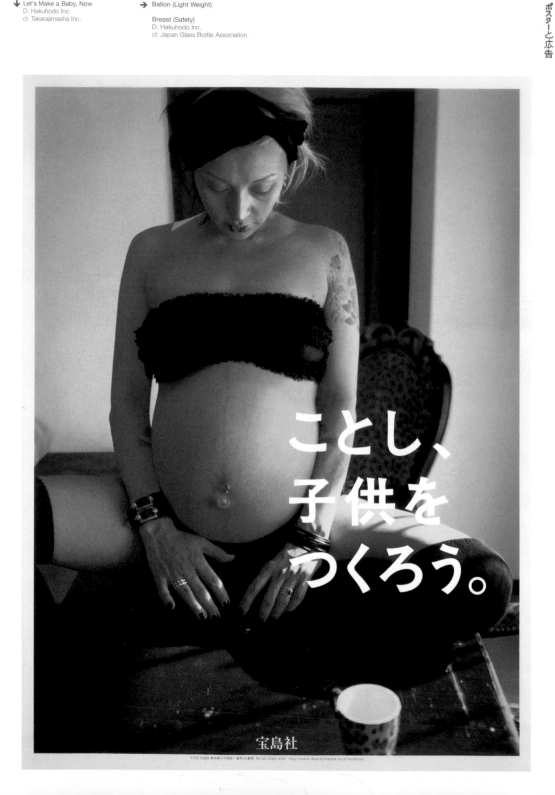

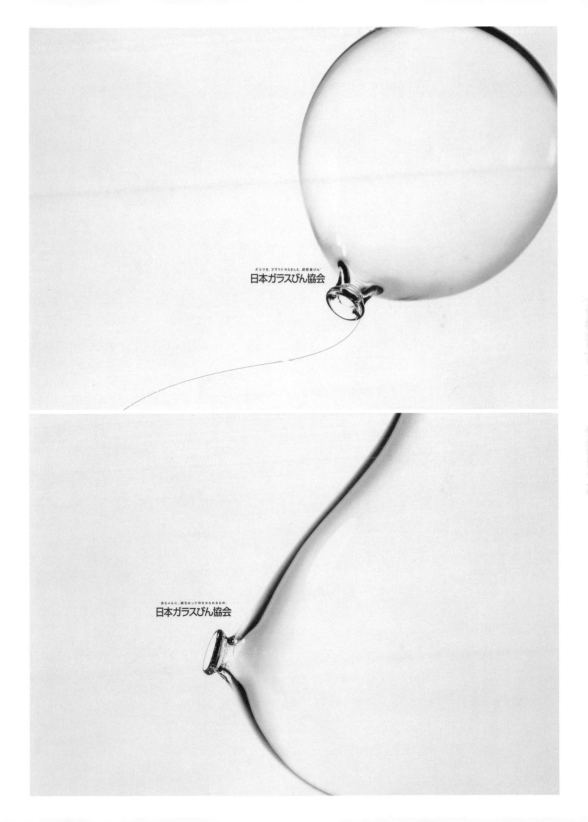

ズシリモ、フワリにかえました。超軽量びん
日本ガラスびん協会

赤ちゃんに、胸をはってのませられるもの。
日本ガラスびん協会

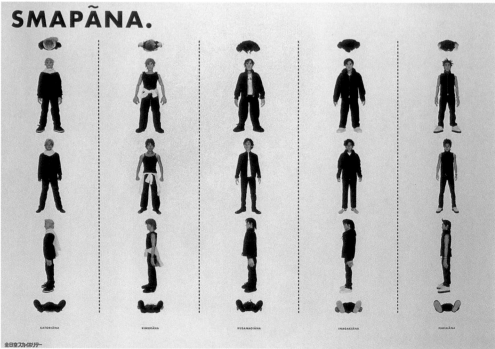

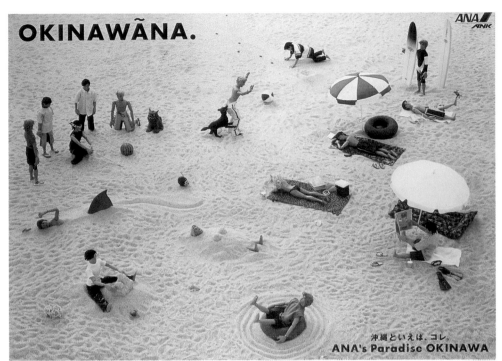

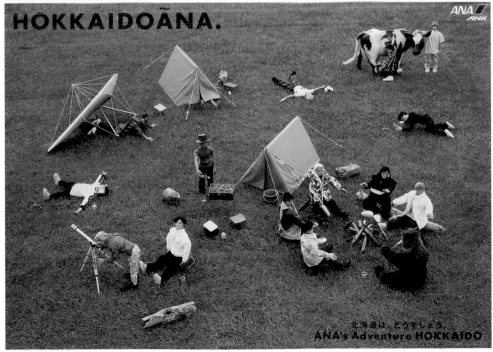

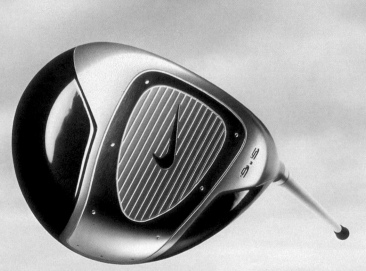

ゴルファーという名のアスリートへ。
Nike Tour Forged Titanium 350 Driver X Version
Nike Tour Forged Titanium 275 Driver

一本、筋を通したウイスキー。

山崎のモルト原酒だけでつくる。
きっぱりとした個性がある。
それは山崎で生まれ山崎で育った。純血である。
ただ一つの自分をぐいと主張する。長い年月を重ね
すべてを受けとめる懐の大きさ。向かい合うと背筋を
すっと伸ばしたくなる。清々しい緊張感がある。

サントリー ピュアモルトウイスキー 山崎

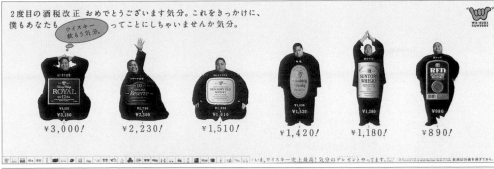

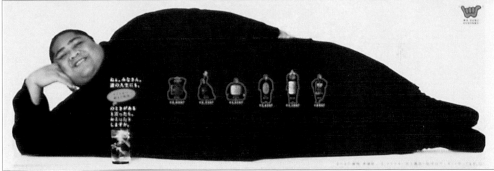

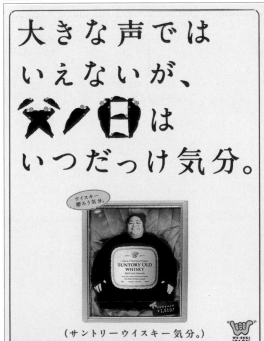

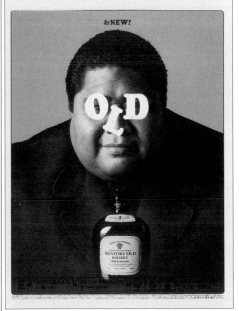

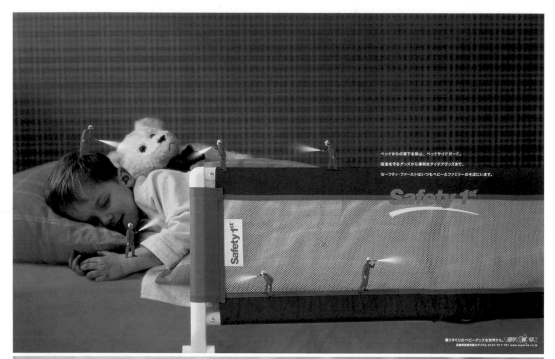

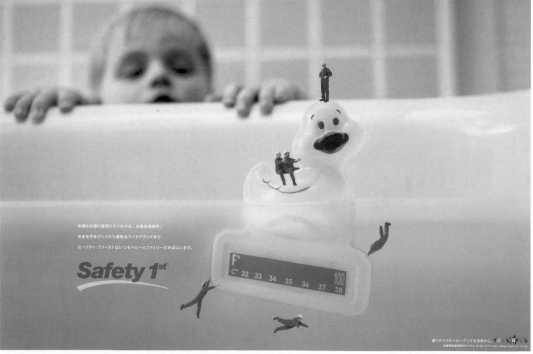

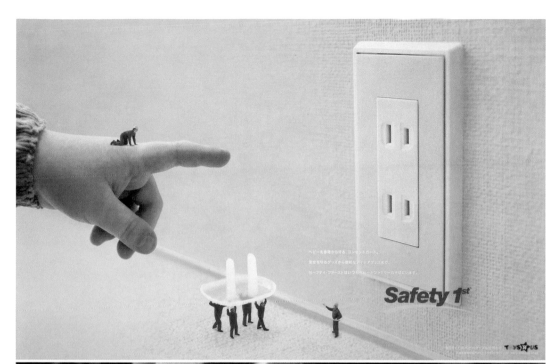

ベビーを感電から守る、コンセントカバー。
安全を守るグッズから便利なアドバイスまで。
セーフティ・ファーストはいつもベビーズワンダーワールドにいます。

Safety 1st

TOYSЯUS

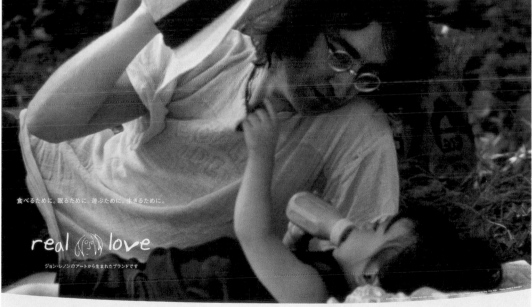

食べるために。眠るために。遊ぶために。生きるために。

real love

ジョン・レノンのアートから生まれたブランドです

TOYSЯUS　BABIESЯUS

↓ Graco [Snow Board]
D: Masaki Negishi

→ Graco [Spa]
D: Masaki Negishi

ポスターと広告

274

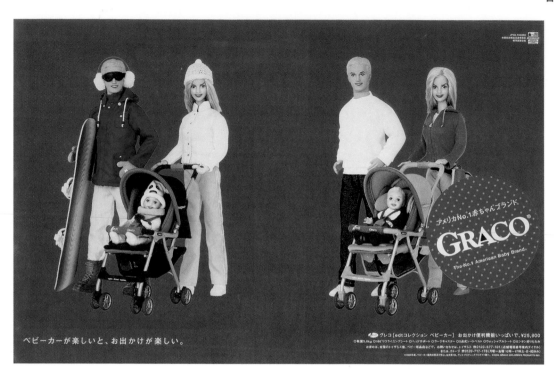

ベビーカーが楽しいと、お出かけが楽しい。

アメリカNo.1赤ちゃんブランド

GRACO®
The No.1 American Baby Brand

← Murata vegetables and fruits
Egg plant

Tomato

Cabbage
D: Masaki Negishi

↓ Murata vegetables and fruits
Petit Tomato

Banana
D: Masaki Negishi

save nature

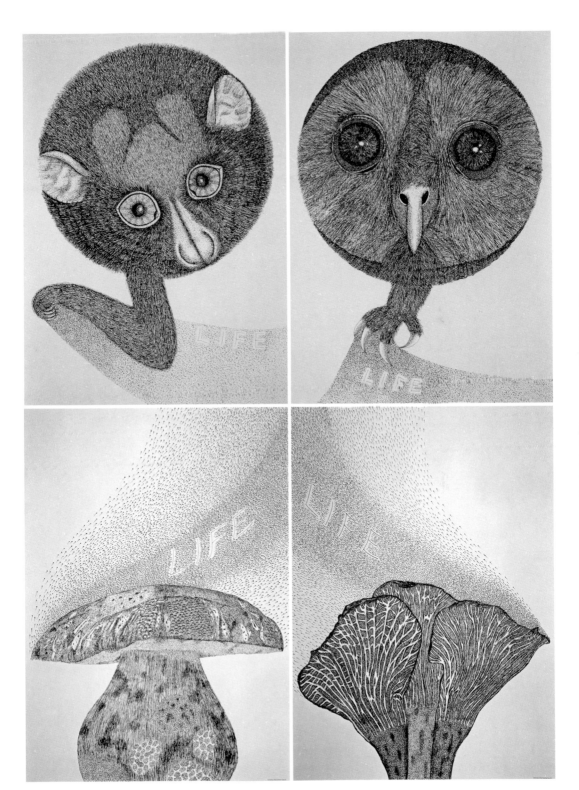

↓ Life 2001
D: Kazumasa Nagai

→ Life 2000
D: Kazumasa Nagai

Life to share
D: Kazumasa Nagai

Life to share
D: Kazumasa Nagai

Life 2000
D: Kazumasa Nagai

ポスターと広告

280

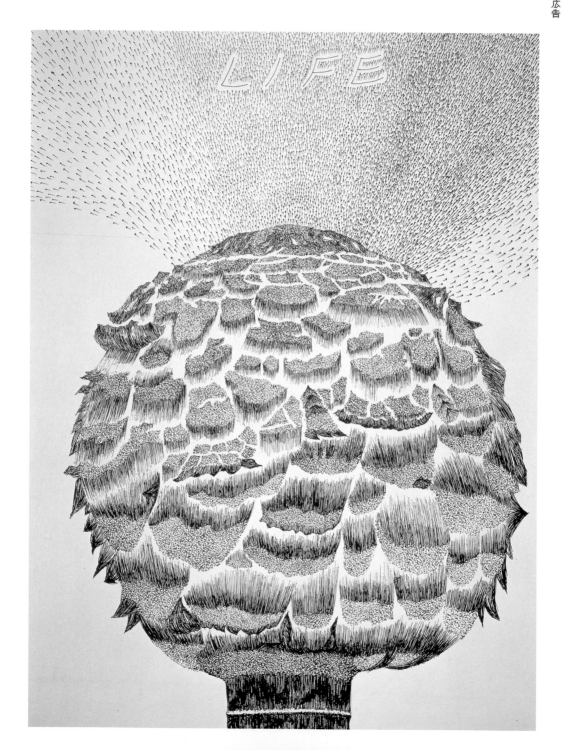

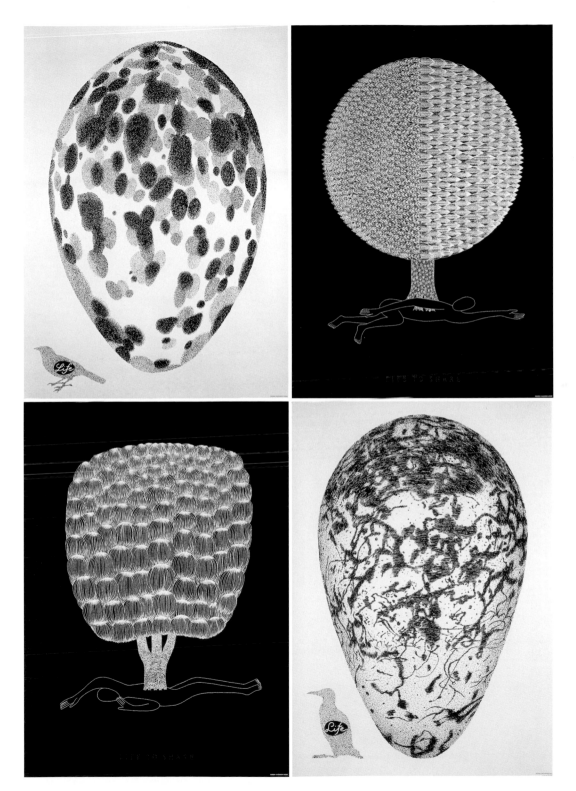

Poster LaChapelle Land
Tadanori Yokoo
D: Callaway Edition Inc.

→ Brutus Magazine Cover
art w: Tadanori Yokoo
cl: Magazine House Ltd.

ポスターと広告

282

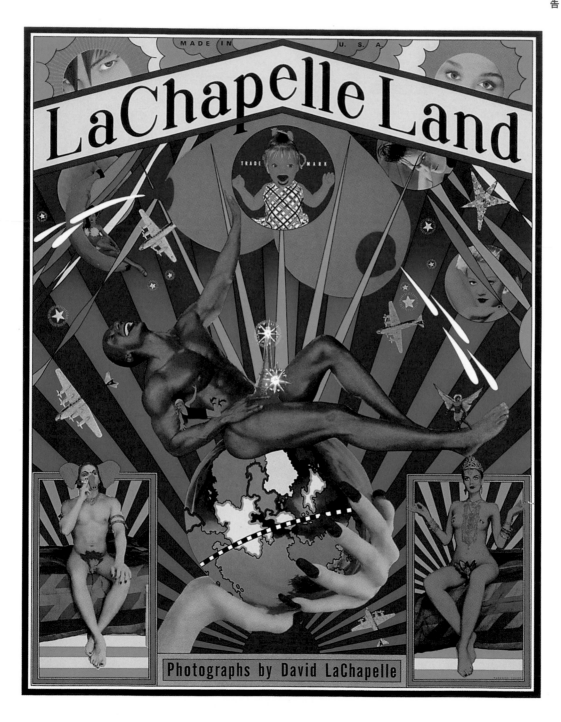

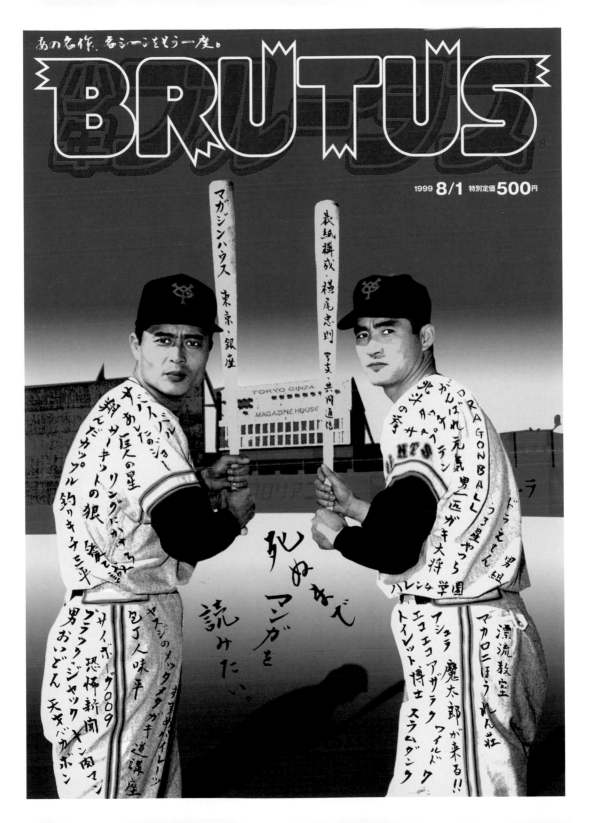

Issey Miyake Body Works
D: Tadanori Yokoo
cl: Miyake Design Studio

Glay Expo'99 Survival
D: Tadanori Yokoo
cl: Unlimited Records Inc.

Gohatto
D: Tadanori Yokoo
cl: Shochiku Co., Ltd.

ポスターと広告 284

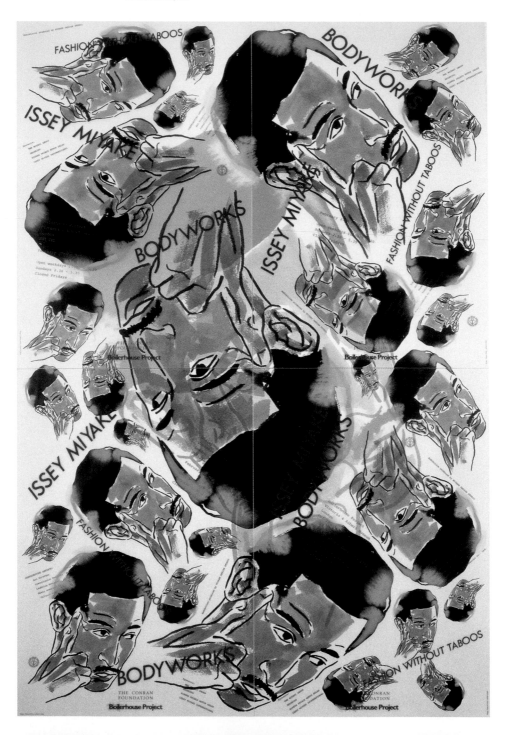

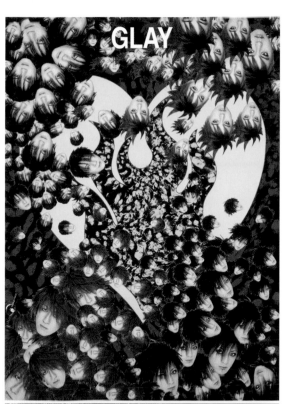

GLAY

御
法
度
GOHATTO

Print

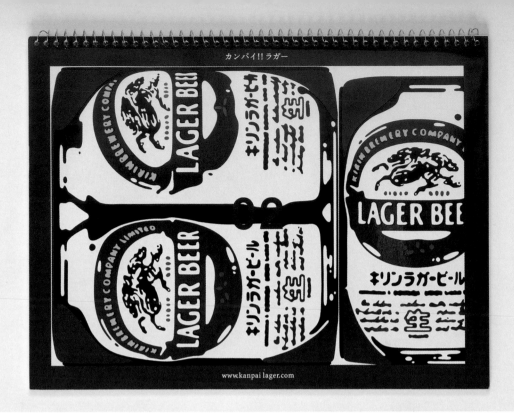

カンパイ!! ラガー

www.kanpai lager.com

2002 March 03

2002 June 06

◀ Kirin Lager Beer Calendar 2002
D: Butterfly Stroke Inc.
cl: Kirin Brewery Co., Ltd.
cd+ad+d: Katsunori Aoki
cd+c: Hidenori Azuma
d: Kana Takakuwa
i: Bunpei Yorifuji

↓ Lager Beer Logo mark
D: Butterfly Stroke Inc.
cl: Kirin Brewery Co., Ltd.
cd+ad+d: Katsunori Aoki
i: Bunpei Yorifuji

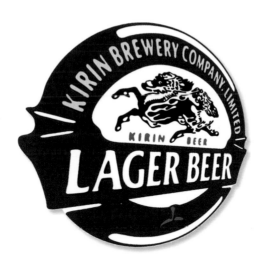

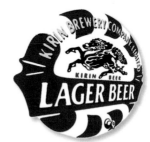

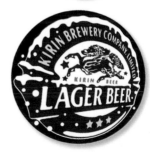

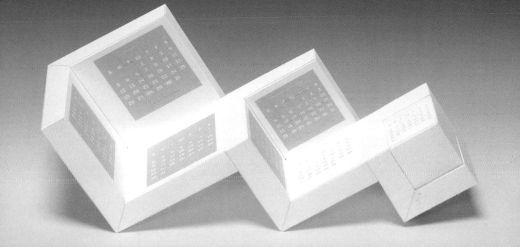

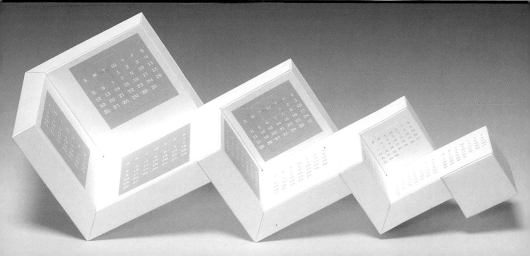

↓ Shinmachi Atrium 1st
D: Takaaki Fujimoto

→ Brochure for Beniya "Mukayu"1995
D: Kenya Hara
ad+d: Kenya Hara
d: Rie Shimoda

プリント 292

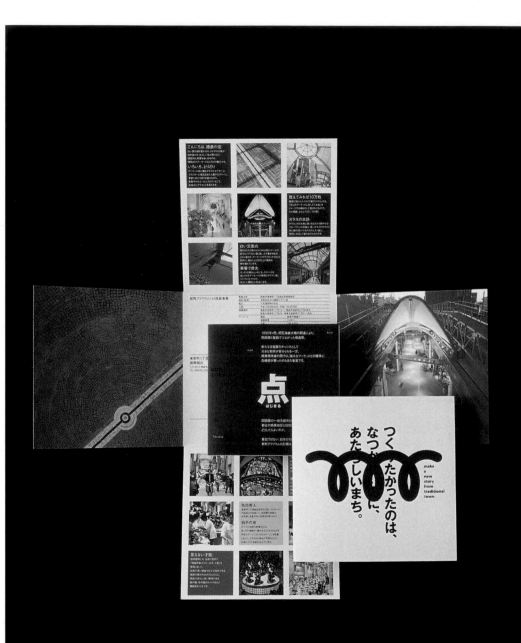

加賀・山代温泉
こまわりの宿
べにや

〒922-0242
加賀市山代温泉ハ-5-1
TEL(0761)77-1340 Fax(0761)76-1340

永遠のような時間——むかゆう

無門有

写真／竹田明

↓ Olympic Winter Games, Nagano 1998
→ Opening Ceremony Program
D: Kenya Hara
ad+d: Kenya Hara
d: Chihiro Murakami / Yukie Inoue
i: Hiroki Taniguchi

プリント

294

御柱

Raising of the Onbashira to Consecrate 'Sacred Ground'

L'érection des Onbashira va transformer le taufa en espace sacré

Le chasse-neveux ou chasse sacré afors que des milliers d'habitants de la splendide Nagano s'appréttent à ériger huit arbres géants de plus de dix mètres, les onbashira.

Il s'agit d'une coutume ancestrale de Sawa, une région proche de Nagano. La croyance veut que donner des arbres coupés dans la forêt constitue à purifier l'espace. Cri selon, conçu dédain des divinités, figurent les quatre points de l'Est, de l'Ouest du Sud et du Nord.

À Nagano, la nature est à la fois bienveillante et hostile. Après un hiver habituellement rigoureux et enneigé, les habitants attendent avec impatience le retour du printemps. Dans la rudesse de cet environnement, sont nés ces sentiments de peur et de respect de la Nature qui ont inspiré ces rites et croyances. C'est un animaux leur repris et leurs fêtes que ces humains parvenaient à donner des suites priant chacun deux saisons. Ainsi, le rite de l'ouverture des Jeux s'est remifiacel par l'érection des onbashira en un épisode sacré apte à accueillir les athlètes.

To the sound of celebratory singing, more than 1,000 local people make their entrance. Eight ceremonial wooden pillars over 10 meters tall, known as onbashira, are raised at the arena to form four gates: north, south, east, and west. The Onbashira Festival, originating in the Sawa region of Nagano Prefecture, is a tradition handed down from ancient times.

According to ancient Japanese beliefs, gods reside in the wood of these pillars. People in the Sawa region have long believed that the way to purify a place is by erecting pillars cut from mountain forests. Year after year, Nagano residents endure long, snow-blanketed winters, while eagerly anticipating the first breath of spring. These conditions have engendered an awe of nature and an abiding respect for the environment. This wish to create in harmony with nature manifests itself in folk festivals passed down over the ages.

The raising of the onbashira transforms the Olympic Stadium into a sacred arena, ready to welcome the athletes.

La fête de Onbashira

La région de Sawa est sinuée au centre-sa-la la région de Nagano. Tous les ans, au moment le plus éminencé de plus importante des rituels, celui des pilíers sacrés. On dresse des sapins géants à chaque rite de quatre bâtiment du temple décorabine de Suwa afin de repore la sacré du prédire et de parifier l'espace. Des mâlliers de personnes empressent les arbres au son d'une chanson traditionnelle, les lancent glisser à fois de montagnes (kburiek), puis les font remonter la visite d'honneur) puis aux centre en aplénue de la culmine et le pareil l'époque l'honneur de l'émotio. Bien que les plus important rituel des origines du Japon.

The Onbashira Festival

The Onbashira Festival, which relay plus relay relay arena, is the Nagano folk festival in the Suwa area of central Nagano Prefecture. At this festival, the people raise huge logs at each of the four corners the successful the restricted the structure Suwa pavilion. This square the dwelling place of the gods from the sacred world and purifies the sacred ground. The logs, cut from the mountain forest nearby, are lowered slid by several thousand people, staging a special log-coursing song as they go. Highlights include festival-riding the giant logs down a mountainside and dragger-featuring them across a river. Many people consider the Onbashira Festival one of Japan's most unique folk festivals.

八
8

九
9

土俵入

The Dohyo-iri Ceremony: Sumo Wrestlers Consecrate the Arena

La cérémonie Dohyo-iri: Les lutteurs de Sumo consacrent l'arène

Les lutteurs de Sumo vêtus de leur tablier de cérémonie (keshomanosh), pénètrent dans l'arène. L'arrivée dans cette scène dohyo-iri consacrée en rétablit cérémonial au moment du sacré à... dans plusieurs, sa présence consacre aux terrains d'Hizaki. À la fois, apice d'adresse et de force, le Sumo est un art millénaire consacré aux divinités.

En ce rite, à régime les Jeux Olympiques établit une décision de l'Antiquité. Le Sumo est pétrine d'une importante charge spirituelle pour un Japonais. Le champion pétriste, fait au visitile dans l'arène. Il élance les fentes villaniques culbi... ils sommes publics vétrifs à nouveau les athlètes. Chacun de un peu en vain! par un thúshé - avec le trait du Japonais - rounbli par les cinquante mille spectateurs.

Sumo wrestlers wearing their ceremonial keshō-mawashi aprons gird themselves for the dohyo-iri, the ring-entering ceremony. The ceremony reaches its climax when the preheater world champion wrestler enters the dohyo and stamps his feet to drive away evil spirits and purify the ground for the athletes.

The audience of 38,000 calls out the traditional shout, "hoho!". Like the ancient Olympic sport, sumo matches are dedicated to the gods. Sumo is a sport that not only incorporates both strength and technique, but also embodies the Japanese spirit in every one of its rituals.

Sumo

Sumo

十
10

十一
11

聖火

Lighting of the Olympic Flame: Oaths by Athlete and Judge

Allumage de la Flamme olympique: serments de l'athlète et de l'arbitre

Allumée à Olympie le 19 décembre 1997 et expédiée par avion au Japon, la Flamme olympique a été relayée par des milliers de coureurs sur les territoire japonais avant de parvenir dans l'arène olympique.

Le Baron Pierre de Coubertin, père des Jeux Olympiques moderne, a déclaré: "Ici qui veut se dépasser, forger son corps et son âme pour découvrir le meilleur de soi-même, «Sur toujours un degré au-dessus de celui que tu t'es fixé. Plus vite, plus haut, plus fort." «Cîtius, Altius, Fortius» Au nom de tous les athlètes des Jeux de Nagano, leur représentant prête le serment de se conformer à l'esprit des Jeux Olympiques. Une fois le serment des athlètes prononcé, des milliers de ballons en formes de colombes sont lâchés. Ces ballons porteurs des messages de paix et d'amitié des enfants de Nagano à destination du monde entier.

The Nagano Olympic flame was kindled in Olympia, Greece, on December 19, 1997 and flown to Japan. It was then hand-carried by several thousand runners throughout the country in a torch relay on the Olympic Stadium.

Baron Pierre de Coubertin, father of the modern Olympics, said: "You must train your hard, forge your body and soul to discover the best in yourself, always aim one degree higher than the goal you have set for yourself. Faster, higher, stronger." His words live on as the Olympic motto: 'Citius, Altius, Fortius.' On behalf of all the athletes who have so diligently trained for the Nagano Olympics, one athlete stands before the world and swears an oath to uphold the spirit of the Olympics. After the oath has been taken by the judge, thousands of balloons in the shape of doves are released. The balloons carry messages of peace and friendship from the children of Nagano.

La Flamme olympique

La Flamme olympique a été transportée depuis le palais de Mira, sieu le Japon par avion. La course de relais reconnaissée de 6 janvier 1998, a reporté trois kilomètres différent qui courtiront vers les départements japonais. Lorsque les différentes torches se sont rejoints sur le modèle japonais en l'arène olympique, célbe-ci ont éclairé un vase toril, qui a oncé le chaque la Flamme olympique illumina. Cette serment de la course de la Flamme olympique a été toublavé sur Jean de Mira en 1938, on clics en perpetruté au s'intégrera sur ce renoncation de diverses des pays réunis.

The Olympic Flame

The Olympic torch was kindled in Olympia and flown to Japan, where the torch relay begins on January 6, 1998. The relay continued off three separate routes, covering all of Japan's prefectures, was simultaneously. The torches analyse the three routes were lit. Then the mountaintop of the vault and Nagano, they reached the cauldron in the Opening Ceremony venue and aced to light the Olympic flame. The Olympic relay torch is designed to look like a comet-like flame. The Olympic relay symbolised condensated Japanese plan used, while the flame event symbolises a signal fire. With its beginning at the 1948 Berlin Olympics, the torch relay has grown into a tradition, which each four-country combn was in a moment expressing its own unique culture.

十四
14

十五
15

function Conveniently designed inside space —

書類などビジネス用途に使用する空間と

衣類などを入れる

プライベートな空間とを分けるなど

you can part and pack your belongings according to the purpose : documents are into the business room and clothes the private.

収納するものの用途や大きさに応じて

スペースの大きさ・種類・使用を扱的的に考え

より使い易さを追求しました

9-1-394　9-1-415　9-1-393　9-1-416　9-1-408　9-1-398　　9-1-453　9-1-381　9-1-416　9-1-416

material Ultra-lightness and hyper-durability —— both

ケミカル素材のなかでも

水に浮くほどの軽さと撥水性を

合わせ持った画期的な新素材

realized a miracle chemical fiber, "Polyester Hollow Fiber (Aerocapsule)".

ポリエステル中空糸

（エアロカプセル）を使用

軽量でしかも耐久性に優れています

ORGANIZER BRIEF 9-1-390	OVERNIGHT BRIEF 9-1-392	OVERNIGHT BRIEF 9-1-393	SLIM ATTACHE 9-1-394	SLIM ATTACHE 9-1-415	SOFT ATTACHE 9-1-416

← im product MOVI
Catalog
D: Taku Satoh

↓ Smap goods
D: Samurai

Ura Smap goods
D: Samurai

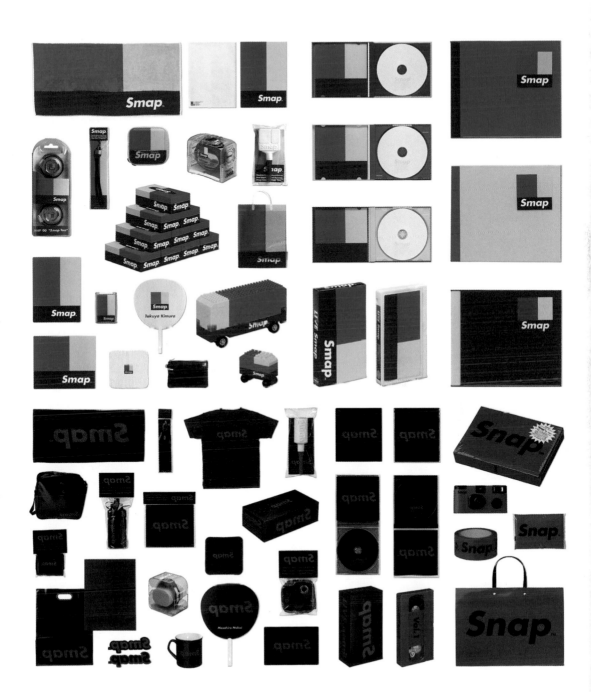

Playing the Orchestra 1997,
Ryuichi Sakamoto
CD jacket
D: Hideki Nakajima

El Mar Mediterrani, Ryuichi Sakamoto
CD jacket
D: Hideki Nakajima

Crescent Moon
CD jacket
D: Hiroyuki Matsuishi

1996, Ryuichi Sakamoto
CD jacket
D: Hideki Nakajima

Kinjito, Kazuyoshi Nakamura
CD jacket
D: Hideki Nakajima

Kitakyushu Media Dome
CD jacket
D: Hiroyuki Matsuishi

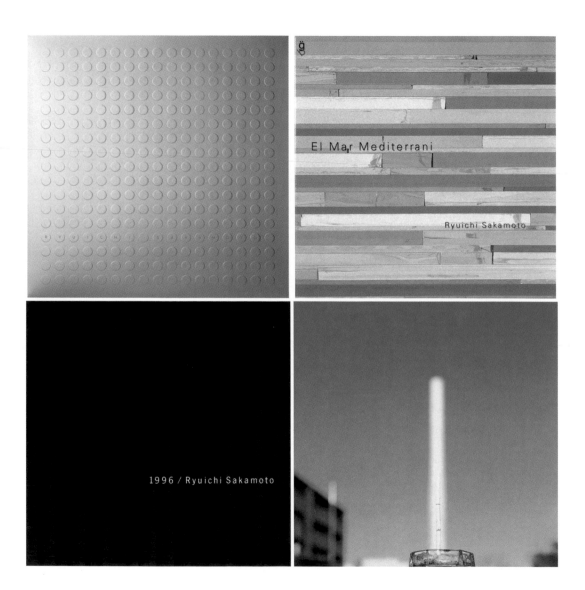

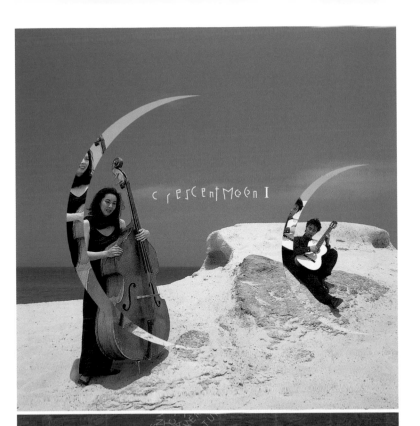

crescentmoon I

SPORTS CONVENTION
CONCERT CULTURE EVENT
MULTI MEDIA
EXHIBITION

Kitakyushu Media Dome

北九州メディアドーム

PROMOTION VIDEO CD

↓ Miyagawa Pharmacy
Inagaki co.,ltd
Shinmachi Atrium 1st
D: Takaaki Fujimoto

Deguchi Insurance Office
Noguchi Architect & Associates
Ichikawa-cho Cultural Center
D: Takaaki Fujimoto

プリント

300

DEGUCHI
INSURANCE
OFFICE

Noguchi Architect & Associates

Shinachi
ATRIUM 1st

市川町文化センター
Ichikawa-Cho Cultural Center

↓ WonderBorq
D: Devilrobots Inc.

Futureshot logo
D: Yoshihito kawata

ABE Survey
D: Ken Miki & Associates

Tram
D: Devilrobots Inc.

Futureshot logo&mark
D: Yoshihito kawata

Paper Studio
D: Ken Miki & Associates

↓ Sanbyoushi

Casablanca

Cuoca cafe
D: Takaaki Fujimoto

Fitness Club Machiken

Shijan Cafe

SeiChan
D: Takaaki Fujimoto

302

Isshin

Kikuya

Cuisine Kanya
D: Takaaki Fujimoto

Cuisine Kanya

Fujimoto Noodle

Cuisine Kanya
D: Takaaki Fujimoto

POOL
プール

COACHINGROOM
コーチルーム

SHOWER
シャワー

WARMINGROOM
採暖室

POWDERROOM
パウダールーム

STUDIO1
スタジオ 1

STUDIO2
スタジオ 2

TRAININGGYM
トレーニングジム

MEN'SLOCKER
ロッカールーム

NURSERY
託児室

GIRLSLOCKER
おんなの子のロッカー

KIDS POOL
こどもプール

ATELIER
アトリエ

MAN
おとこ

LADY
おんな

Guica.com
D: Takaaki Fujimoto

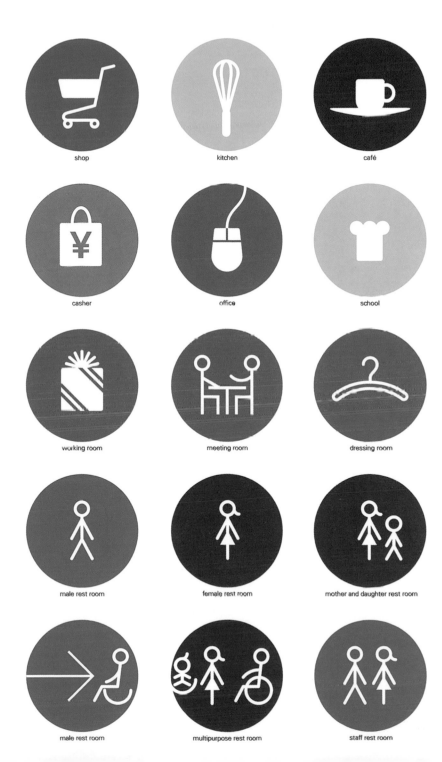

shop

kitchen

café

casher

office

school

working room

meeting room

dressing room

male rest room

female rest room

mother and daughter rest room

male rest room

multipurpose rest room

staff rest room

Tsukasa Logo
D: Noriaki Hayashi

Appare Sanuki [Noodle Shop]

OZ Entertainment Inc.
D: Minato Ishikawa

Maruya Logo
D: Noriaki Hayashi

Umehati Co., Ltd. [Pickled Ume Shop]

Kenso Co., Ltd. [Constructor]
D: Minato Ishikawa

Onnikawa Orthopedic Clinic

Arjo Wiggins Paper Collection

Heiwa
D: Ken Miki & Associates

Abilit

Futuristic Pulse

Ecology paper
D: Ken Miki & Associates

↓ Hokusetsu

Paper studio

KSC Kamoike Bild.
D: Ken Miki & Associates

Kagawa Education Institute of Nutrition

World Environment Day'99

2001 Wine
D: Ken Miki & Associates

タ・ユニット

308

Fontic, Logomark

Kawasaki Electronics, Logomark

Sumire Clinic, Logomark
D: Hiroyuki Matsuishi

Hako Cafe, Symbolmark

Hakoshiki, Logomark

Sanwagiken, Symbolmark
D: Hiroyuki Matsuishi

HAKOCAFE

KAWADEN

HAKOSHIKI

治療院

↓ Tsukitei Happo

02

Sasaya
D: Koshi Ogawa

Kokoro

Swimming

Car
D: Koshi Ogawa

プリント

310

↓ Port/End
Akio Okumura

Wind
D: Akio Okumura

Glico

Web-Database-Logistics

Interface Humanities
D: Akio Okumura

port/end

IM-LAB

物流工作

Interface Humanities

Iwate Nature School
D: Norito Shinmura
cl: Seiyu

Renkonya
D: Norito Shinmura

Crawl X Crawl
D: Norito Shinmura
ad+d: Norito Shinmura

Gradog
D: Norito Shinmura

Tachibana
D: Norito Shinmura
cl: Tachibana Town

Potter's pot
D: Norito Shinmura
ad+d: Norito Shinmura

 Hibiki no sato
cl: Oyama town

Green Smile
D: Norito Shinmura
cl: Shinmura Design Office
ad+d: Norito Shinmura

Kenkoukan

Wintec Wire

Watanabe Dental Clinic
D: Norito Shinmura
ad+d: Norito Shinmura

ADMT (AD Museum Tokyo)
D: TUGBOAT

Flag
D: TUGBOAT

Concept
D: TUGBOAT

Medical Channel (Courtesy of Sony)
D: Masaaki Omura

Xiidea
D: Romando Co., Ltd.

Coamix
D: Romando Co., Ltd.

Medical Channel

Aibo (Courtesy of Sony)
D: Masaaki Omura / Contrail

Harvest Drive (Courtesy of Sony)
D: Masaaki Omura

Aperios (Courtesy of Sony)
D: Masaaki Omura

Sony Eco Plaza (Courtesy of Sony)
D: Masaaki Omura / Contrail

Sony Life (Courtesy of Sony Life Insurance)
D: Masaaki Omura / Kouki Yamaguchi

So-net (Courtesy of Sony Communication Network)
D: Masaaki Omura

↓ BS Asahi
Stationery, CI-Manual
D: Taku Satoh

→ Japanese paper stationery
D: Mihiko Hachiuma

プリント 318

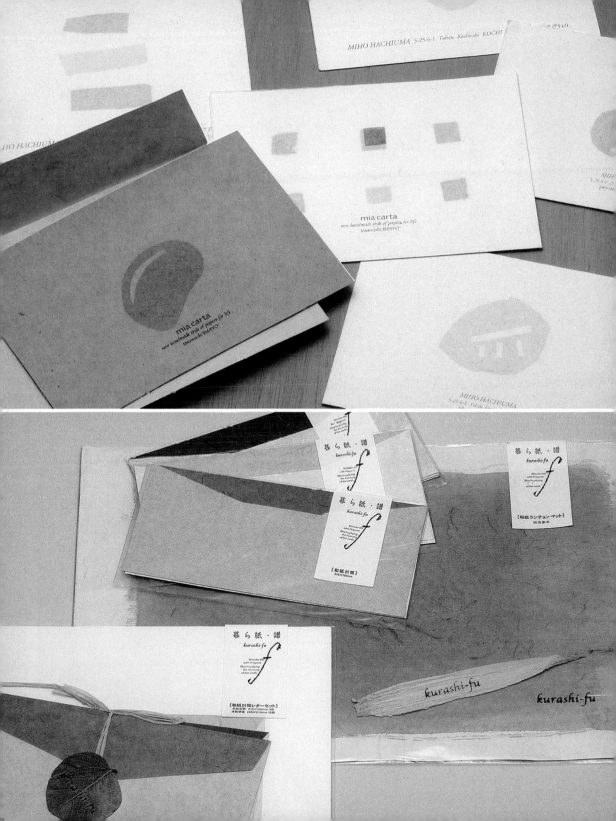

↓ Signage for Katta Hospital
D: Kenya Hara
ad: Kenya Hara
d: Yuji Koisoa

プリント

320

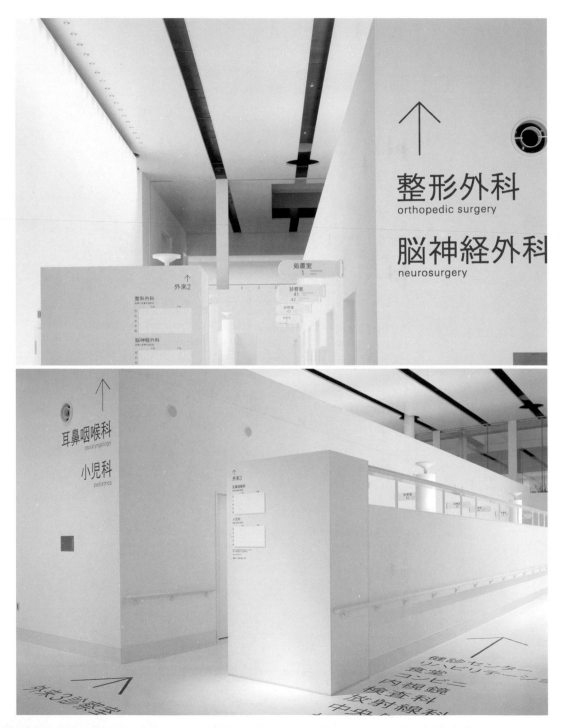

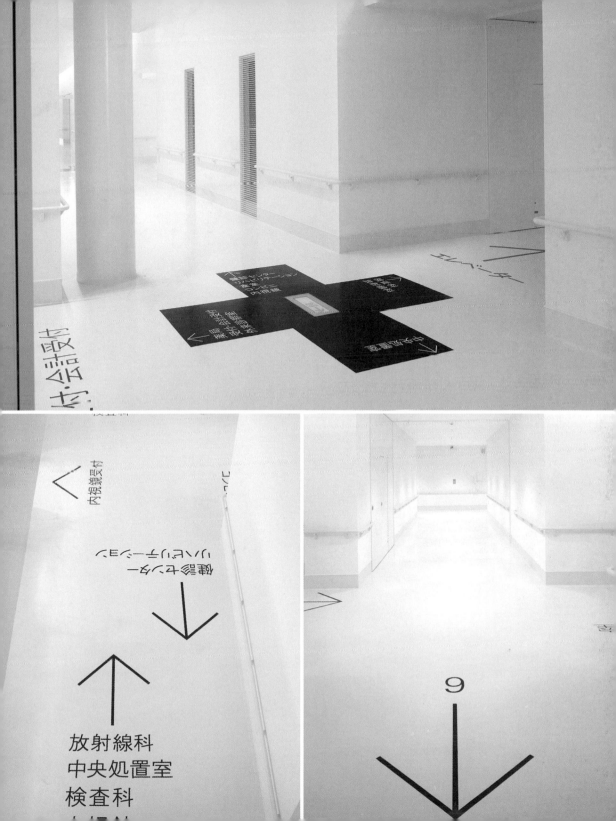

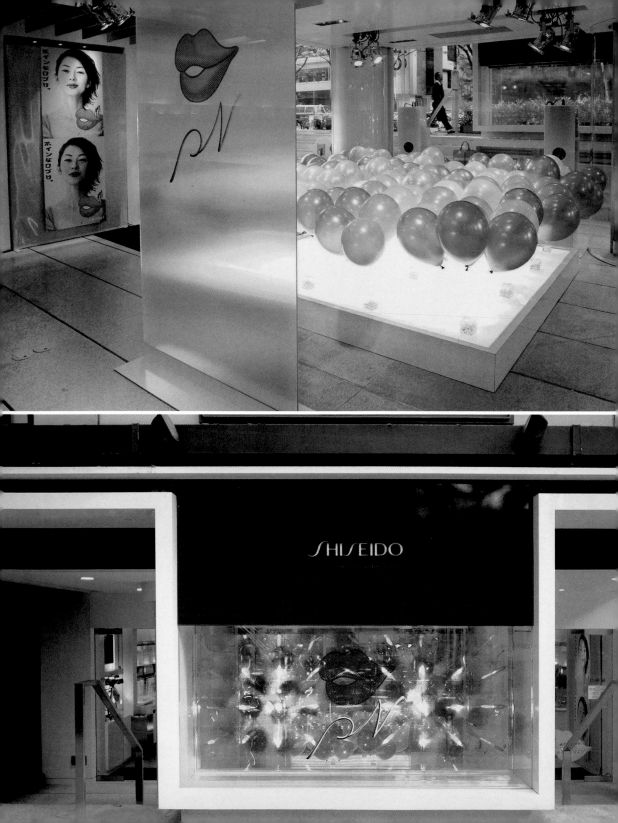

← Shiseidō PN display
Display design
D: Sayuri Studio, Inc.

↓ Issey Miyake HaaT
Collateral items
D: Sayuri Studio, Inc.

A.D.2000

The very first work of
butterfly·storke inc.
katsunori aoki
keiko aoki / masumi saito / yuji sakai / keisuke takizawa

A.D.2000

david duval-smith / enlightenment / groovision / hiroyoshi koyama / seijiro kubo
tomomi maeda / takashi murakami / ichiro tanida / bunpei yorifuji / masayuki yoshinaga

← A.D.2000
Cover design
D: Butterfly Stroke Inc.
ad+d: Katsunori Aoki
i: Bunpei Yorifuji / Enlightenment

↓ A.D.2000
Page design

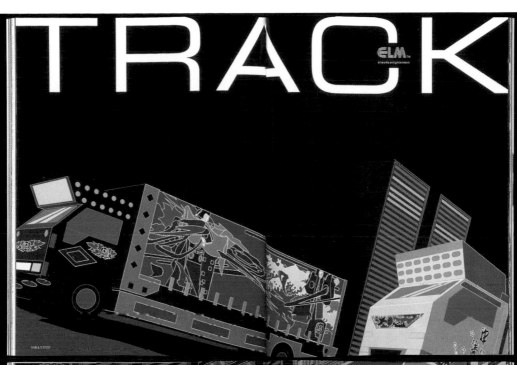

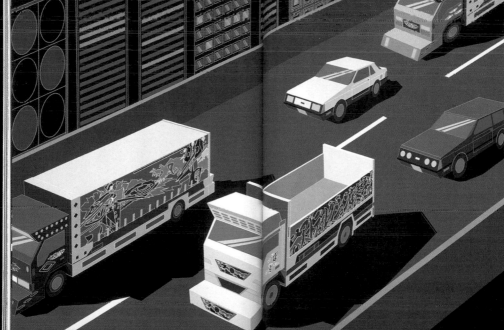

← Mina Ryushi
Book design
D: Bluemark Inc.

↓ Takehito Koganezawa Drawing
Book design
D: Bluemark Inc.

ルイ・ヴィトン BRUTUS SELECTION

BRUTUS

2002 8 15 550円

ルイ・ヴィトンの謎？

世界の集合住宅ベスト・オブ・ベスト付き。

BRUTUS

2002 11/1 特別定価 550円

安藤忠雄

ジャン・ヌーヴェル、
スティーヴン・ホールが
あなたのために
集合住宅を
建ててくれます

第2特集
ウイスキーの逆襲！

← Brutus Nr. 507 / 512
Editorial design
D: Magazinehouse

↓ Casa Brutus Nr. 5
Editorial design
D: Magazinehouse

季刊『カーサ ブルータス』
★Casaは家。
でも、ハウスじゃなくて、
ホームです。

BRUTUS®
Casa

海外の
モダニズム住宅を
買いませんか？

日本一美味しい
ケーキを作る
パティシエを探せ！

★特集
P・スタルク、R・ピアノ、J・ヌーヴェル、
G・ポンティ…有名建築家が手がけた
デザイン ホテルに
泊まりたい。

BRUTUS増刊 2000 1/10 定価880円

Casa Brutus Nr. 7
Editorial design
D: Magazinehouse

Casa Brutus Nr. 16
Editorial design
D: Magazinehouse

Casa Brutus Nr. 20
Editorial design
D: Magazinehouse

Casa Brutus Nr. 21
Editorial design
D: Magazinehouse

プリント

330

↓ Dream Design [Kitchen & Kitchen Tools] → Dream Design [Bath & Sanitary design]
 Editorial design Dream Design [Italian Mid-Century]
 D: Magazinehouse Dream Design [The Era of Design Shop]
 Dream Design [Joyful vs. Functional Kitchen]
 Editorial design
 D: Magazinehouse

プリント 332

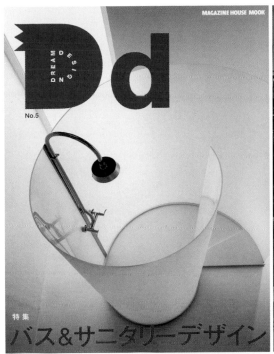

MAGAZINE HOUSE MOOK

No.5

特集
バス＆サニタリーデザイン

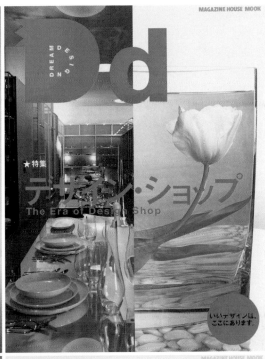

MAGAZINE HOUSE MOOK

★特集
デザイン・ショップ
The Era of Design Shop

いいデザインは、ここにあります。

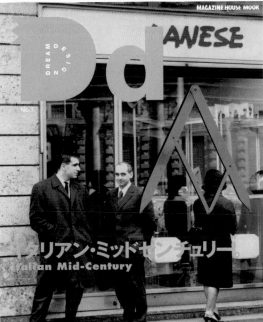

MAGAZINE HOUSE MOOK

No.7

イタリアン・ミッドセンチュリー。
Italian Mid-Century

テキスタイルの復活。
Surface Beauty!

MAGAZINE HOUSE MOOK

8

楽なキッチン、楽しいキッチン。
Joyful vs. Functional Kitchen

今年こそデブ・ズン胴から脱却を!

2003年2月12日発行（毎月第2・第4水曜日発行）第18巻第2号
昭和61年6月23日第三種郵便物認可

Tarzan ®

2 12 2003 No.389
450YEN 特別定価
http://tarzan.magazine.co.jp/

男と女の
年間トレーニング計画

男は自然なカラダが、
女は筋肉を感じさせる
カラダが断然いい!

このエクササイズで、
理想の
カラダに
なる!

← Tarzan Nr. 388
Editorial design
D: Magazinehouse

↓ Tarzan Nr. 389
Editorial design
D: Magazinehouse

男と女のパーフェクトボディBOOK

2003年1月22日発行（毎月第2・第4水曜日発行）第18巻第1号
昭和61年6月23日第三種郵便物認可

Tarzan®

総集編

カラダ
デザイン
自由自在

It's your body.

効果的な鍛え方、
痩せるための方法論、
全身ケアの秘訣——
すべてに答える強力決定版！

1/8,22 2003 No.388

550YEN 特別
http://tarzan.magazine.co.jp/

高原直泰

↓ Morisawa Font, 2nd version 1997
Booklet for digital font
D: Shinnoske Sugisaki

→ Morisawa Font, 1st version 1997
Booklet for digital font
D: Shinnoske Sugisaki

プリント 336

文字の物語が画面を行き交う。ことばを映像化する力が、漢字にはある。

潔

文字の音楽が紙上を流れる。ひらがなの響きは、いつの時代も心に近い。

な

↓ Tokyo ADC Annual
　Book design
　D: Yoshie Watanabe

→ Did God reply yet?
　Book design
　D: Yoshie Watanabe

プリント　　338

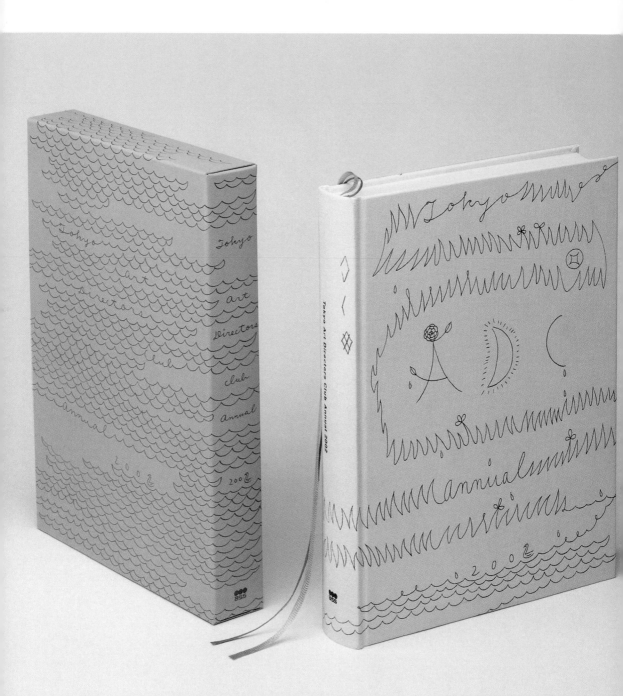

かみさま
どうして このごろ
あたらしい どうぶつを
はつめい しないのですか？
もう ずっとずっと
おんなじ どうぶつ ばっかり
　　　　　　ジョニー

かみさま
あなたは きりんを
ああいうふうに なればいいと
おもって つくったの？
それとも まちがって
ああなったの？
　　　　　　ノーマ

↓ Buch up and down
Book design
D: Yoshie Watanabe

Buch open
Book design
D: Yoshie Watanabe

→ Mine
Book design
D: Yoshie Watanabe

プリント 340

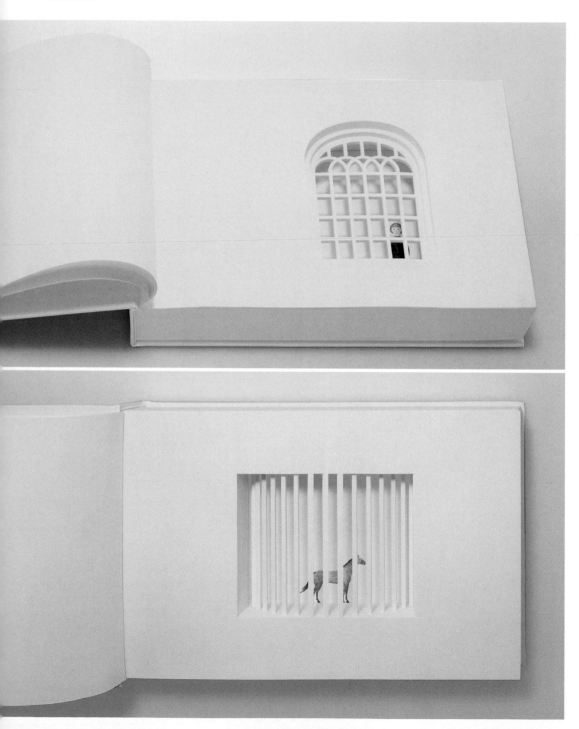

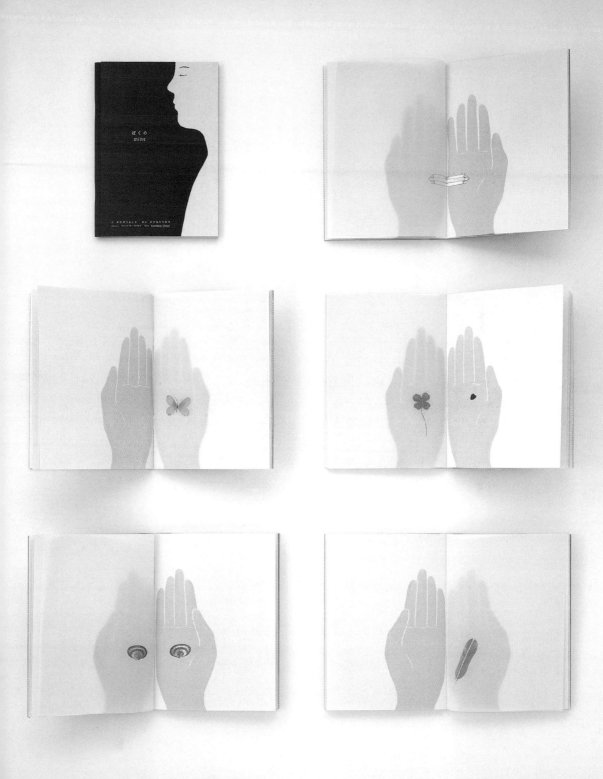

An Arbitrary Point P

Keio University Masahiko Sato Laboratory and Norio Nakamura

任意の点P

3D
STEREO BOOK
48 stereoscopic graphics inside

慶應義塾大学 佐藤雅彦研究室＋中村至男

美術出版社

任意の点P

慶應義塾大学 佐藤雅彦研究室＋中村至男

← An Arbitrary Point P
 D: Kohji Yamamoto
 cd: Masahiko Sato

↓ Tokyo Art Directors Club Annual 2000
 D: Taku Satoh

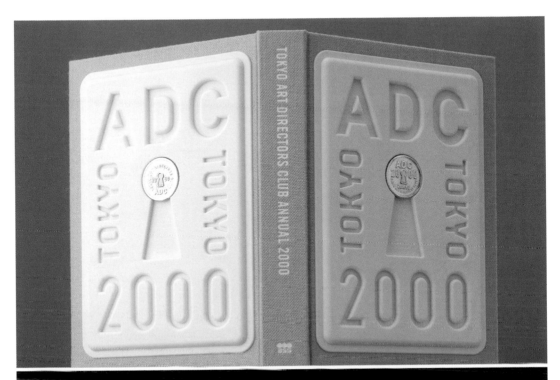

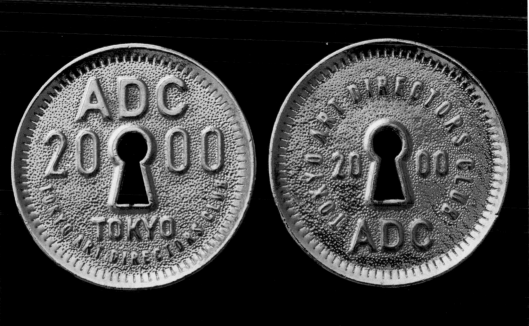

↓ Sampled Life
Editorial design
D: Hideki Nakajima

→ Revival
Editorial design
D: Hideki Nakajima

プリント 344

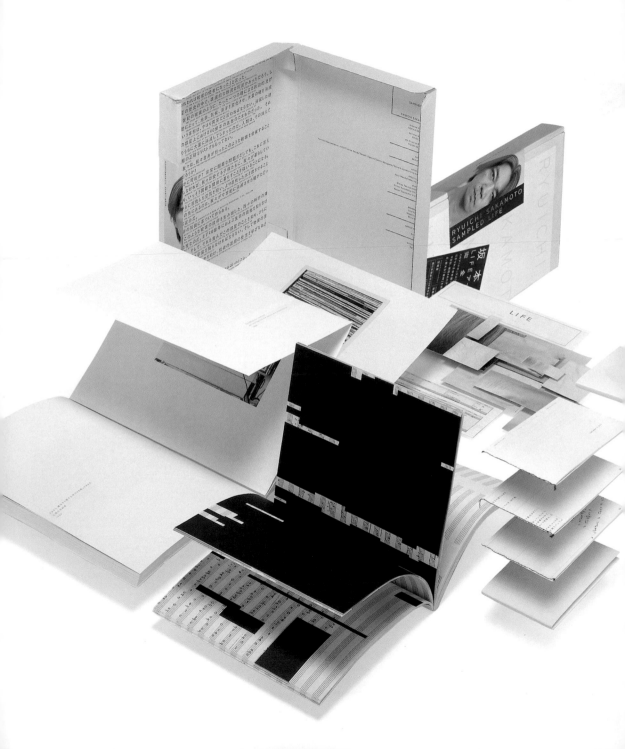

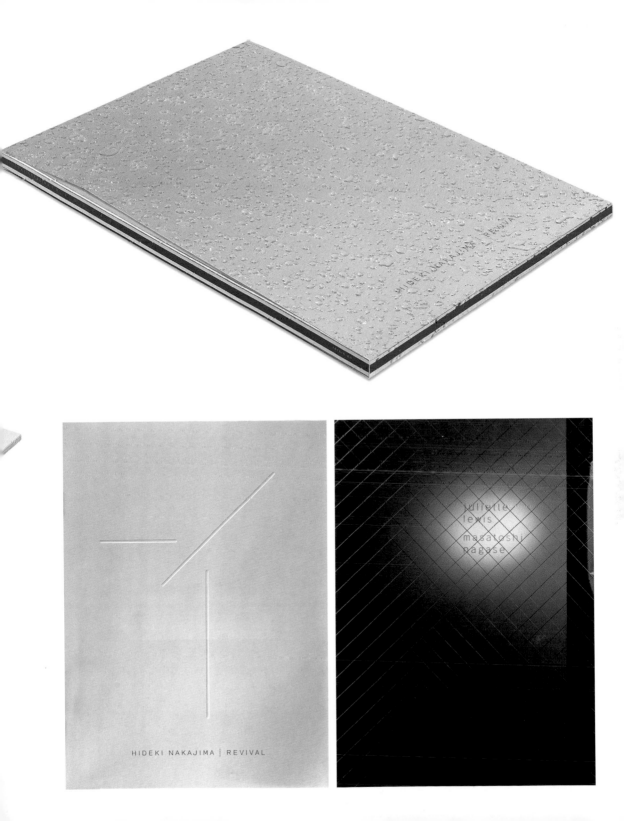

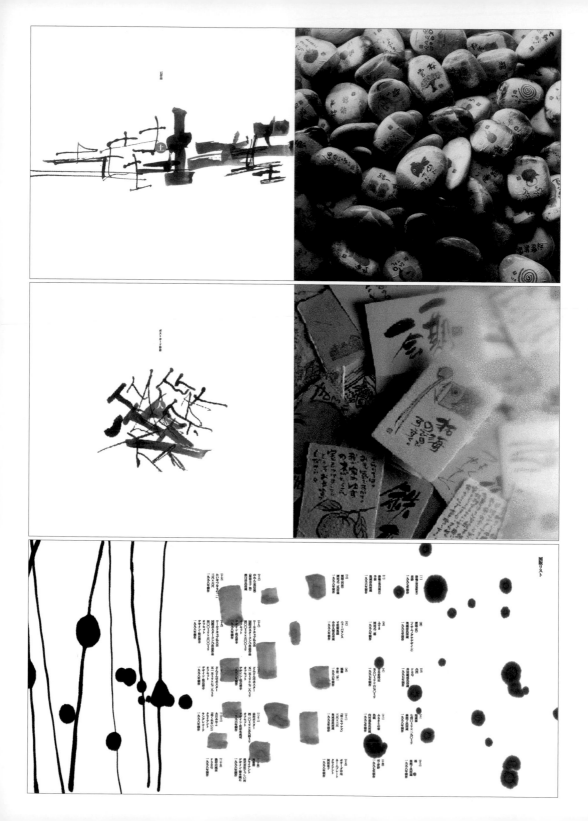

← Selected Works Youseki Miki
Editorial design
D; Hiroyuki Matsuishi

↓ Selected Works Youseki Miki
Editorial design
D; Hiroyuki Matsuishi

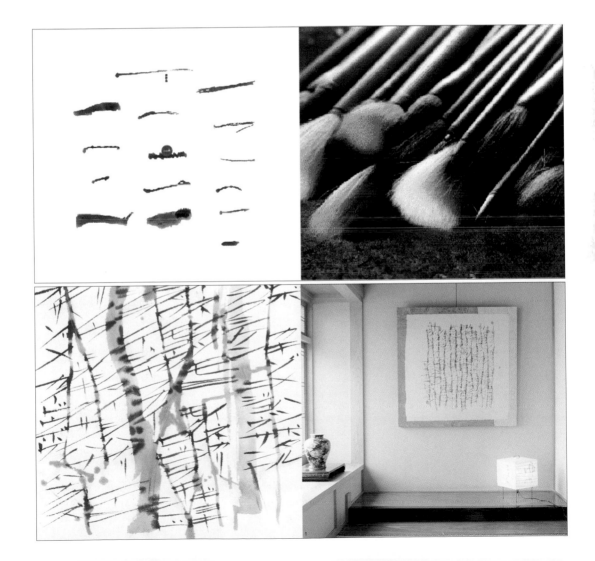

Strange Against Strange

You're strange and we like fur
Strange, walking down the avenue
You're strange just the way you are
Strange, always doing something new

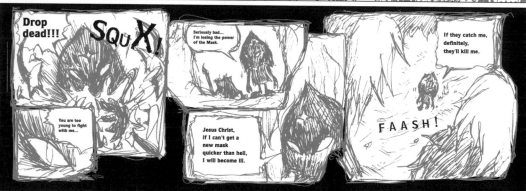

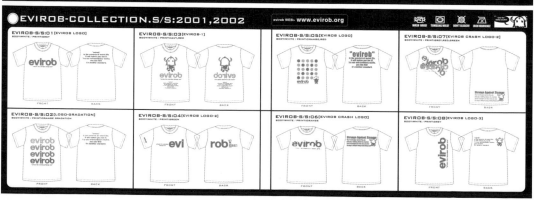

← Evirob-KIT
Booklet
D: Devilrobots Inc.

↓ Exposure
Free paper cover design
D: Devilrobots Inc.

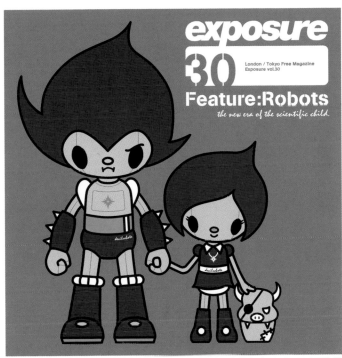

INDEX

We would like to thank for the brilliant cooperation we have had from all the designers during all the production process and for their willingness to help us to make this publication a significative showcase of how graphic design has developed in Japan.

We would like to thank of course all the professionals and friends that contributed to make this publication better, among them Yasuo Satomi, TASCHEN's director in Japan and Kiyonori Muroga, editor of IDEA Magazine in Tokyo, that in the last minutes have helped us do much. We thank also the people and institutions that have helped us to find all the designers we were willing to feature in the book, such as Naoki Kondo, from JAGDA (Japan Graphic Designers Association), Tokuzo Ito from Dentsu Inc. for his help and introduction to the Japanese advertisement business, Junko Fujii also from Dentsu Inc. for her intense collaboration, Noriko Iwamoto from the ADMT (Advertising Museum Tokyo), for introducing the Museum collection, Leila Kozak-Gilroy for the comments on the introduction, and special thanks to Takashi Tsurumaki for his support and invaluable help all along the process. At last, but not at least, we would like to thank all the staff at TASCHEN Japan, specially Yuko Aoki and Mari Omura, who have done so much for us during the whole production.

To stay informed about upcoming TASCHEN titles, please request our magazine at www.taschen.com/magazine or write to TASCHEN, Hohenzollernring 53, D-50672 Cologne, Germany, contact@taschen.com, fax: +49-221-254919. We will be happy to send you a free copy of our magazine, which is filled with information about all of our books.

IMPRINT

© 2006 TASCHEN GmbH
Hohenzollernring 53, D-50672 Köln
www.taschen.com

Original edition: © 2003 TASCHEN GmbH
Design: Julius Wiedemann, Cologne
Layout: Julius Wiedemann, Cologne & Gisela Kozak, Tokyo
Cover design: Sense/Net, Andy Disl & Birgit Reber, Cologne
Production: Ute Wachendorf
Editors: Gisela Kozak & Julius Wiedemann
German Translation: Anke Caroline Burger
French Translation: Marc Combes
Japanese Translation: Ritsuko Hiraishi, Tokyo

ISBN 978-3-8228-5088-6
Printed in China